Style and Content in
CHRISTIAN ART

Style and Content in
CHRISTIAN ART

JANE DILLENBERGER

CROSSROAD · NEW YORK

1988
The Crossroad Publishing Company
370 Lexington Avenue, New York, N.Y. 10017

Printed in the United States of America

Library of Congress Cataloging-in-Publication Data

Dillenberger, Jane.
 Style and content in Christian art.

 Bibliography: p.
 Includes index.
 1. Christian art and symbolism—Themes, motives.
2. Composition (Art) I. Title.
N7831.D54 1986 704.9'482'09 86-6189
ISBN 0-8245-0782-7

E. for J.D.

preface to the second edition

This book was conceived as a handbook for those interested in art with religious subject matter, and was written more than twenty years ago. Were it written today, it would, of course, be a different book. In particular, Chapter III, "Early Christian and Byzantine Art," would be re-written. Subsequent scholarship has yielded a picture of the Graeco-Roman world, the matrix in which early Christian art appears, as much more complex than the two strands discussed in Chapter III. Today's readers should consult the splendid volume edited by Kurt Weitzman, *The Age of Spirituality: Late Antique and Early Christian Art, Third to Seventh Centuries* (The Metropolitan Museum of Art, 1979).

I want to thank Diane Apostolos-Cappadona who, as friend, initiated the republication of this volume and, as editor, has skillfully and per-sistently attended to every detail.

JANE DILLENBERGER

The Graduate Theological Union
Berkeley, February 1986

acknowledgments

The opportunity for the study of art and architecture in England and Europe was provided by a grant from the Rockefeller Foundation in 1961. This made it possible to see the works of art discussed in this book, and to talk with those who are daily involved in the care of the churches and the works of art housed in them.

I am indebted to my many colleagues who have read and criticized parts of the manuscript in the field of their own competence and interests—Professor Gordon Harland, Professor Will Herberg, and Dean Stanley Romaine Hopper, all of Drew University; Professor Neill Hamilton of the San Francisco Theological Seminary; and John Humphrey, Curator of Painting, the San Francisco Museum of Art. My particular thanks to Dr. Paul Tillich, who read the manuscript in its entirety, and who for many years has been a friend and colleague in the endeavor to accent the place of the visual arts in our culture.

My thanks are also due to Ruth Harland who, with patience and skill, did the first typing of the manuscript and to the secretarial staff of the San Francisco Theological Seminary.

And finally, my gratitude, and much more, to my husband, John Dillenberger, who helped most of all.

JANE DILLENBERGER

San Francisco Theological Seminary
February, 1965

contents

9

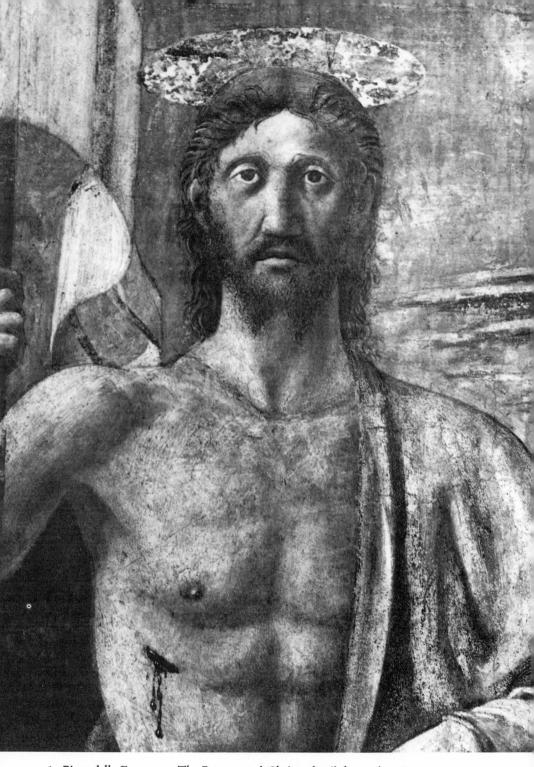

1. Piero della Francesca, The Resurrected Christ; detail from plate 2.

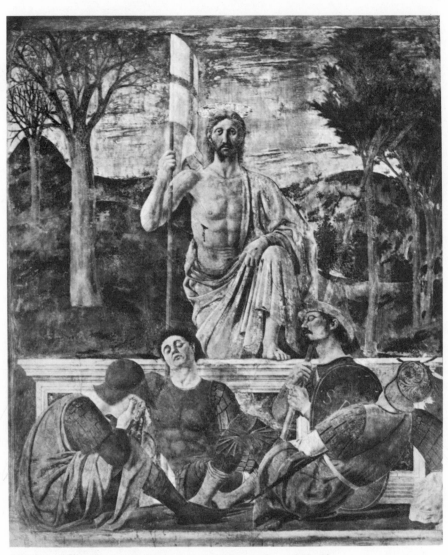

2. Piero della Francesca, THE RESURRECTION (c. 1462-64;
Palazzo Communale, Sansepolcro).

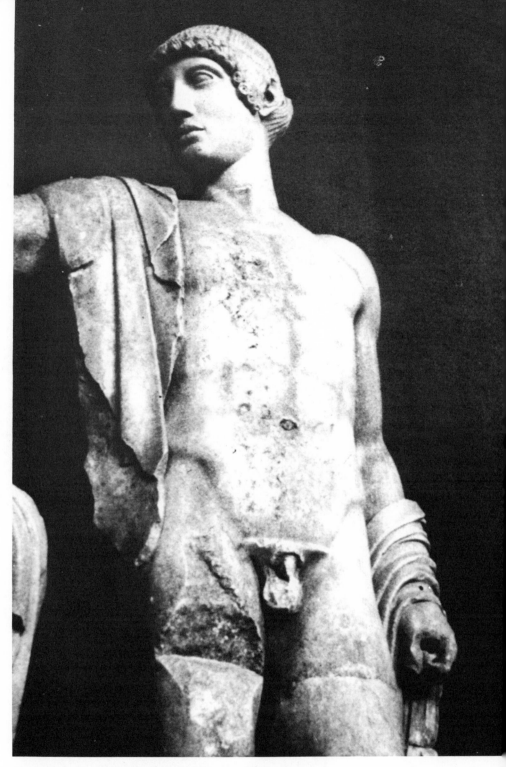

3. APOLLO (c. 460 B.C.; Olympia Museum, Olympia).

4. APOLLO (c. 460 B.C.; Olympia Museum, Olympia).

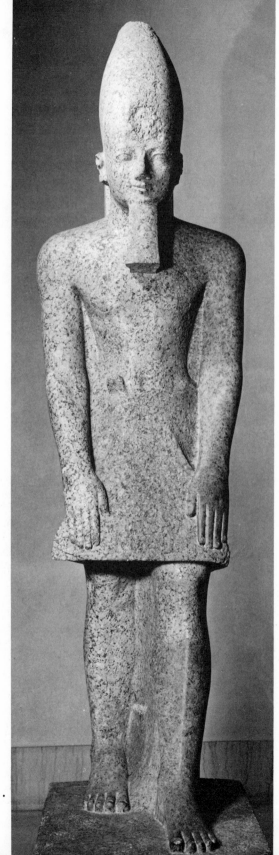

5. THUT-MOSE III (c. 1500 B.C.;
The Metropolitan Museum of Art).

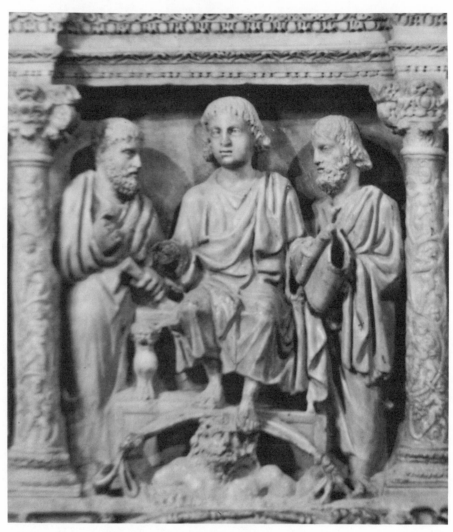

6. Christ Giving the Law to Peter and Paul; detail from plate 7.

7. THE SARCOPHAGUS OF JUNIUS BASSUS (c. 350; Crypt of St. Peter's Basilica, Rome).

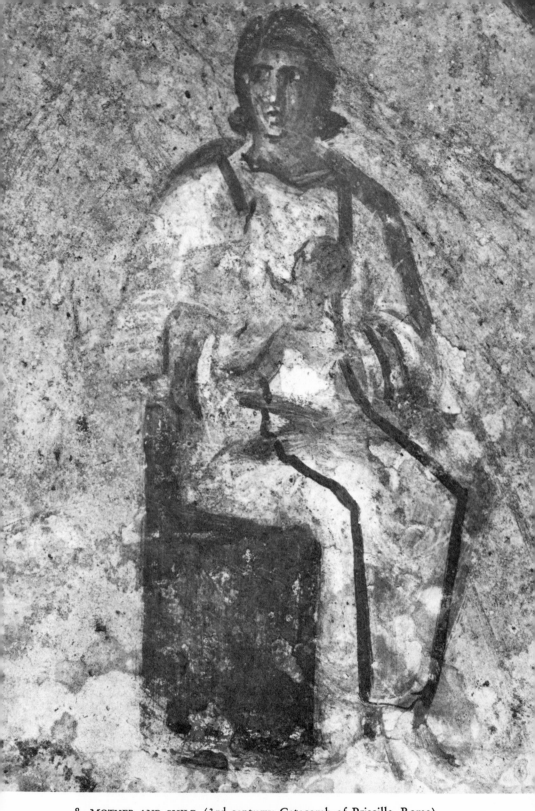

8. MOTHER AND CHILD (3rd century; Catacomb of Priscilla, Rome).

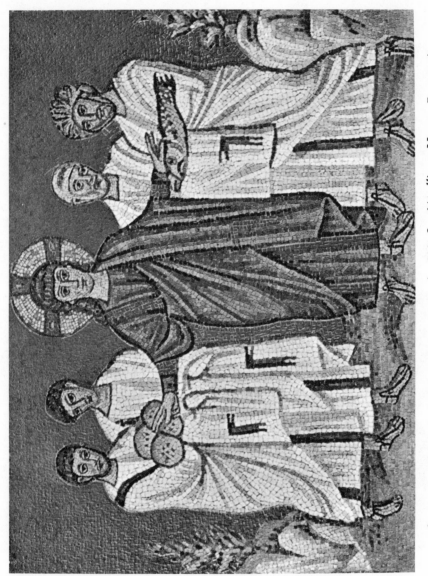

9. CHRIST BLESSING THE LOAVES AND FISHES (c. 520; Sant'Apollinare Nuovo, Ravenna).

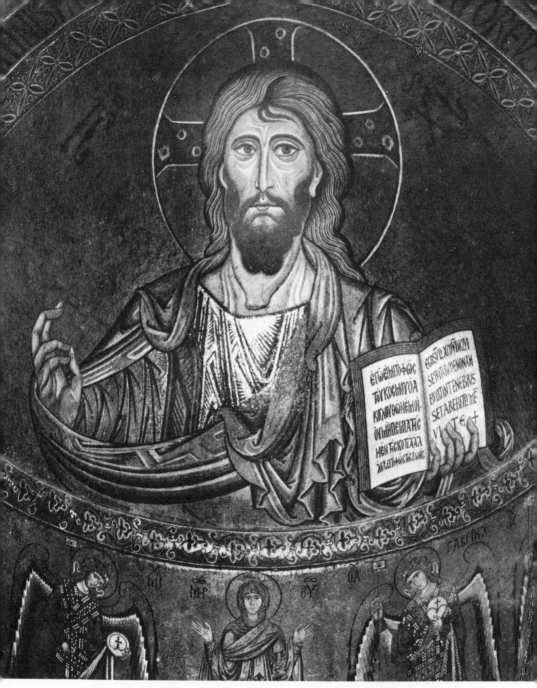

10. CHRIST PANTOCRATOR (completed 1148; Cathedral of Cefalù).

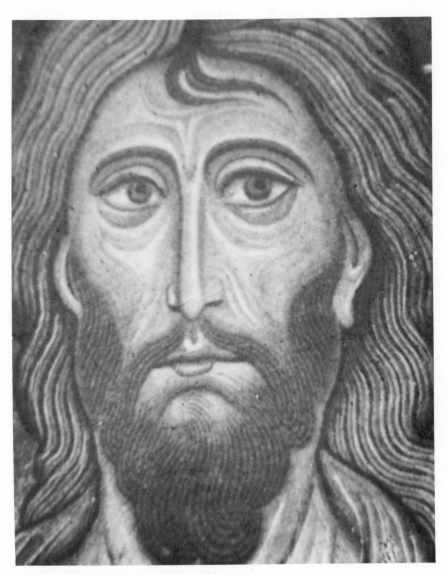

11. The Cefalù Christ; detail from plate 10.

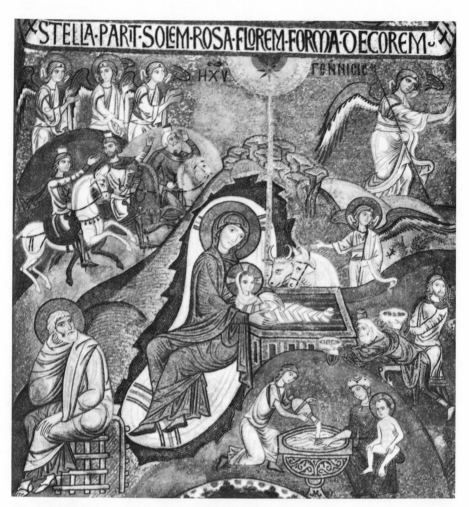

12. THE NATIVITY (12th century; Palatine Chapel, Palermo).

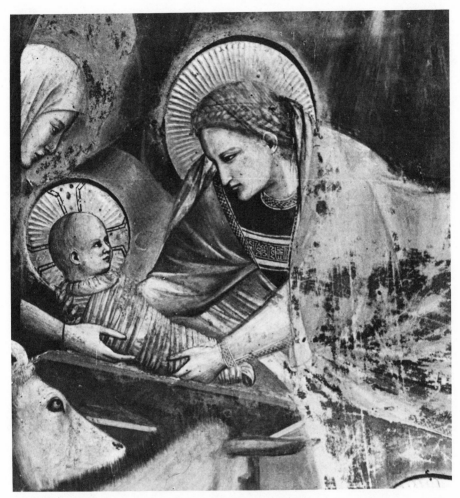

13. Giotto, THE NATIVITY (1305; Arena Chapel, Padua).

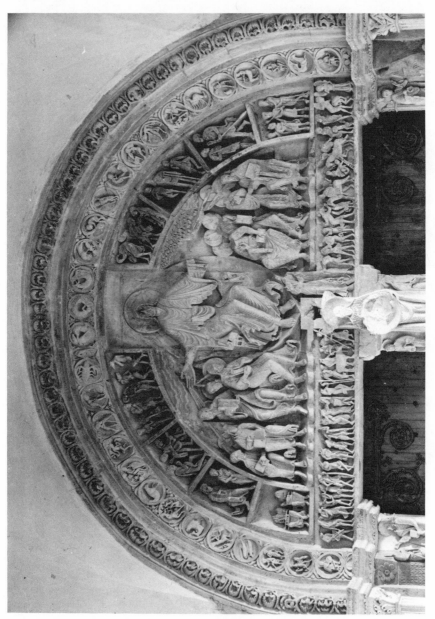

14. THE PENTECOST (c. 1130; Church of the Madeleine, Vézelay).

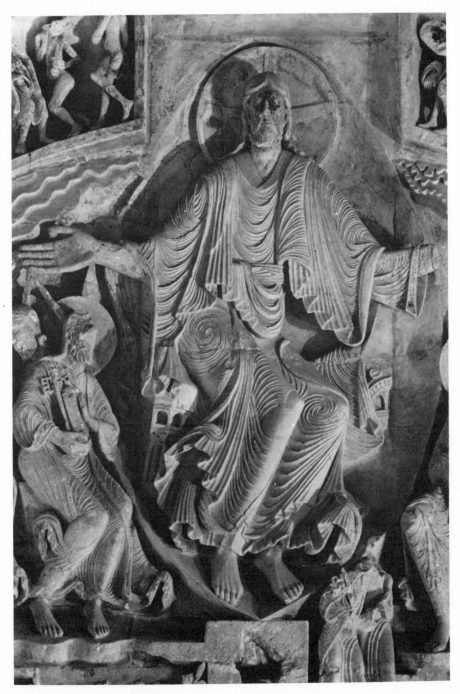

15. Christ, detail from plate 14.

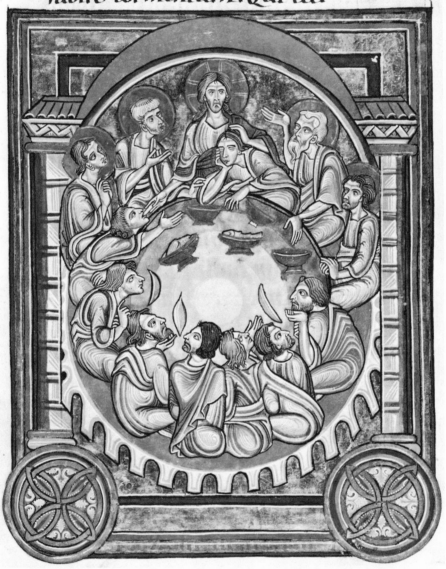

16. THE LAST SUPPER (c. 1225; The Berthold Missal, M. 710, f. 39v).

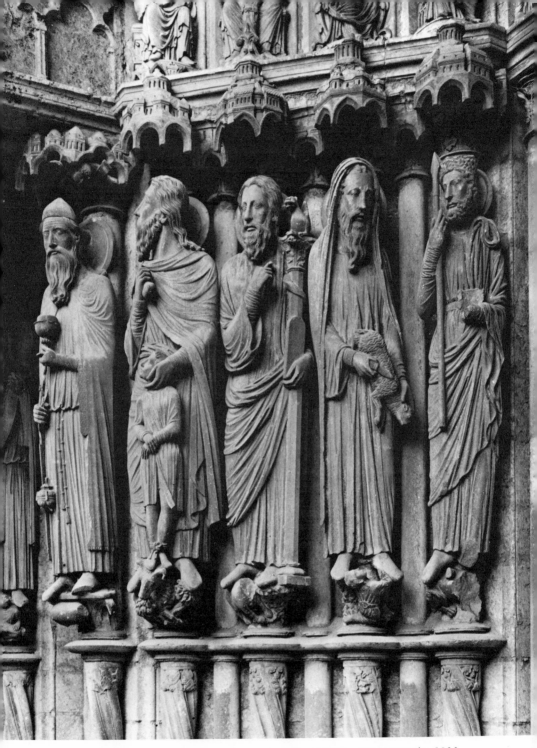

17. MELCHIZEDEK, ABRAHAM AND ISAAC, MOSES, SAMUEL, AND DAVID (c. 1230-50; Cathedral of Notre Dame, Paris).

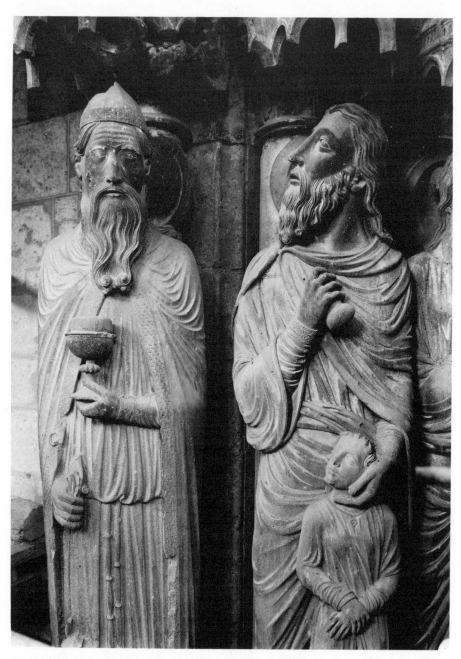

18. Melchizedek, Abraham and Isaac; detail from plate 17.

19. Feet of Abraham and Isaac; detail from plate 17.

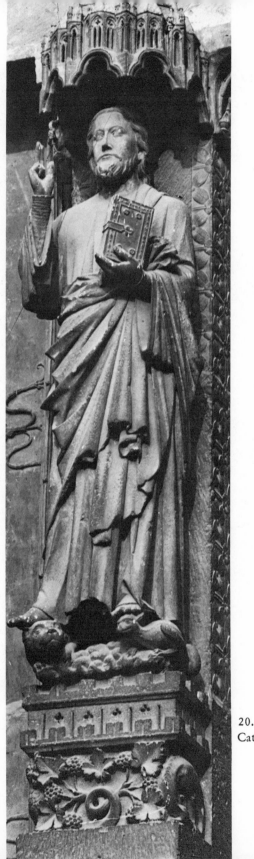

20. The BEAU DIEU (c. 1225;
Cathedral of Notre Dame, Amiens

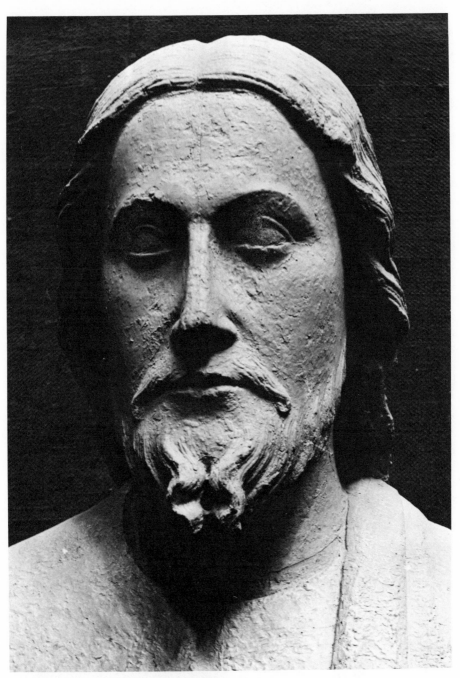

21. The BEAU DIEU; detail from plate 20.

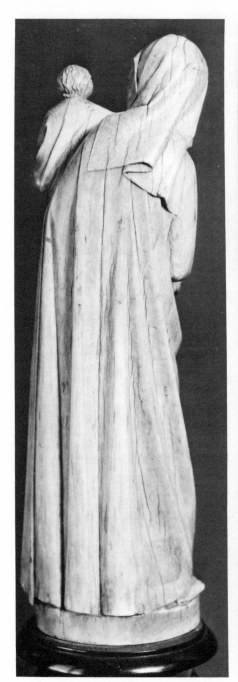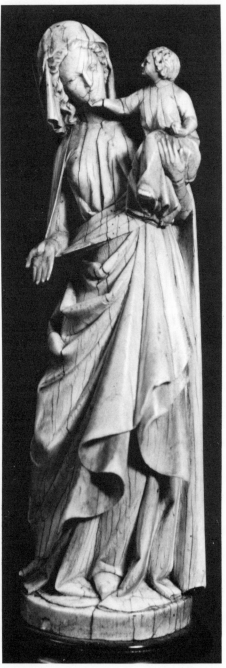

22. MADONNA AND CHILD (c. 1225; Musée Historique de l'Orleanais, Orleans).
[Front and back views].

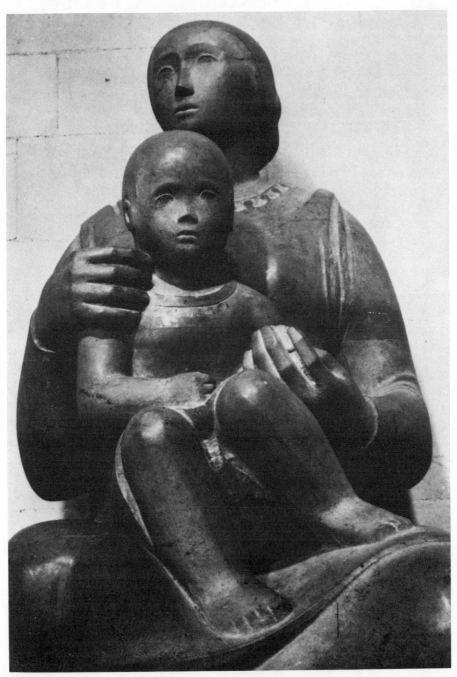

23. Henry Moore, MADONNA AND CHILD (1943; St. Matthew's Church, Northampton).

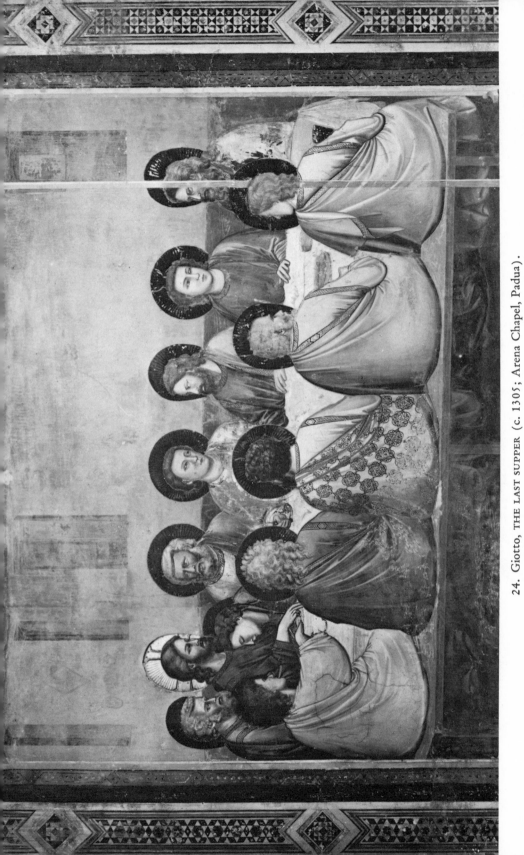

24. Giotto, THE LAST SUPPER (c. 1305; Arena Chapel, Padua).

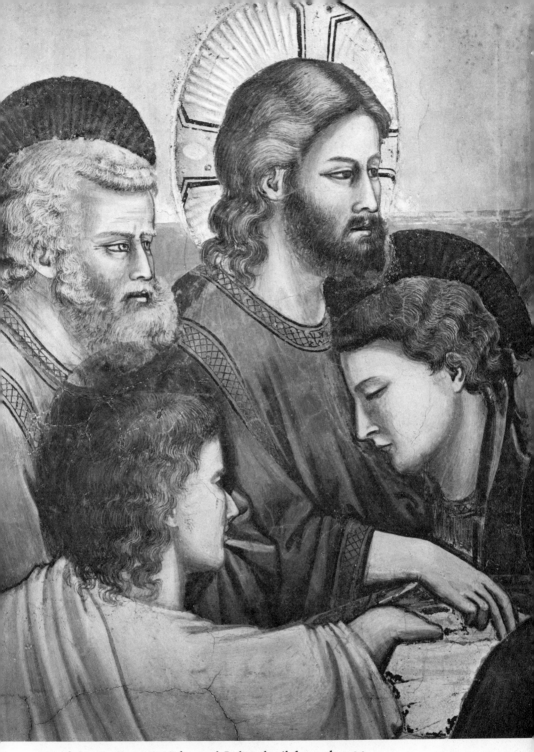

25. Christ, St. Peter, St. John, and Judas; detail from plate 24.

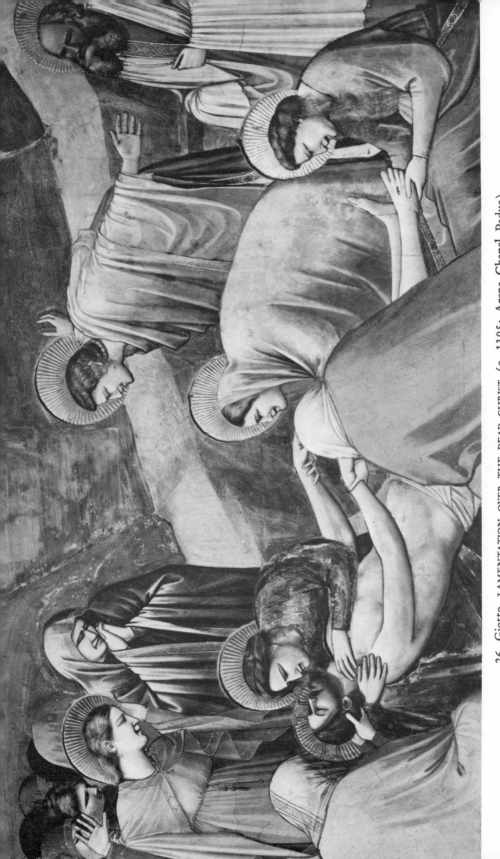

26. Giotto, LAMENTATION OVER THE DEAD CHRIST (c. 1305; Arena Chapel, Padua).

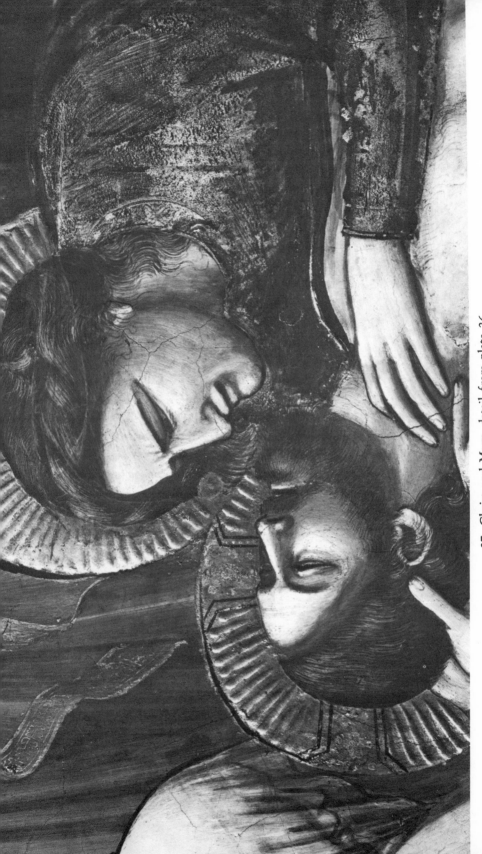

27. Christ and Mary, detail from plate 26.

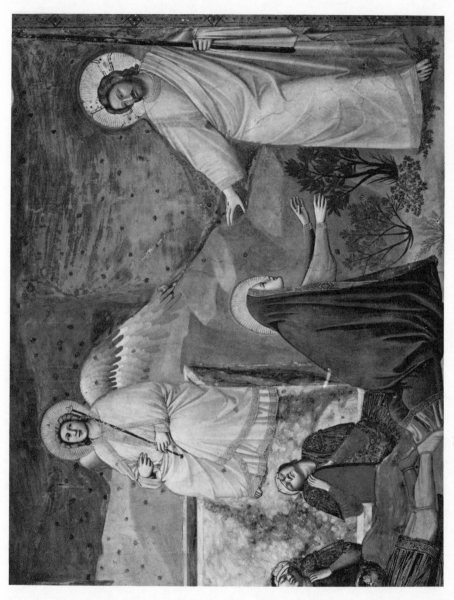

28. Giotto, NOLI ME TANGERE (c. 1305; Arena Chapel, Padua).

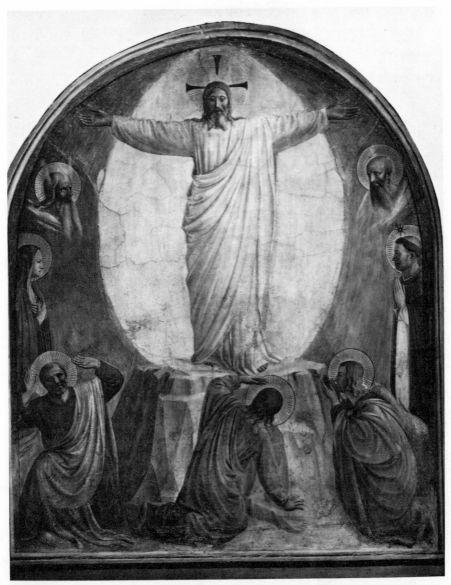

29. Fra Angelico, THE TRANSFIGURATION (c. 1440; Convent of San Marco, Florence).

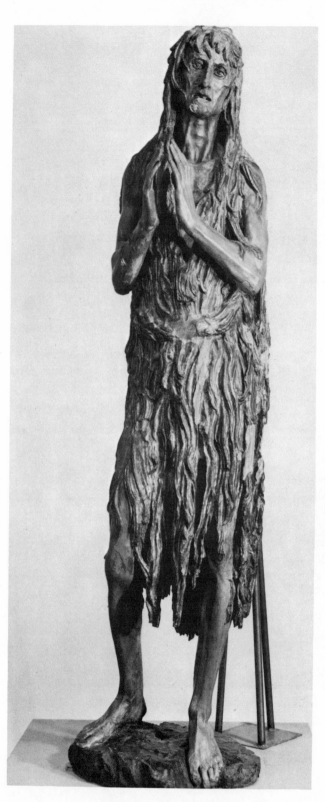

30. Donatello, THE
PENITENT MAGDALENE
(c. 1455; Museo
dell'Opera del
Duomo, Florence).

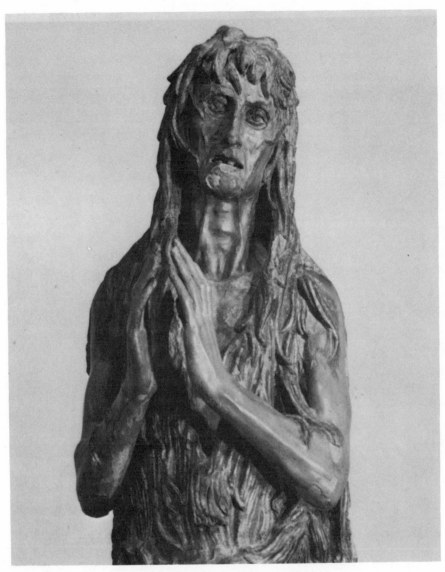

31. Head and hands of the Magdalene; detail from plate 30.

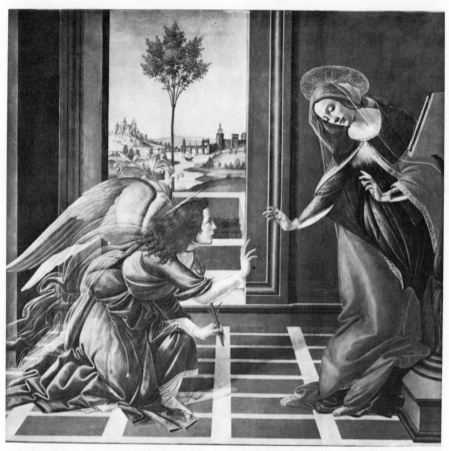

32. Botticelli, THE ANNUNCIATION (c. 1490; Uffizi Gallery, Florence).

33. The Enclosed Garden; detail from plate 32.

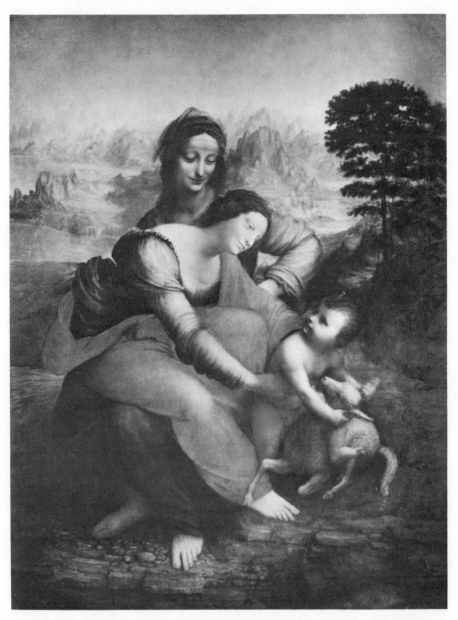

34. Leonardo da Vinci and Pupils, VIRGIN AND CHILD AND ST. ANNE (c. 1508-10; The Louvre, Paris).

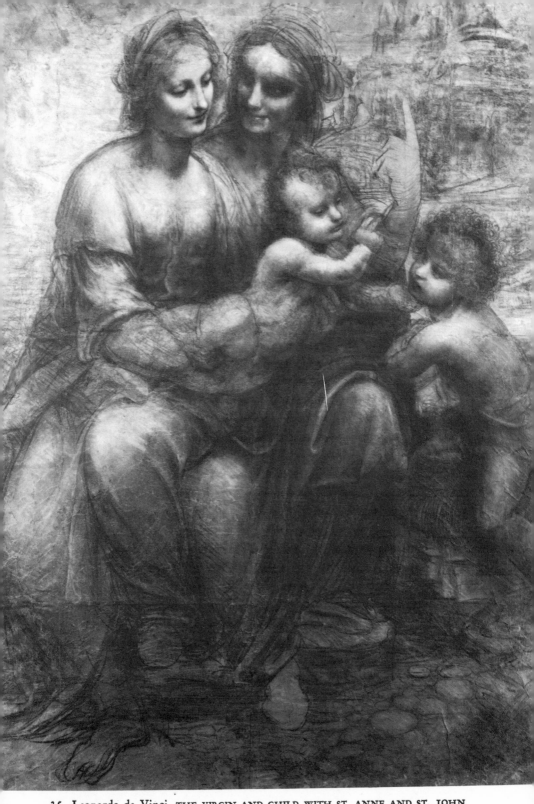

35. Leonardo da Vinci, THE VIRGIN AND CHILD WITH ST. ANNE AND ST. JOHN
THE BAPTIST (c. 1498; The National Gallery, London).

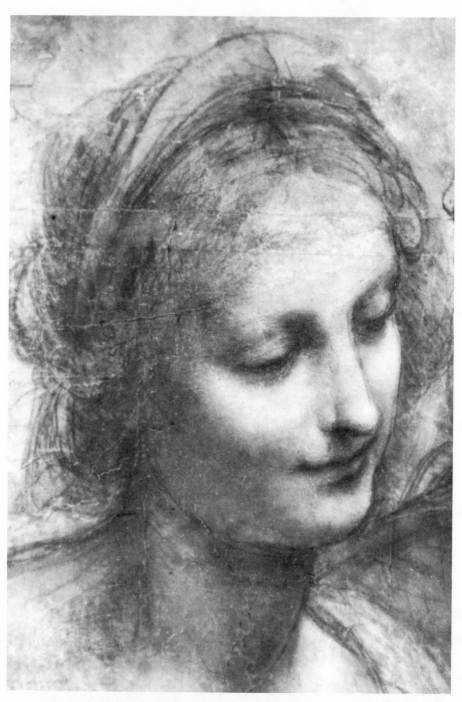

36. Head of the Virgin; detail from plate 35.

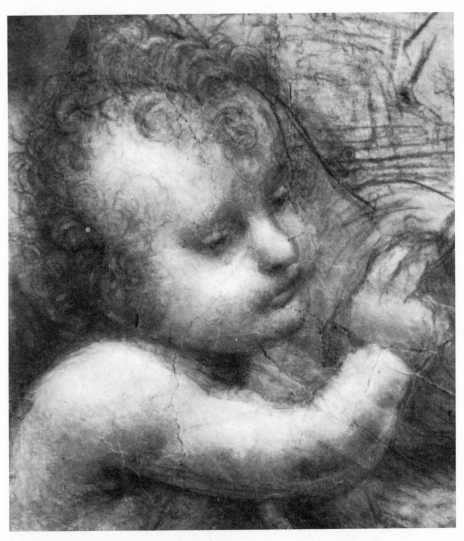

37. The Christ Child; detail from plate 35.

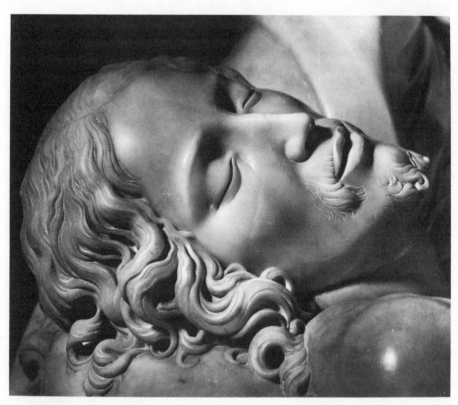

38. Head of Christ; detail from plate 39.

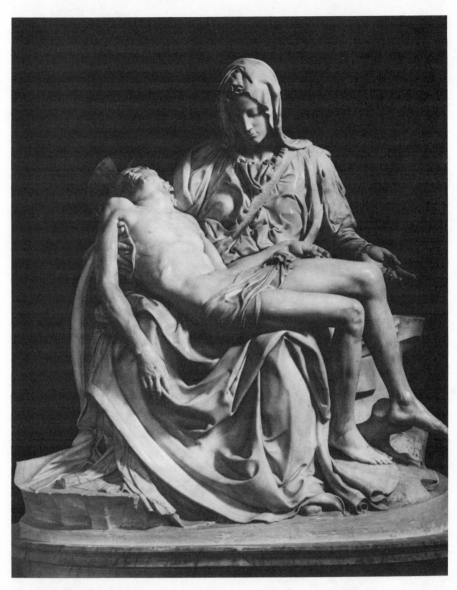

39. Michelangelo, PIETÀ (c. 1498-99; St. Peter's Basilica, Rome).

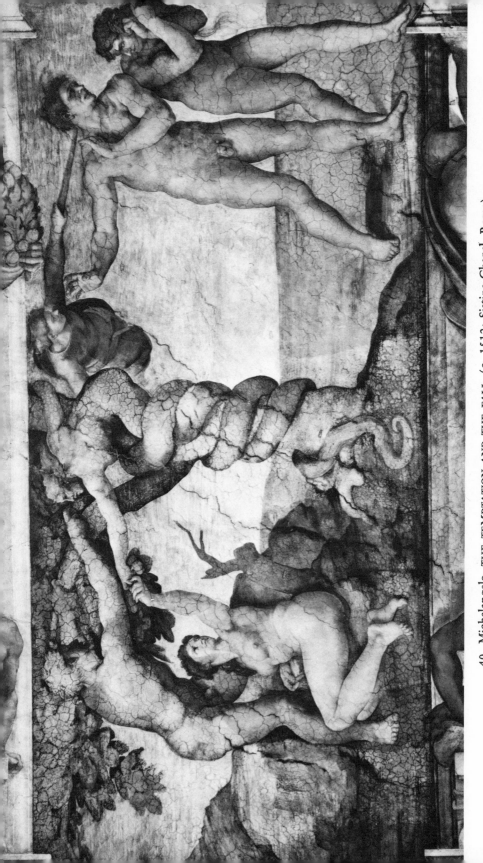

40. Michelangelo, THE TEMPTATION AND THE FALL (c. 1512; Sistine Chapel, Rome).

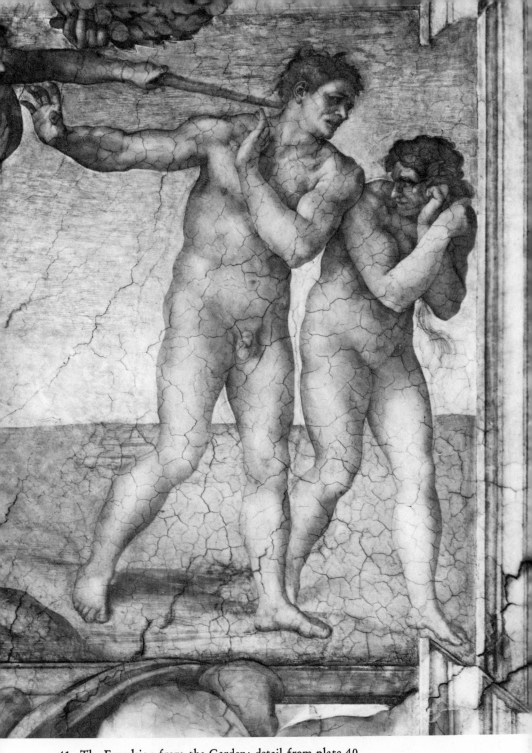

41. The Expulsion from the Garden; detail from plate 40.

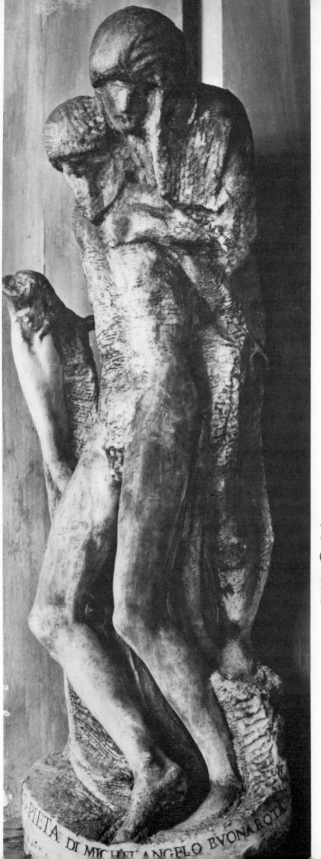

42. Michelangelo,
THE RONDANINI PIETÀ
(unfinished at the
artist's death in 1564;
Musei del Castello
Sforzesco, Milan).

43. Detail from plate 42.

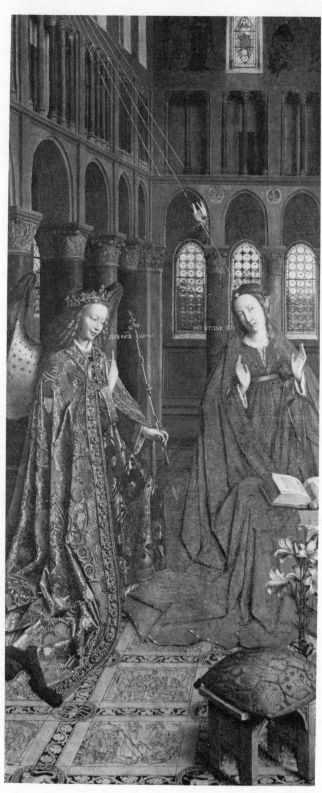

44. Jan van Eyck,
THE ANNUNCIATION
(c. 1434-36;
The National Gallery of
Art, Washington, D.C.).

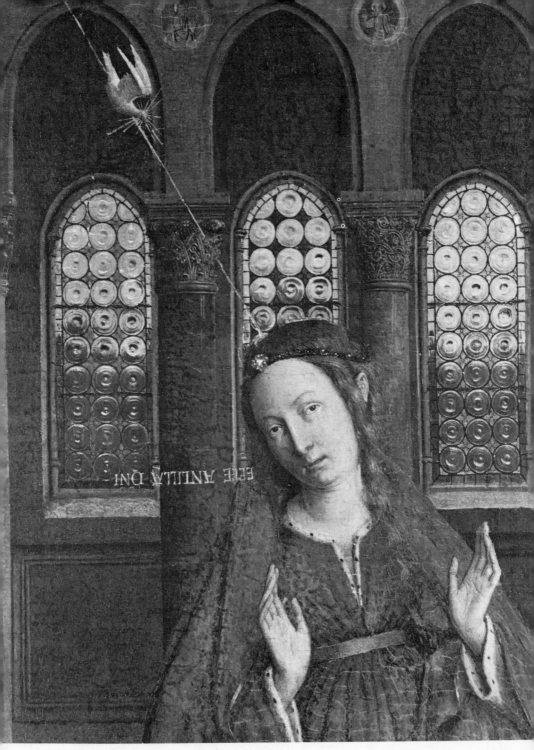

45. Mary; detail from plate 44.

46. Tile Floor; detail from plate 44.

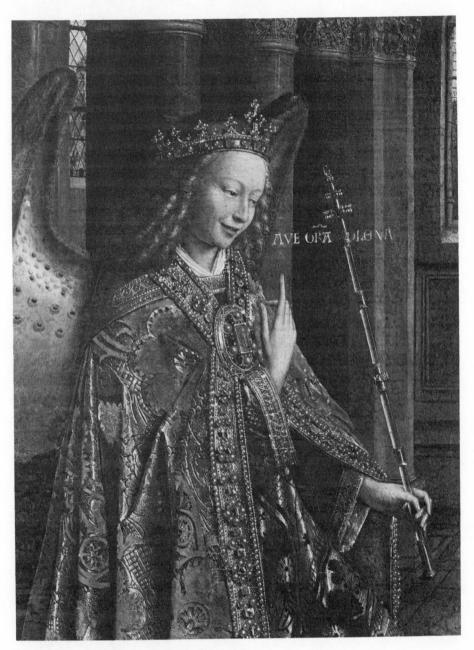

47. Gabriel; detail from plate 44.

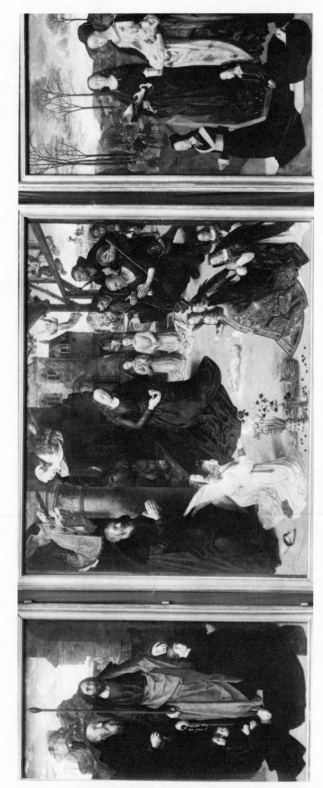

48. Hugo van der Goes, THE PORTINARI ALTARPIECE (c. 1475; Uffizi Gallery, Florence).

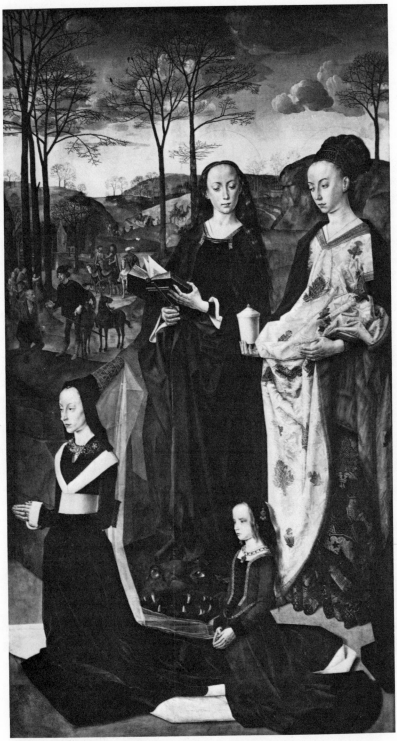

49. St. Mary Magdalene, St. Margaret, and the donors from the right
wing of THE PORTINARI ALTARPIECE; detail from plate 48.

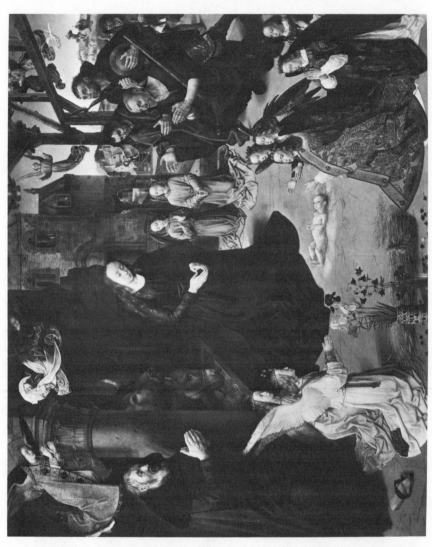

50. The Nativity from the central panel of THE PORTINARI ALTARPIECE; detail from plate 48.

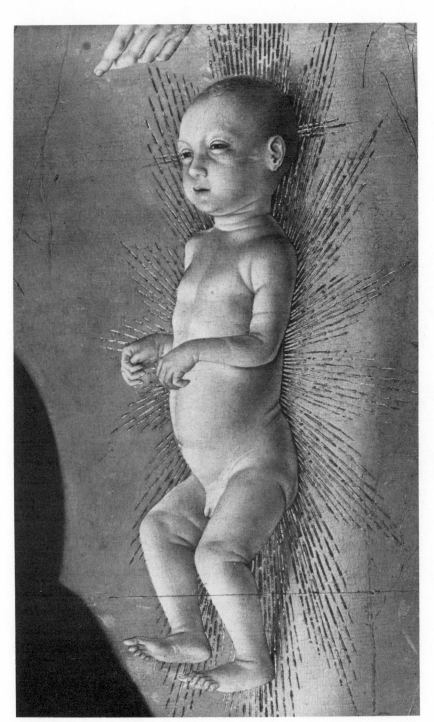

51. The Christ Child from the Nativity panel of THE PORTINARI ALTARPIECE; detail from plate 48.

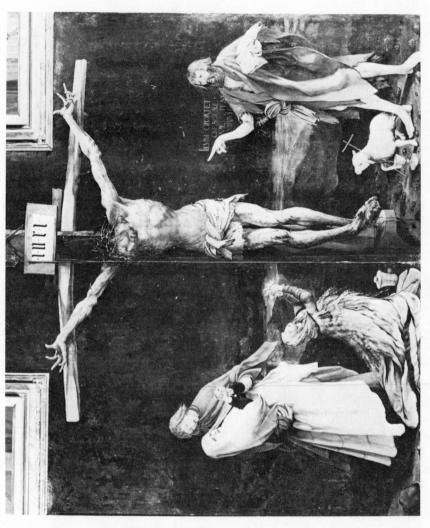

52. Mathias Grünewald, The Crucifixion from THE ISENHEIM ALTARPIECE (c. 1515; Musée d'Unterlinden, Colmar).

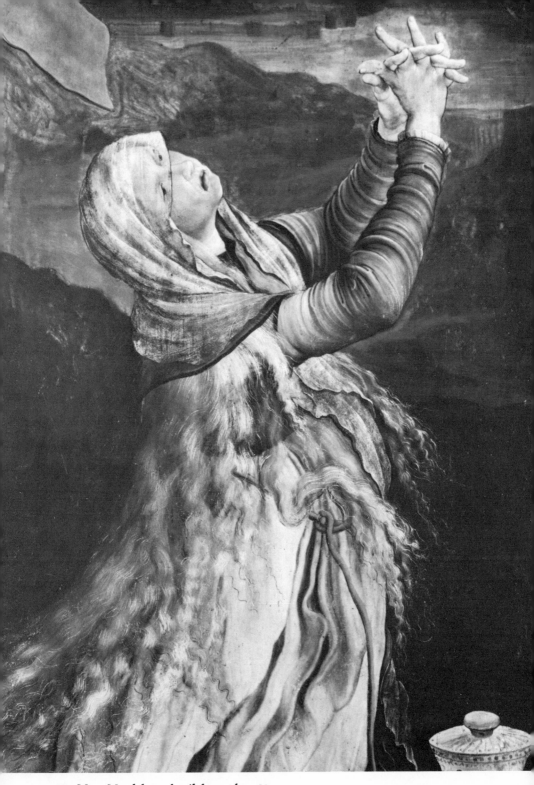

53. Mary Magdalene, detail from plate 52.

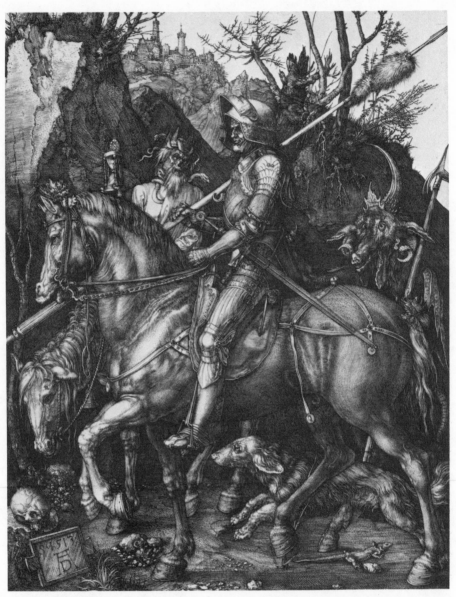

54. Albrecht Dürer, THE KNIGHT, DEATH, AND THE DEVIL (1513;
The Metropolitan Museum of Art, New York).

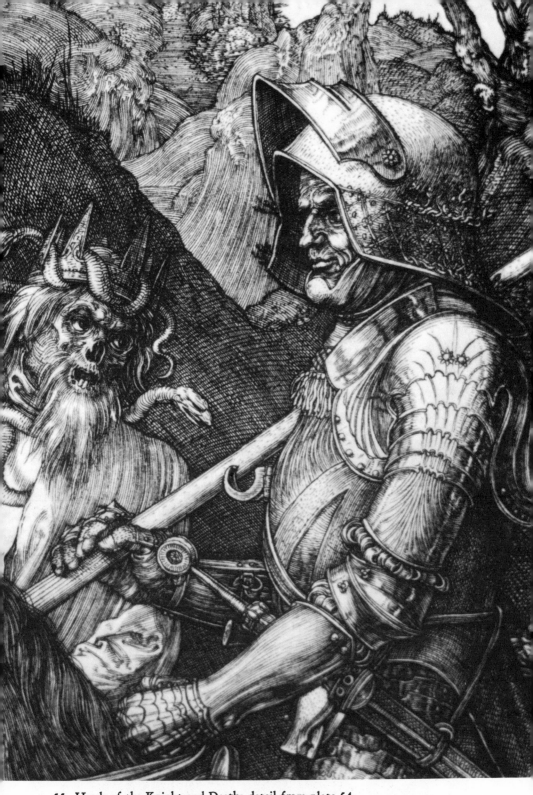

55. Heads of the Knight and Death; detail from plate 54.

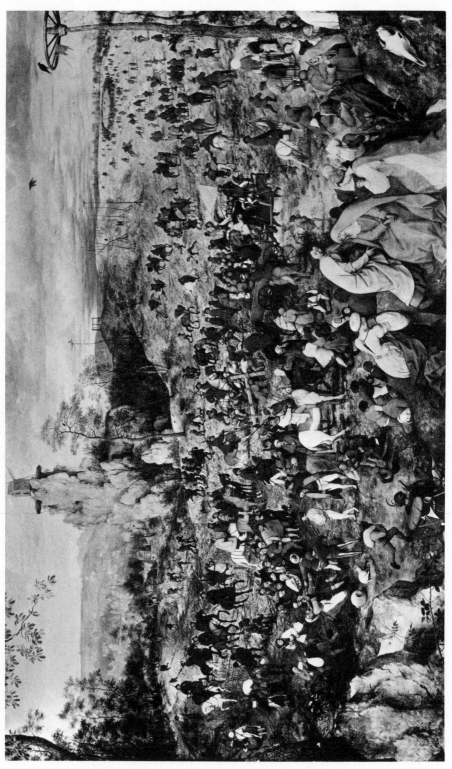

56. Peter Bruegel, CHRIST CARRYING THE CROSS (1564; Kunsthistoriches Museum, Vienna).

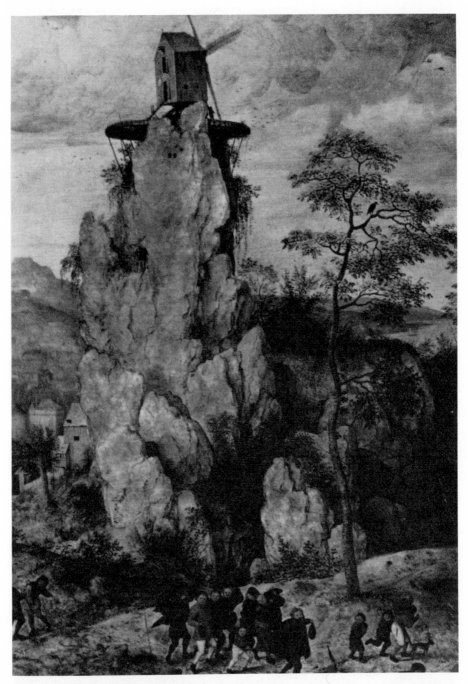

57. The Windmill; detail from plate 56.

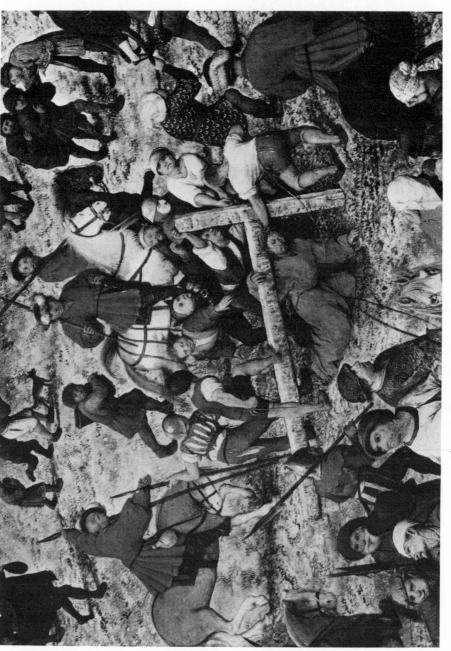

58. Christ Falling Beneath the Cross; detail from plate 56.

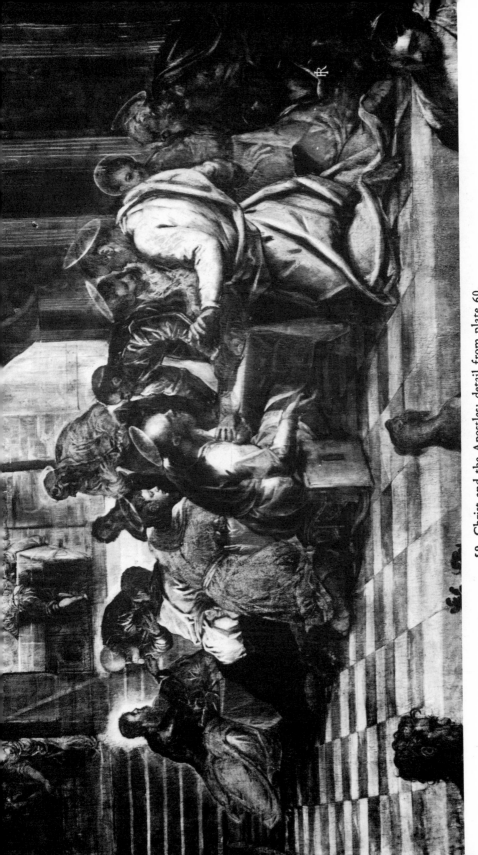

59. Christ and the Apostles; detail from plate 60.

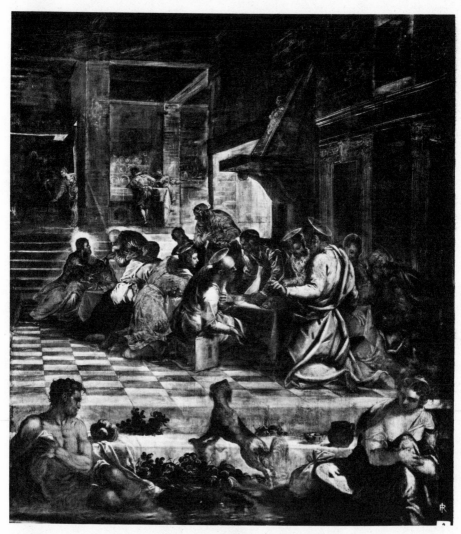

60. Tintoretto, THE LAST SUPPER (c. 1580; Scuola di San Rocco, Venice).

61. The Upper Chambers: detail from plate 60.

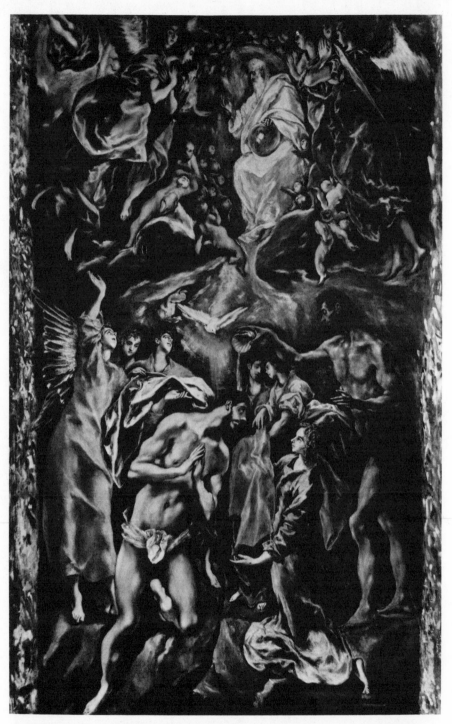

62. El Greco, THE BAPTISM OF CHRIST (1612–14; Hospital de Tavera, Toledo).

65. Angel's face; detail from plate 64.

66. Nicodemus and an apostle; detail from plate 67.

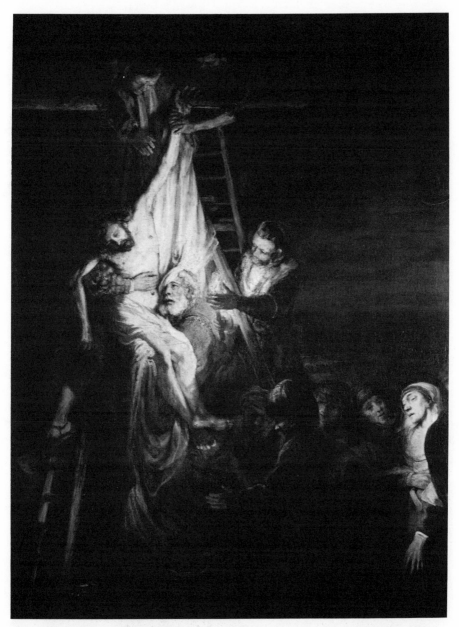

67. Rembrandt van Rijn (after), THE DESCENT FROM THE CROSS (1655; The National Gallery of Art, Washington, D.C.)

68. Rembrandt van Rijn, CHRIST PREACHING (c. 1650; The Metropolitan Museum of Art, New York).

69. Woman seated; detail from plate 68.

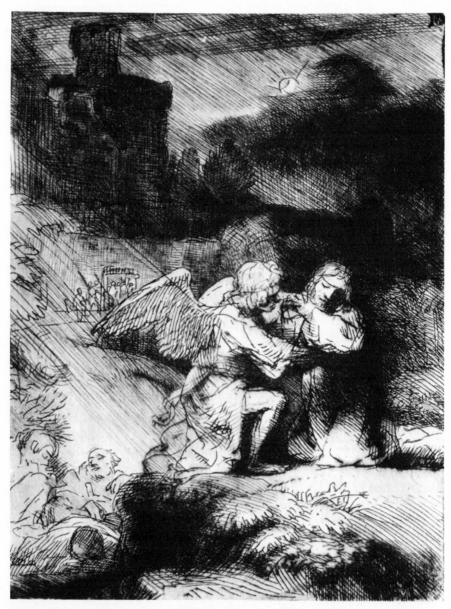

70. Rembrandt van Rijn, THE AGONY IN THE GARDEN (1657;
The Metropolitan Museum of Art, New York).

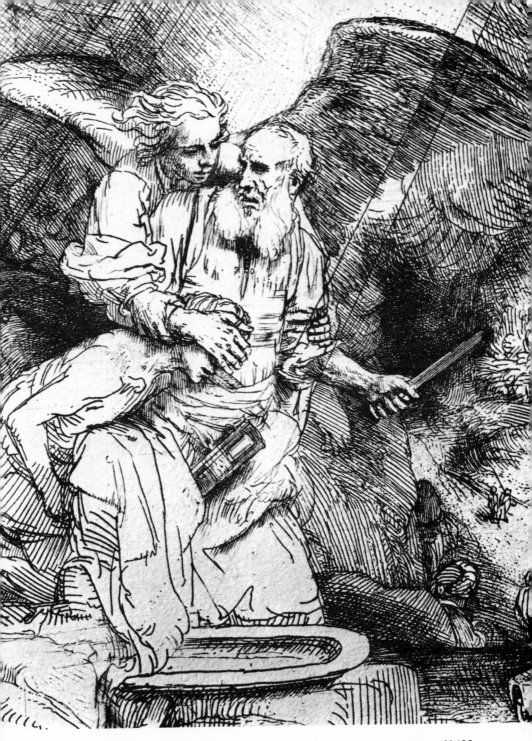

71. Rembrandt van Rijn, Detail from ABRAHAM'S SACRIFICE OF ISAAC (1655; The Metropolitan Museum of Art, New York).

72. Emil Nolde, THE ENTOMBMENT (1915; Stiftung Seebüll Ada und Emil Nolde).

73. Georges Rouault, "Jesus will be in anguish until the end of the world . . . ,"
Plate 35 from *Miserere* (1922; The Museum of Modern Art, New York).

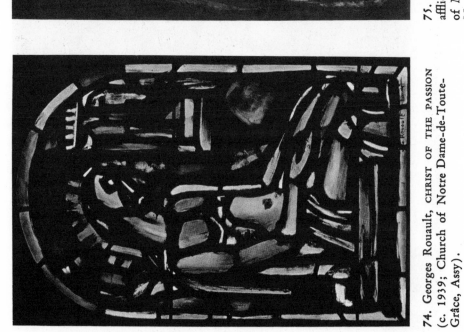

74. Georges Rouault, CHRIST OF THE PASSION (c. 1939; Church of Notre Dame-de-Toute-Grâce, Assy).

75. Georges Rouault, "He was oppressed and he was afflicted, yet he opened not his mouth," Plate 21 of *Miserere* (1923; The Museum of Modern Art, New York).

76. Georges Rouault, HEAD OF CHRIST (1905; Chrysler Museum, Norfolk).

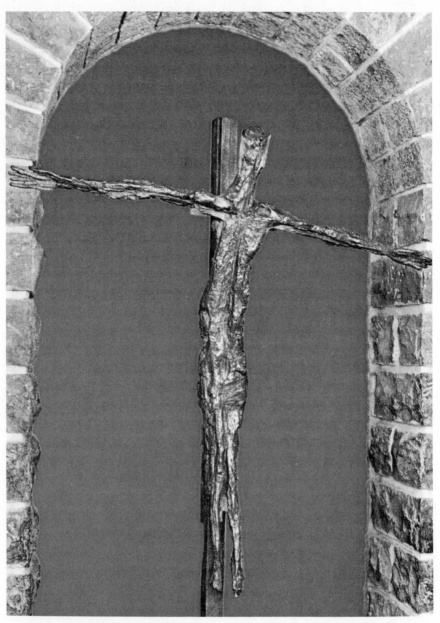

77. Germaine Richier, CRUCIFIX (1951; Church of Notre-Dame-de-Toute-Grâce, Assy)

78. Alfred Manessier, CROWN OF THORNS (1955; Museum of Art, Carnegie Institute).

80. Henri Matisse, Bell Tower of the Chapel of the Rosary, Vence.

79. Henri Matisse, Jesus Meeting with Veronica; preparatory drawing for the WAY OF THE CROSS (1949; Chapel of the Rosary, Vence).

81. Henri Matisse, WAY OF THE CROSS (1949-51; Chapel of the Rosary, Vence).

82. Henri Matisse, Chapel of the Rosary, Vence, consecrated 1951.

CHAPTER I

INTRODUCTION

This book is intended for those who want an orientation to a particular area of the history of art—works of art relating to the Christian heritage. Thus the objective is necessarily twofold: to acquaint the reader with a way of seeing masterpieces of art and of understanding their *style,* and to bring to bear upon these works of art the biblical and apocryphal materials which relate to their interpretation, and thus make their *content* understandable.

The works of art discussed are all acknowledged masterpieces, chosen with what may seem a simple conviction—that only great art can be great religious art. In recent years there has been a plethora of literature on religion and art, and unfortunately some of the most widely circulated books are those which choose paintings and sculpture on the basis of their superficial illustrative character. Selecting works of art on this basis leads to deplorable results, such as the choice of Forest Lawn's pseudo-archaeological, cinerama-style CRUCIFIXION over Rembrandt's THREE CROSSES. Illustration is, of course, a part of the communication of masterpieces, but only a part. Their message is more profound, more complex, and more freighted with multiple meanings.

To understand the *style* of the work of art, and thus participate in one level of these multiple meanings, a way of seeing the works of art is introduced and used throughout the book. Rather than presenting a survey of the entire panorama of Western art, the method used is a detailed study of a selection of individual masterpieces. The works dis-

cussed were selected because each represents a period; each embodies not only the vision of its creator, but speaks for its age.

To understand the *content* of these works of art, the relevant biblical, historical, and legendary materials are drawn together. And since the subject matter is concerned with the major events of the life of Jesus Christ, these materials tend to overlap and interlace and form constellations of meaning, which have both a kind of fluidity and a kind of wholeness. The great artists foretell one event with another, or recollect that which came before in that which now is, and is for all time. Time and space in great art have an ever-changing character sometimes suggesting illimitable expansion, and at other times the contraction of all meaning into an instant of time in a particular place. The biblical texts pondered by the artists—and the interpreters of the church—are represented lovingly over and over again during some periods of history with little change in the specific details or general content. At such times the artist's role is more like that of the pianist who plays a concerto composed by another musician, and thus the structure and melodies are not of his invention but for his interpretation. Such artists bear forward the heritage of the past in modified form. In other periods a great genius seizes upon the text and represents it anew, with startling originality and insight. He is then the composer as well as the interpreter, and his masterpiece influences the course of art thereafter. Indeed it becomes a part of the imaginative history of his culture.

This twofold approach, through the study of style and of content, is used in this book to delineate works of Christian art because of the problems associated with the term "Christian art." In what sense can the word "Christian" be used as an adjective? Semanticists in their scrupulous search for accurate meaning have made us wary and self-conscious in our use of language. What is Christian art? If we give the simplest answer—art with Christian subject matter—we are left with a host of problems about what is to be included as Christian subject matter.

Is Old Testament subject matter to be included? If it were excluded, works of art like Michelangelo's vast cycle of paintings on the Sistine

ceiling dealing with the Creation and the Fall of Man, would be outside the definition. If this kind of subject matter is granted, which indeed it must be, how are we to classify the magnificent stained glass windows on Old Testament themes by the Jew Chagall for the Hebrew University Synagogue in Jerusalem? Chagall has also painted New Testament subject matter, in particular the Crucifixion, and these haunting depictions, reiterated again and again by this Jewish artist, communicate a depth of understanding of the meaning of the event not always reflected in the works of artists who are avowedly Christian believers.

If Christian art is taken to be sacred art—that is, art commissioned or owned by the Christian churches—one would have to count as outside the definition most of the paintings and graphic works by Rembrandt and Rouault, for the Roman Catholic Church of today has been as indifferent to Rouault as the Protestant churches in the seventeenth century were to Rembrandt.

These are but a few of the problems to be confronted by those who seek definitions. Either the definition must be so elastic and inclusive that it becomes amorphous, or it must be compartmentalized, with all the contradictory categories neatly disposed of in a succession of points and subpoints.

We are on no more certain ground when we try to define art. In this book we shall be discussing sculpture, mosaics, and paintings which range in size from the twenty-five square inches of the twelfth-century Romanesque manuscript illumination (plate 16) to the fifty-six square feet of the Michelangelo TEMPTATION AND FALL (plate 40). We shall be considering techniques as diverse as fresco and oil painting, stained glass and tile painting. What do these have in common that makes them art—indeed that makes them *great* works of art, so that they bear within them not only the creative expression of one man at one moment in time, but speak for their historical period, epitomizing the highest aspirations and the most profound insights of mankind? Here again if definition is required it must either be all-encompassing or neatly subdivided. In either case, the inquiring mind and eye is cheated,

for the work of art resists definition and exceeds all descriptions, living its own life, inviting our scrutiny, and inviting our participation in its secrets.

This invitation is ever present in the work of art; yet often its initial strangeness of style provokes a negative response or indifference, and the visitor to the cathedral or museum moves on to the next sculpture or painting with the hope that its blandishments will accord more with his taste. It is not only that the style may alienate the viewer, but also the subject matter may be incomprehensible. The persons, events, and symbols represented in many of the major works of art created before the nineteenth century cannot be identified by many viewers of our day. The spectator viewing an early religious painting is often like the audience that hears a song by Schubert sung in German—the melodies are fully available, but the full intention of the composer cannot be communicated to those who do not understand German.

Michelangelo is reported to have said that great painting is a "music and a melody which only the intellect can understand, and that with great difficulty." [1] It may seem strange that he should link the intellect with the understanding of the music and melody. The present-day tendency to decry and dismiss the part which the mind plays in an aesthetic response is summed up in the oft-repeated vulgarism, "I don't know anything about art but I know what I like." This simply is not true; the opposite is the case. The more that is known about art in general, and about the particular painting confronted, the more accessible it becomes to understanding. The informed mind and attentive eye provide the "Open, Sesame" for the vivifying moment when the barriers between our world and the artist's vision disappear. Momentarily, then, we see with the artist's eyes and feel with his pulsebeat.

The purpose of the following chapters is to enrich the intellectual resources, sharpen the visual focus, and thereby assist in deepening the emotional sensitivity to a group of representative works of Christian art of the Western world.

[1] Robert Goldwater and Marco Treves, eds., *Artists on Art* (New York: Pantheon Books, 1945), p. 69.

CHAPTER II

LOOKING AT PAINTINGS

Our first acquaintance with a painting is like our first meeting with a person. We may feel immediately interested and attracted, or we may feel indifferent or hostile. But experience teaches us to question these initial responses, for often further acquaintance reverses our attitude. With paintings as with people further acquaintance is essential for full enjoyment and appreciation. The more we know about the painting, the richer our experience of it will be.

The method of study used in this book will be an examination of the three significant aspects of the work of art—iconography, form, and content. Briefly stated, iconography includes all that relates to subject matter; form is the design or pattern or composition of the work of art; and content is the total communication or meaning conveyed by the work of art.

Even in as concise a statement as this it must be apparent that each of these aspects of the painting is wedded to the others, and that in a sense it is an artificial breaking up of what must be an indivisible unity —the work of art itself. It is difficult to describe iconography without using language that has to do with the composition. Perhaps most difficult of all is the language for describing the composition. Even descriptive words tend to have emotive suggestions and thus point to the content or meaning of the painting. Admittedly the three aspects present difficulties. But when one is aware of the way each aspect impinges upon another, and that there is no implied separation of the

three in a work of art, the division provides a useful structure for the study of the works of art. Before examining the chronological sequence of selected works of religious art which form the main body of this book, a single painting, Piero della Francesca's RESURRECTION, is described by this means, and a few terms from the artists' and art historians' vocabulary are explained.

Iconography or Subject Matter

Iconography means literally writing with images, or communicating via pictures. It is this function of art which Pope Gregory the Great's statement, "Painting can do for the illiterate what writing does for those who can read," underscores. Originally the term "iconography" was used for the identification of persons and events in religious art, but it is now used for all aspects of the identification of subject matter in works of art, be they religious or secular.

The title of Piero della Francesca's mural (plate 2) in Sansepolcro, Italy, gives the clue for the sources of the iconography in the Gospel of John. The event which Piero has depicted in this somber RESURRECTION is implied rather than described in John's Gospel, for the narration of this Gospel moves from the moment when Jesus' body was laid in a new tomb in a garden "where no one had ever been laid," [1] to the second, or Easter, morning when Mary Magdalene found that the stone had been taken away from the tomb, and Peter and another disciple had run to the tomb to discover it empty. Between these moments in time, the resurrected Christ rose from the tomb, and it is this event of which Piero has made us witnesses. But we are not the only witnesses; the guard of soldiers requested by the Pharisees are in front of the sepulcher and one of the soldiers, the figure at our right, leans backward as he gazes wonderingly at the majestic figure at the center of the scene. Jesus stands with one foot still in the tomb and the other placed on the moldings, as if in the act of stepping out of the tomb. Yet the

[1] John 19:41.

quietude of his posture belies all movement, and we feel that we are witnesses of a timeless, frozen moment.

A simple, golden oval ellipse halos Christ's head. In his right hand he holds a staff surmounted by a flag with a red cross emblazoned upon it; it is the flag of victory, a traditional symbol associated with the resurrection since earlier days. The stigmata (wounds made by the nails) are visible on Christ's left hand and foot, and a narrow wound from the spear of the soldier who pierced his side has drops of blood still flowing from it.

Piero has dressed his soldiers in a variety of Roman-type armor. The shield of the soldier who leans against the tomb at the right has the beginning letters of the familiar Roman signet, SPQR. Piero lived at a time of revived interest in the art of antiquity. Classical sculpture was studied with renewed interest, and evidence of the Renaissance artists' archaeological enthusiasms keeps recurring, as here, in their own art.

Piero has placed his Christ and soldiers against a landscape setting; "In the place where he was crucified there was a garden, and in the garden a new tomb." [2] An interesting feature of this garden landscape is the disparity between the trees on the left and right sides of the composition. We see barren boughs naked against the sky at the left and trees in full leafy foliage at the right. The significance of this contrast may be related to the fact that in the left half of the composition we see the two soldiers who seem totally lost in slumber and also the side of Christ which still stands within the tomb. On the right are the emerging leg of the Christ figure and the wakeful soldier—life seems to return to this side first.

Now that we have examined the iconography of a single painting, it should be pointed out that the choice of subject matter by the artists and their patrons of any one period is an interesting index to the religious focus of that particular age. In the early Christian period the oft-repeated subjects have to do with deliverance from sin and death—

[2] John 19:41.

Noah and the ark, Daniel in the lion's den, Jonah's deliverance from the fish's belly. There are conspicuously few representations of the Crucifixion and Passion scenes. Similarly, subjects about the birth and infancy of Jesus—the Nativity, the Adoration of the Shepherds, the Flight into Egypt—are infrequent subjects in early Christian times. The early Christians' faith and hope focused upon salvation as deliverance.

In the Romanesque period, around the year 1000 and later, the subject frequently represented is the Last Judgment—a subject which gives full expression to man's fear of death and punishment over against his hope for eternal life. God's justice was separated from his mercy, and it is the judgment of God that dominates this period.

The Gothic period, which came to full flower in the thirteenth century, gave us many and vast cycles of art; for example, Chartres Cathedral, where over ten thousand different figures are represented in stained glass, carved wood, and stone. But this is typically the period of the Madonna and Child. Most of the great cathedrals were dedicated to Mary, the Mother of Jesus—Notre Dâme de Paris, Notre Dâme de Chartres, Notre Dâme d'Amiens, Notre Dâme de Reims. In the statues of the Gothic Madonnas, the natural and the supernatural blend into each other. The realms of nature and grace are not shown in contradiction to each other, but rather are intertwined.

The Renaissance, too, gave us a vast number of paintings on the Madonna and Child theme, but the emphasis shifted gradually away from the Gothic balance that the artist achieved between the human and the divine, toward an increasingly human mother and child. Also frequently represented in the fifteenth century are Mary Magdalene and John the Baptist, and in the sixteenth century, the conversion of Paul. These three New Testament figures epitomize in one form or another the repentant sinner who experienced the forgiveness of God.

In the seventeenth century many Roman Catholic religious paintings deal with miraculous or mystical subject matter, whereas a Protestant artist such as Rembrandt emphasizes the intimate moment or the personal relationship of Jesus with his followers.

Artists of our own century re-create the event of the Crucifixion or suffering of Christ, depicting it as an event occurring in an indifferent or hostile world. With rare exceptions artists are not now interested in the Madonna and Child and the infancy of Christ, or any of the miracles or parables of Jesus. Nor do they depict doctrinal subjects or subjects relating to the Last Judgment, or life after death. Their religious concern seems to center upon a Christ on the cross, who in Pascal's words "will be in anguish until the end of the world." [3]

Form or Composition

The form (or composition) of a painting is the pattern (or design) which it makes for the eye when shapes, lines, and colors are regarded *simply as shapes, lines, and colors* rather than as depicting objects and persons. We may think of the form or composition of the work of art as being abstract in the dictionary sense of the word, that is, conceived as separate from matter. Similarly, we can think of the abstract number seven without thinking of seven specific objects.

Nevertheless, it is difficult to see a painting as pure form which has recognizable subject matter. The twentieth-century mind resists this kind of reversal of its usual procedure of clothing even the most abstract shapes with meaning. Even such an abstraction as the number seven must have suggested some kind of subject matter to most readers—the seven-branched candlestick, the seven deadly sins, *The Seven against Thebes*, the Seven Wonders of the World.

By half closing the eyes and looking at the painting we are able to eliminate the detail which makes the shapes identifiable; thus the form of the whole becomes more easily accessible to the sensibilities. Looked at in this way, Piero della Francesca's RESURRECTION has a form which is as carefully structured as an abstract twentieth-century painting. The elements of form or composition are *line* (which is the principal means of communicating *rhythm*), *mass, space, light* and *shade,*

[3] Georges Rouault, *Miserere* (New York: Museum of Modern Art, 1952).

and *color*. We shall discuss each of these as it applies to one painting, Piero's RESURRECTION.

LINE

Studying the form of this work of art, we see that the most dominant area of the composition is the strong vertical mass made by the upright body of Christ, a vertical emphasized by the shaft of the flag of victory held in his right hand. These verticals are repeated, like the variations on a melodic theme of music which reiterate an opening phrase of melody, by the two sturdy trees at our left and the slender saplings at the right. A strong horizontal line is made by the edge of the tomb; this horizontal is emphasized by its lightness of tone as opposed to the dark areas around it, and by the reiterated horizontal lines of the moldings at its edge. The artist further accentuates this horizontal by contrasting it with the *horizon line*—the edge of the earth against the sky. This edge might have been a straight line or a gently undulating one—instead it has a great deal of variation. It rises to a conelike shape at the left, sinks into a valley behind the body of the Christ, rises again to a hillock, and descends slopingly to the right. Thus rather than repeating the forceful static horizontal of the tomb, it presents a freely curving, moving line.

In addition to the prominent vertical and horizontal lines there are other more subtle but equally important diagonal lines which move across the surface of the composition and into its depth dimension. The head, shoulders, and arms of Christ form an apex to a triangle which has its two sides along the implied line between his outstretched elbow and the back of the sleeping soldier at the left; the right side of the triangle runs along the other arm of Jesus, the neck of the sleeping soldier below, and the chin of the soldier looking upward. The base of the triangle is formed by the edges of the soldiers' garments and limbs along the lower edge of the painting.

This triangle is the central unifying structure for the composition. Within it we find numerous other interlocking triangles, but the essen-

tial shape of the almost equilateral triangle made by the Christ and
the four recumbent figures below is the basic formal motif in the com-
position. For example, the two sides of another triangle formed by the
soldiers' heads can be extended upward on either side, thus forming a
cross shape which has its focal point on the torso of the Christ. Thus
all of the abstract lines and shapes within the composition center upon
the important psychological focal point—the figure and face of the
Christ.

RHYTHM

The lines we have observed are the vehicle for rhythm. If we compare
the lines used by Piero in this painting with the lines of El Greco's
BAPTISM OF CHRIST (plate 62), we are at once conscious of the slow,
sustained rhythm of Piero's lines in contrast to El Greco's leaping,
agitated lines. Piero's lines are balanced and organized into an archi-
tectural unity, while El Greco's lines are flamelike, and rather than
emphasizing three dimensional forms, seem to render them insubstantial.

MASS

Lines delineate the edges of objects. The shapes which lines enclose,
giving an illusion of roundness, are called masses. In Piero's paintings
these masses are always solid and ponderous and static. Again contrast
the Christ by Piero with El Greco's Christ, who seems to move to the
side and upward weightlessly, and whose posture appears somewhat
precarious.

When a figure represented in a painting or sculpture has a solid or
weighty appearance, we may describe this by saying that it is _monu-
mental_. The word does not necessarily mean the masses are large _in size_.
It refers rather to their ponderousness. This effect is achieved by simple
contour lines and relatively simple and clearly indicated surfaces within
the outlines. The group of soldiers in Piero's painting are individually
clearly and simply delineated. They are therefore monumental, whereas

the watchers in El Greco's painting have contours which are complicated, broken, and fluid, as they leap and gesticulate.

One of the interesting features of the quality described as monumentality is that paintings and sculptures which are monumental tend to grow larger in size as we recall them in the mind's eye. Having seen a painting which has monumentality, and returning to it several days or weeks later, one is often surprised to find that it is considerably smaller than it had seemed in recollection.

SPACE

Line and mass are the artist's instruments for describing space for us. Space exists in a painting first as the artist's choice of size and shape for his composition. Even in such an elementary choice, significant limits and possibilities are immediately determined. It is no accident that Piero's monumental and static RESURRECTION is composed within a space which is almost square. The square is, of course, one of the most stable and rational of geometric shapes. El Greco's panel of the BAPTISM OF CHRIST is almost twice as high as it is wide; the narrow, tall shape is as appropriate to his attenuated, ecstatic figures as the square is to Piero's solid and monumental figures.

We call the surface on which the painting is rendered the *picture plane*. When we spoke of line, we noted the lines which play about the contours of persons and things and knit together the whole into a pleasing surface pattern. But we must also recognize the relationship of these lines to the illusion of *depth* which the artist creates on his canvas. Piero's painting, like most of the Italian Renaissance paintings, assumes that the spectator sees the event as if it were upon a stage, enframed by the proscenium and side draperies. If we were to imagine the figures and objects of Piero's painting arranged upon such a stage, and then we were to abandon our place in front of the scene and instead look at it from the gallery, we would discover that the figures are arranged in a triangular pattern in depth, with the Christ again the focal point of that triangle. By extending the sides of this triangle, as we did in the case

of the surface triangle we spoke of in connection with line, the result
will again be a cross with Christ at its center.

This kind of analysis of the way space is depicted is apt to cause
skepticism on the part of some art lovers. They at once ask whether the
artist *consciously* determined all of these complex interrelationships.
With Piero we have sufficient evidence to answer that he certainly did!
He was the author of a widely known treatise on perspective in painting.
He was the first to treat the subjects of optics and perspective with a
scientific method, basing his work on the geometry of Euclid. The
Renaissance artist did not look upon these compositional devices as arti-
ficial or contrived but rather as an essential and exciting part of the
creative effort. We can be quite certain that Piero was entirely intel-
lectually conscious in his construction of the unified and coherent com-
position which we find in the RESURRECTION and his other works.

We have noted the arrangement in depth, but not Piero's rendering
of perspective. The first question to which we seek an answer in regard
to perspective is where our eye level is supposed to be in regard to the
painting: are we above the scene, level with the scene, or below it,
looking up at it? As we study the painting we discover that there are
two distinct eye levels. First, in regard to the group of soldiers, our eye

level seems to be just above the moldings of the sarcophagus. We are able to see a portion of the arch of the foreshortened foot of Christ, as if our eye level were slightly above this point. Yet the Christ is seen as if our eyes were level with his. Therefore, a second eye level is at this point. The significance of this dual eye level shall be discussed in connection with the content of Piero's mural. Here we note it as part of the structure of the composition.

LIGHT AND SHADE

Light and shade are two other properties of design which the artist uses to achieve his effects. Effects of roundness and volume are attained by highlighting certain areas and shadowing the areas that are supposed to recede away from our eyes. But over and above this, light may be used symbolically, as Piero used it, in having Christ's figure the lightest one of the group ("I am the light of the world") and his head alone set against the light sky. Or the artist may use light and dark expressionistically as El Greco did. El Greco was more interested in involving the spectator emotionally, and he did this by creating dark shadows which eat into the masses and flickering lights which seem to move across the bodies in flamelike patterns.

Line, mass, space, and light and shade are the elements of composition or design with which the artist works to achieve his purpose. Color, too, is one of these elements, but inasmuch as we shall be referring to black-and-white plates, this element will be discussed minimally. These elements of design are the instruments for the artist's communication, the way he conveys *meaning* to us.

Meaning in Works of Art

Meaning involves the difficult problem of communication. The problem with communication is that it involves a receiver. Even a telephone circuit depends for its use upon one who can speak and one who can

hear. Since we are studying known masterpieces of art, we have chosen those which can speak—the question is in regard to those who hear, the receivers.

All of us look at the visible world in a highly selective way. The focus of our attention is determined by our past experience and present interests. The constant selecting of what will be seen and how it will be seen is a kind of editorial activity of the conscious mind which ceaselessly shapes our individual seeing of the exterior world. Every lawyer knows the problems in regard to the conflicting evidence of two eyewitnesses of the same event; each may endeavor to the best of his ability to describe accurately his visual experience. But their eyes may in fact *see* differently, because they have been conditioned differently.

To abdicate consciously our own self-determined and self-centered way of seeing is not easy. But nothing less than a kind of self-abdication is demanded of us by a great work of art. It asks us to see it, if for only a few moments, in the terms of the vision that it represents and expresses. Those who go to art galleries and museums confined within the vision of their own making tend to respond to paintings with "I like this one, that one I don't like"—that is to say, this one accords with and confirms my own private, limited vision, whereas the second one does not.

But when we are willing to receive the meaning of the work of art in accordance with the artist's vision, we experience an exhilarating expansion of understanding. Momentarily, we see with the artist's eyes, and feel with his pulsebeat. This moment is a truly creative interval for the beholder. The famous art critic and connoisseur, Bernard Berenson, has described this experience:

In visual art the aesthetic moment is that flitting instant, so brief as to be almost timeless, when the spectator is at one with the work of art he is looking at, or with actuality of any kind that the spectator himself sees in terms of art, as form and colour. He ceases to be his ordinary self, and the picture or building, statue, landscape, or aesthetic actuality is no longer outside himself. The two become one entity; time and space are abolished and the spectator is possessed by one awareness. When he recovers workaday consciousness it is as if he had

been initiated into illuminating, exalting, formative mysteries. In short, the aesthetic moment is a moment of mystic vision.[4]

One of the most curious effects of this experience of aesthetic vision is that it makes artists of us, creating in us a new vision for everyday life. Berenson gives an example when he tells us of his visit to the Freer Collection in Detroit, Michigan, on a frosty winter afternoon:

I had been looking for hours at Chinese pictures of trees in snowy landscapes. The light of day was failing, and as no lamps or candles were permitted, there was nothing to do but to start going away. As I was getting up from the table I turned round, and without realizing that I was looking through a window at the out of doors, at natural objects and not artifacts, I cried out, "Look, look, these trees are the finest yet!" So they were, for how can man compete with "nature"? I had been enabled to feel this without the aid of an artist to reveal it.[5]

The succession of humdrum events of daily living, as well as the rare precious events, when seen in terms of their iconography are graced with significance and dignity because their symbolic possibilities are underlined. When we experience the kaleidoscope of daily visual experiences as changing form, design, and composition, it ceases to be meaningless. When we, like the painter, who creates a work of art, endow with significance the forms of our visual experience, we become artists in relation to the visible world about us.

Turning back to the study we have made of the iconography and form of Piero's RESURRECTION, it will be noted that at a number of points it was with difficulty that the discussion was confined to *just* iconography or form. The description tended to expand into interpretation, that is, to deal with the *meaning* of the painting.

We noted the fact that the left side of the painting has barren boughs, the side of Christ which has been pierced, and the leg which still stands within the sepulcher. We observed also that the two soldiers on this side

[4] *Aesthetics and History* (Glasgow: Pantheon Books, 1948), p. 80.
[5] *Ibid.*, p. 69.

are deep in sleep. All of these are references to sleep, death, or uncon-
sciousness. On the other side of the painting are leafy trees, the emerging
leg of Christ, and the soldier who awakens and looks upward. So we see
the transformation from unconsciousness to consciousness symbolized
here before our eyes. The leafless tree, like the recumbent guards, is
in a state of dormition. But as Christ rises from the tomb, his movement
awakens nature to life and the soldier at the right to consciousness.

Though the painting has a static quietude about it, a subtle feeling
of ascending movement is experienced by us when we study the Christ
figure. This effect is produced by the two different eye levels. Our eyes
focus alternately on the one just above the tomb and then on the one
which is level with the eyes of Christ. This movement, which is part of
our visual response rather than implied within the still and somber
figure of Christ, differs from the precarious diagonal movement of El
Greco's Christ.

We are compelled to return again and again to the eyes of Piero's
Christ, whereas it is the body and gesture of Christ which attract our
attention in El Greco's painting. Those eyes, once one has met their gaze,
are unforgettable. They focus upon us but seem to look also through
and beyond the spectator. The recollection of pain and suffering is
present in them as well as a terrible weariness. Yet the body is firm and
commanding. The wound in the side is but a small incision from which
several drops of blood issue forth. If we contrast this torso with the
mutilated flesh of the Christ in Grünewald's Crucifixion from the
ISENHEIM ALTARPIECE (plate 52), Piero's reticence in regard to physical
suffering is apparent. The deepest suffering of this Christ has been other
than physical.

Conclusion

Iconography includes all that relates to subject matter. If we ask, What
is the painting about? all of the information required to fully answer this
question is iconographic data. Form is the design or pattern of the work
of art—that is, how the subject matter is composed. We perceive form

optically and sensually, whereas iconography is identified intellectually. *Content* is expression or meaning—that is, what is communicated and why.

Whereas subject matter and form are perceived by us through an activity primarily of the mind in the one case and of the senses in the other, the content of a painting is communicated to us more generally, and in one sense, more passively. We *receive* the content or meaning of a work of art; the meaning is *bestowed* upon us, rather than being attained through a specific activity on our part. What *is* required of us for the communication of content is a kind of consent or openness on our part. When we confront a painting, it is not a matter of a few moments of visual contact—in those few moments of temporal time, our entire lifetime of visual, emotional, intellectual, and spiritual experience is being drawn upon and stimulated.

EARLY CHRISTIAN AND BYZANTINE ART

The Roots of Christian Art

Christian art as well as its thought sprang from a double root. The genius of two different peoples and cultures of the Mediterranean basin were fused in the new religion which the apostle Paul carried to the farther shores of the Mediterranean Sea. Neither of these peoples were large in number nor politically aggressive. Their genius was of another kind. What they held in common was a sense of their own differences from the other peoples of their time. To the Jew all other men were pagans and Gentiles. He was one of God's chosen people, the people who held a covenant with God, and from whose numbers the promised Messiah should come. The Jew was set apart from his contemporaries at all times and in all places by his religion and his racial heritage.

The Greek tribes who by the sixth century B.C. were firmly established in the Greek peninsula also saw themselves as different from their neighbors. To the Greek the world was divided between Greeks and barbarians—that is, between those who spoke Greek and those who did not. His language was the language which initiated most of the forms of literature of the Western world. One major exception is those originated by the authors of the Old Testament. The Old Testament had religious and love poetry and the oratorical power of the prophets. The Greeks originated epic poetry, history and drama, philosophy in all its branches, mathematics, and many of the natural sciences. But more

29

important for us is the fact that the Greek's language was related to his sense of freedom and independence, and his conviction of his importance as an individual.

The moral earnestness and spirituality of the Jews and the individualism and humanism of the Greeks contributed essential characteristics to the nascent Christian religion of the first centuries A.D. These general characteristics of course shaped the art of Christianity. More specifically, however, Jewish literature provided the major source for iconography, and classical art the major source of artistic style for Christian art.

The early Christian artists inherited from the Jews a source book of history, incident, and imagery in the Old Testament. This book, or compilation of books, had remained unillustrated in the hands of the Jews. But we now know that the church had illustrated copies of the Old Testament which were produced in Alexandria, where the first Greek version of the Old Testament was made. The original probably came from the second century, and it was faithfully copied for many centuries thereafter and influenced the imagery in early Christian and Byzantine art. The stories of the Creation of the world and of man, of the Fall, the Noah, Jonah, and Job stories, and the Abraham and Moses accounts—all provided the Christian artist with iconography for his works of art. The Old Testament as a source of artistic subject matter was particularly important in the earliest years of Christian art, when the New Testament canon had not been established, and when artists were reluctant to represent the face or figure of Jesus because of the prohibition stated in the second commandment. Instead of representing him and his acts, they represented both by analogous incidents from the Old Testament.

To the early Christians the Old Testament was a history of God's preparation of his people for the coming of Christ. Many of the cryptic predictions were reinterpreted as foretelling the coming of Jesus. Also, many of the incidents of the Old Testament were thought to be "prefigurations" of the events of Jesus' life. Thus the announcement to Sarah in Genesis that she would bear a son was paralleled with the

Annunciation to Mary of the Incarnation of Jesus. Matthew has Jesus himself likening Jonah's three days in the belly of the whale to his own imminent "three days and three nights in the heart of the earth" [1] before the Resurrection. Thus the early Christian artists often represented Jonah on sarcophagi and in the catacombs as a reference to resurrection and salvation. The worshiper saw in the paintings and sculptures of Jonah not only the Old Testament story, but reminders of the resurrection of Jesus Christ, and the hope for his own resurrection.

This kind of interpretation of Old Testament images and incidents is called typological. Images or incident-types which are used in the Old Testament have corresponding images or incident-types in the New Testament. In their simplest interpretations these types are poetical analogies which enrich our imaginative grasp of the stories or images. But they were far more to the early Christians. These correspondences demonstrated the unity of the Old Testament with the New, and showed the events of Jesus' life as a fulfillment of God's purpose which had been working through the history of his chosen people and his chosen prophets. There is much evidence in the Gospels that the evangelists themselves regarded the Scriptures as being fulfilled in what they recount of Jesus. For these reasons the Old Testament was the source of much of the subject matter we find represented in early Christian art.

However, the *style* of early Christian art—that is the form in which it was expressed—was derived principally from Greek art. Most of the art of the Western world for the thousand years after the fifth century B.C. can be seen as part of this tradition. For the most part the artistic style brought to perfection by the Greeks at the time of Pericles and Socrates and Aeschylus is the dominant element in Western art in the following centuries, and thus of Christian art for a millennium and more thereafter.

The style of Greek art, of course, underwent great changes in the period between the fifth century B.C. and the centuries at the beginning of our own era when the first Christian works of art were created. But certain of the characteristics of Greek art of this golden age remained

[1] Matt. 12:40.

constant during the next centuries, and some remained visible beneath the modifications and increments of later periods. Many characteristics were revived by Renaissance artists. Thus it will be helpful to look at an example of Greek sculpture from the fifth century B.C., when Greek art attained a balanced beauty and grandeur of expression. The APOLLO (plates 3, 4) made for the Temple of Zeus, Olympia, about 460 B.C. is a majestic exemplar. The statue was originally on the pediment of the temple, where Apollo was placed between two groups of struggling combatants. The scene depicted is the battle between the Lapiths and the half-human, half-bestial Centaurs. Apollo is considerably larger in size than any of the other figures, and it is his noble and easy gesture which assigned the victory to the Lapiths.

The APOLLO is monumental—that is, it has a grandeur which derives from the simple, quiet pose and the relatively undetailed large surfaces of the body and face. Apollo stands directly in front of us, his shoulders and hips almost parallel and entirely frontal to us. His outstretched arm has a balanced ease of movement. This is no impetuous or forceful movement, but a grand and serene gesture. It is the gesture of one who is not involved in any way in the struggle he settles. This Apollo has an appropriate Godlike certainty of his own power over the conflict.

The unknown sculptor's depiction of the human body is interesting to us as it is representative of the Greek ideal of the human figure during the fifth century. The unique and revolutionary features of the Greek APOLLO are underlined if we contrast it briefly with an Egyptian statue THUT-MOSE III (plate 5). THUT-MOSE III is rigid and "unreal." Like most freestanding sculptures before the time of the Greeks, the body is represented as obeying "the law of frontality." The law of frontality requires that the artists use a rigidly vertical pose, with no differences on either side of the axis of the body. The axis of the human body is the imaginary line which would be made if a plumb line could be dropped through the middle of the skull of a standing figure through its neck and torso, ending at a point between the two feet which are placed side by side on the ground. Ancient sculptural arts began with forms which are strictly symmetrical—that is, having both sides of the middle axis

identical. THUT-MOSE III, which was created about 1,500 years before the birth of Christ and is the product of a great artistic culture, is almost exactly symmetrical. One foot is advanced beyond the other, but this has not altered the tilt of the pelvis as it has in the case of the APOLLO, or as it would, of course, in life. Only the advanced leg varies the symmetry of the two sides of the statue. The same could not be said for the APOLLO, whose varied position of the arms and whose turned head result in a posture which is not wholly symmetrical. These differences of posture give a kind of freedom and possibility of movement of the APOLLO which makes THUT-MOSE seem very static and rigid and unlifelike.

If the torso of THUT-MOSE is contrasted with the torso of the APOLLO, major differences are to be observed. The rounded and tubelike waist of THUT-MOSE, with its simple depression for a navel, differs from the complex shapes organically related to each other which the Greek sculptor depicts. The Greek sculptor has studied the bodies of the Greek athletes and he has utilized this firsthand knowledge in his sculpture, showing the threefold muscular division of the upper abdomen, the lines of the ribcage beneath the flesh, and the navel as an organic part of flesh and muscle rather than as a geometric depression.

The differences between the two statues result from two different attitudes toward the depiction of persons, places, and things in works of art. The Egyptian sculptor began with a concept or a cluster of ideas about the human figure. Egyptian artists, rather than studying anatomy and sketching the body and its parts from a model, studied the statues of earlier artists and followed established patterns when depicting the human figure. Artists of other cultures of the Near East and the Orient worked in a similar way, as did the Greeks themselves until the sixth century. It was the Greeks of the subsequent classic period who were the first to look with fresh eyes upon the human body and depict it as an organic unity capable of movement. The structure of flesh, muscle, and bone and their interrelationships were studied by the Greeks with a passion and thoroughness that made them masters of every conceivable movement or position of the human body.

The contrast with the Egyptian conceptual approach to the human figure has a relevance for our inquiry that goes beyond its value in underlining the revolutionary character of Greek art. Recurrently in the art of the Western world, there are periods when the prevalent artistic style is dominated by an attitude toward reality which is nearer to the Egyptian style than to the naturalism of classical art. For the present it will be best to think of this attitude as nonnaturalistic. Each of these nonnaturalistic artistic styles will be described as we meet it in chronological order. But here, however, let it be stated that the term "naturalistic" as it will be used in this book will mean that the artist is basing his representation of the human body and of all objects on his observations and his studies of the human body and the chosen objects. The artist working in a naturalistic style represents people, places, and things naturalistically; that is, the artist's intention is to re-create for us the persons and objects of our visual experience recognizably—a chair will look like a chair, a tree like a tree, a human being like a human being. It must be emphasized that within naturalism there are immense differences and that there are specific works of art which we have difficulty in labeling either naturalistic or nonnaturalistic. Nonetheless, broadly speaking the distinction is a useful and a valid one.

We may summarize our observations thus far by saying that the Greek sculptors of the fifth century had achieved an understanding of the human body which, taken together with great technical skill, permitted them to represent the nude body as an organic unity capable of movement.

What other characteristics are seen in the APOLLO, the example of classical art? The idealizing of the human face and figure is another notable characteristic. The artist has not represented one particular human figure with all of its idiosyncrasies and irregularities. He has presented us with an image which is Godlike, all details which might betray frailty or transitoriness having been eliminated. This typical concern for ideal beauty must not be interpreted as a wholly aesthetic one. It springs from deeper sources. Plato's writings record that Socrates, who drank the fatal hemlock potion about fifty years after the APOLLO was com-

pleted, ended the *Phaedrus* with a prayer which gives us an insight into the Greek religious consciousness: "Give me beauty in the inward soul; and may the outward and inward man be at one." [2] It is this aspiration toward inner beauty which motivates the outward idealism of Greek art.

It was a Greek, Lucian, who, in one of the first documents of art history, recommended that the artist when representing a woman choose the most beautiful and comely features of many different women and put them together to form the ideal woman. The APOLLO may have been similarly composed. Certainly the proportions of the figure were dictated by an ideal rather than by any particular model. At the time the APOLLO was created the human figure was usually represented as being seven heads high—that is, the height of the head multiplied by seven would give the height of the figure. In the case of the APOLLO the head measures about seventeen inches and the entire figure about ten feet in height. This proportion or artistic canon has remained a kind of norm in art of the West. When the canon is significantly altered, it always indicates that nonnaturalistic elements are beginning to dominate the art style. If the head is considerably smaller in relation to the body height than the norm, the effect is one of spirituality or elegance as in most Byzantine art (plate 12), or of attenuation and ecstasy as in El Greco's art (plate 62). If the head is noticeably larger in relation to bodily height, the body often appears peasant-like and somewhat gross as in much of Bruegel's art (plate 58).

It should also be noted that the APOLLO is represented not only as a kind of ideal norm in physique and proportion, but in age as well. He is the mature male in command of his full strength, wisdom, and vigor of early mid-life. He is beardless and his hair is relatively short and close to his head. We shall meet these characteristics again in some of the early representations of Jesus. These are referred to as the "Apollonic Christ type," because they are based on Greek prototypes which derive from the Olympian APOLLO and other Greek sculptures of this classical deity.

[2] Irwin Edman, ed., *The Works of Plato* (New York: The Modern Library, 1930), p. 329.

The body and face of the APOLLO were painted originally. The face which now seems almost expressionless would have had the iris, the pupil, and the mouth painted in color. Even with this addition, the strict symmetry of the bold features must have resulted in an immobile face. The effect of dignity and nobility is conveyed by the body as much as by the face. The use of the body as well as the face as a vehicle for expressing meaning is a characteristic of Greek art. It appears again as we shall see in the art of Michelangelo at the time of a renascence of classical art called the Renaissance.

The Greek artists' apparently exclusive concern for the human body is dramatically apparent if one visits one of our larger museums. After walking through the painting galleries with their diversity of subject matter, one may step suddenly into a room devoted to classical sculpture. The range of subject matter in the painting galleries has run the gamut from portraits, still life, and landscape, through historical, mythological, and religious subject matter. Paintings range in size too from tiny, intimate, and detailed fifteenth-century portraits to the immense and dramatic biblical scenes of Tintoretto and El Greco. And they range in color from somber monotones to the glorious intensity of the impressionists' paintings of nature. But stepping from this variety presented by paintings into a gallery of classical sculpture, one is confronted with another world. A kind of poetic quietude surrounds the grave figures who stand or sit in these galleries. Time has worn away the color with which they were originally painted, and the beauty of the unadorned marble pleases our senses. The nude figure, or the body clothed in the graceful flowing garments of classical times which subtly compliment the body beneath, is the primary subject matter of classic art. Yet the body is not represented as a mechanism, but with a sense of wonder and reverence; its insistent vitality seems to spring from the creative sources of being itself.

The gods and goddesses depicted by the Greek artists have a nobility and command appropriate to their divinity. Even when they intervene in the affairs of men, as is the case when Apollo dictates the victory in the struggle between the Lapiths and the Centaurs, the gods remain aloof

and uninvolved. Thus the emotional range is limited for the most part during the classical period to the expression of nobility, grandeur, dignity, command, serenity. It will be seen as we look at early Christian art that many of the characteristics of the style of the APOLLO and fifth-century Greek art are present in a diluted and transmuted form in the works of art made during the early centuries of our era.

The great contribution of Jewish literature to early Christian art forms must also be noted. There are four different kinds of subject matter in the Old Testament available to the Christian artist: first, the emphasis on *relationships* between an individual and his God, where there is involvement on both sides; second, the interest in the *personalities* of the leaders and even the minor figures; third, the abundant number of *dramatic events;* fourth, the love of the *natural world* about man.

The God of the Old Testament makes himself known to his people in acts which are taken to symbolize a relationship. Relationships between the gods and mortals are not present in Greek art (and, indeed, are seldom present in their mythology). Even relationships between people are seldom expressed except in relatively small groups of sculptures such as the poignant late classical funerary reliefs. The Old Testament authors dwelt upon the personalities of Abraham, Moses, Job, the prophets, and a host of minor personages. Hebrew writers had a genius for recording the word or act which conjures up before our eyes a living, breathing human being. Greek art shows little interest in the individual personality. The Greek artists were not gifted portraitists. Even their greatest leaders, such as Pericles, and thinkers, such as Plato, are represented in sculpture in idealized and generalized portraits with their individual characteristics suppressed.

The Old Testament abounds with dramatic events—the Creation of the world and man, the Fall, the Flood, the Exodus. Many of these events have parallel stories in Greek mythology, but not many of them are represented in monumental Greek art. When they are used as subject matter, the moment depicted is often before or after the dramatic climax rather than the climax itself.

Finally, the Old Testament has magnificent descriptions of nature in

the scenes of Creation, the Garden of Eden, the psalmist's evocations of a joyous nature which glorifies its Creator, and Job's description of the fearful creatures of the deep. As we reread some of these passages, and return to classic art, we are struck once again by the insistent emphasis of this noble art which focuses upon the human figure in godlike form.

Early Christian Art

We have spoken of the double heritage of Christianity, noting the style of Greek sculpture and the subject matter offered by the Old Testament. In each of these two cases we have referred to style and subject matter in its most representative form. We discussed the style of a work coming from the period of Greece's greatest creative productivity. And we noted the characteristic types of subject matter in the Old Testament. How does the art of the Greek fifth century relate to the first works of Christian art? The earliest works of Christian art which are still preserved are thought to be from the end of the second century. The work which we will be studying is from the mid-fourth century. This means that almost nine centuries separate it from the APOLLO. How is the one related to the other?

In the early years of Christianity, when artists were struggling with the problems of creating a new visual language to express the beliefs and viewpoint of their new religion, what was the influence of Hebraic thought and the use of the Old Testament subject matter in Christian art? To answer these questions, we must look for a moment at the Mediterranean scene just before the birth of Jesus Christ.

After the death of the Greek conqueror Alexander in 323 B.C. the world of the Greek was greatly broadened by the internationalizing of the eastern Mediterranean. Greek cities such as Alexandria in Egypt and Antioch in Syria spread Hellenic culture into these areas. But the cultural exchange was by no means in one direction only. Oriental influences were felt by the Greeks too. It was a time of free exchange of goods and ideas. The Oriental gods became known to the Greeks.

Asiatic cults began to compete with the ancient mysteries of Dionysus and Demeter. As the Hellenic horizons became wider, a new moral attitude became apparent in art and thought. The increased complexity of personal life, the loss of political participation and responsibility, and the economic imbalances and stresses which resulted from international commerce made it more difficult for the individual to adjust to his environment. Ethics and a moral code came to be emphasized by the philosophers.

In the realm of art new subject matter was represented. Sorrow, pain, physical and psychological stress were expressed. All of these expressions of emotional states were eschewed by the fifth-century B.C. classical sculptor whose gods and goddesses were serenely in the possession of their divinity. Even the gods were less divine in later art, and mortals were more frequently represented than during the fifth century. In late classic art sculptors represented people as suffering, finite beings —a boxer with a cauliflower ear, seated, still wearing his cudgels, his head turned sharply and painfully upward as if suddenly alerted; an aged peasant woman trudging to market with a lamb under one arm; a young teenage girl, wistfully absorbed in her own thoughts; and numerous haunting portrait heads which emphasize the pathos and finiteness of man's condition.

It was in this ambience with its new understanding of man and expression of his finiteness that the Hellenic world received the message of Christianity. Christianity spread from Palestine to the cities of the Mediterranean. In its earliest years it was a proscribed religion; the churches could not own property and periodically Christians were under persecution. Consequently very few works of art from the first three centuries have come down to us. Most of what remains is sepulchral art —that is, art made for cemeteries. The Christians during the first centuries buried their dead in underground chambers connected by narrow passages. These networks of cubiculae and passages are popularly known as catacombs. In Rome there are still 550 miles of catacombs, an extraordinarily large network. It must be remembered that by the mid-third

century there were more than forty thousand Christians in Rome alone, although at this time the religion was still proscribed.

Our earliest Christian paintings are to be found on the walls of these underground chambers, and our earliest Christian sculptures were sarcophagi for bodies of deceased Christians. The subject matter for these works of art is drawn mostly from the Old Testament. If we recall that the New Testament canon—that is, the writings officially approved by the church—was not definitely established until the latter part of the second century, we will see that until that time the church had no Bible but the Old Testament.

The choice of subject matter from the Old Testament is interesting; the subjects were all related to deliverance from sin and death. Daniel between two lions was a reminder that God saved Daniel from the lion's jaws. At a time when Christians were sometimes thrown into the arena with wild beasts, this subject must have had a very particular relevance. Jonah, who was delivered from the "big fish" by the mercy of God, and Job, whose afflictions were controverted, were all expressions of God's merciful acts of salvation from sin, pain, and death. These acts were an evidence of God's omnipotence, a confirmation of the faith that "all things are possible with God." [3] To the Christian of the early centuries, who was a member of a persecuted and minority religion, these episodes which told of God's wisdom, power, and mercy must have had a significance beyond the comprehension of twentieth-century Christians who have inherited their faith at a time of relative physical security and maximum religious toleration.

The SARCOPHAGUS OF JUNIUS BASSUS (plate 7) has on it a number of these subjects relating to salvation. Before considering the iconography of this work of art, something of its interesting history should be known. It was made sometime before A.D. 359 since it was in that year, as the inscription on the sarcophagus reads, that "Junius Bassus, *vir clarissimus,* who lived forty-two years and two months and during this tenure as prefect of the city went to God as a neophyte." In view of his

[3] Mark 10:27.

age and active responsibilities it is unlikely that the sarcophagus was made specifically for the prefect in advance. Probably it was chosen afterward by members of his family from a big atelier in Rome where sculptors and marble alike came from the eastern Mediterranean, as well as from local sources. It is interesting to note that Junius Bassus was a neophyte at the age of forty-two. Though he had professed to be a Christian, he had not been baptized; some Christians of the early centuries deferred baptism until death was near.

The sarcophagus is architecturally divided into a succession of niches, each containing a separate episode. The subjects are from the Old and New Testament, arranged, it seems, somewhat arbitrarily. Reading from left to right in the upper register we have: (1) Abraham, whose weapon for slaying Isaac is in his right hand as he looks upward toward the source of God's voice; his right hand is on the kneeling Isaac's head, and his servant stands behind; in the left corner is the ram, and in the right the altar which Abraham had prepared for his offering of his son Isaac; (2) the apostle Paul arrested; (3) Christ seated between Peter and Paul, giving them the law and the responsibility for the church; (4) Jesus being brought before Pilate; (5) Pilate preparing to wash his hands.

The lower register has the following subjects, again reading from left to right: (1) Job seated on the ash heap, visited by his wife and one of his friends; (2) Adam and Eve at the time of the fall; (3) Christ's entry into Jerusalem, and Zacchaeus who climbed the tree in order to see,[4] another follower spreading a cloak for the ass to tread upon; (4) Daniel in the lion's den; (5) Paul led away to execution in the Tre Fontane marshes.

Three of the four Old Testament subjects are on the themes of deliverance noted previously. Not long ago a scholar discovered that the very subjects which appear in early Christian catacomb art are mentioned in an ancient litany of the church:

> Receive, O Lord, thy servant into the place of
> salvation which he may hope of thy mercy.

[4] Luke 19:2-4.

> Deliver, O Lord, his soul as thou didst deliver
> Isaac from sacrifice and from the hand of
> his father Abraham.

The prayer continues with this formula, speaking of the deliverance of Daniel from the den of lions, Job from his sufferings, Noah from the deluge—in fact, all of the subjects common to early Christian art. The relevance of Old Testament subject matter to the early church is abundantly evident in art, liturgy, and theology.

A subject which needs additional explanation is that represented in the upper central group (plate 6), where we see a youthful, beardless Christ seated between Peter and Paul, one foot resting upon the shaggy head of a man who holds an arch-shaped bit of drapery over his head.

Christ's youthful, round-cheeked face and tranquil gaze and his short hair are far from the Christ-type familiar to most of us. But we have seen these very features before—in the APOLLO of Olympia. The serenity and symmetry of features of this young Christ are characteristics which derive from the classical past, and we shall see that this type of Christ continues to be represented sporadically in Mediterranean art for some centuries. Even Michelangelo's Christ in THE LAST JUDGMENT, despite the fury of his powerful body, has a beardless face which is classically symmetrical of feature and curiously passive in expression.

Peter and Paul on either side of Christ are known to us by their types and their location. The law is always given to Peter as he stands at the left of Jesus. Very early in Christian art, Paul is characterized as having a rather narrow face, long pointed beard, and bald head, whereas Peter has a round head and face, short beard, and tonsured hair.

The subject represented is called by the archaeologists "Majestas"— that is, Christ in Majesty. Christ is represented as seated above the firmament, in heaven, addressing his disciples and delivering their commission to them. Matthew's Gospel records Jesus' appearance to the eleven disciples after the Resurrection at Galilee: "And Jesus came and said to them, 'All authority in heaven and on earth has been given me. Go therefore and make disciples of all nations . . . and lo, I am with you

always, to the close of the age.' " [5] These words are called the Great Commission and are the cornerstone upon which the church and its missionary endeavor are laid. Paul's presence here, of course, is symbolical. Matthew mentions eleven disciples, and presumably the commission was given before Paul's conversion. But as the greatest missionary of the church, his importance to the scene is self-evident. Indeed, Christian iconography frequently deliberately and meaningfully violates chronology.

The artist is compelled to express himself in concrete symbols rather than in words, and if he must present an essentially abstract concept, he has a difficult problem. Let us take an example: Jesus said, "Before Abraham was, I am." [6] How can the artist express this paradoxical Christian truth? Of course, he cannot express it fully or directly. But the medieval artist achieves some of the meaning by showing Jesus Christ as the creator of the universe, as he who initiates all of the mighty acts of creation described in Genesis. In a less sweeping but similar way the early Renaissance artist shows the Virgin Mary, to whom the angel announces the birth of Jesus, kneeling in a bedroom which has on its wall a painting of the Crucifixion. This is the artist's way of expressing that all time lies within the hand of God and the time of eternity is not the time we experience in our chronological progress from cradle to grave.

In this "Christ in Majesty" panel, the man beneath the feet of the Christ figure is Caelus, a classical divinity of the sky. The early Christian artist wanted to show Christ in heaven. How was he to make clear to the spectator that Christ was in heaven rather than on earth? Probably unaware of any inconsistency in his use of a pagan god along with Christian subject matter, he used Caelus to denote the place. There are many other examples of a similar use of classical gods or allegorical figures in early Christian art. It is part of the artistic vocabulary of the time, and is no more remarkable perhaps than the English Anglican bishop who, when nettled, exclaims, "By Jove!" and sees no contradiction between

[5] Matt. 28:18-20.
[6] John 8:58.

his Christian faith and his oath naming the father of the classical gods.

We have noted the relationship of the Christ on the SARCOPHAGUS OF JUNIUS BASSUS to the APOLLO of Olympia. There are many additional classical characteristics in the style of this sarcophagus. The garments are classical in style and in the way in which they accentuate the proportions and movement of the bodies beneath. If we contrast the figure of the seated Christ with that of the Romanesque Christ in THE PENTECOST (plate 14) we note that in the latter the drapery does not always follow the movement of the body but has itself an exciting whorllike movement and vigorous linear pattern which is often independent of, or even contradictory to, the body beneath the garment. But, in contrast, the artist of this sarcophagus approaches the human figure from the naturalist tradition and makes the body's position clear and convincing. The faces of Peter and Paul, as well as the face of Jesus, have prototypes in classical art. Paul particularly is the philosopher-orator type familiar to us from statues of Plato and Demosthenes. The figure of Eve, too, is directly derived from classical art, her proportions and posture being akin to the late classical statues of Venus surprised while bathing.

Nonetheless there are many characteristics which show us the dissolution of the classical norms. Note that the proportions of the bodies have altered, the heads seeming to be overly large in several cases. This is especially true of the upper right niche, where the head of the man between Pilate and the attendant who brings the pitcher of water is unaccountably large, and the position and posture of the body entirely unclear. The crowding of the niches is another nonclassical characteristic. The Abraham niche—where three figures, lamb, and altar are all compressed within a relatively small space—is an example of this crowding, as is the Pilate scene with its ambiguous third figure. The addition of details suggesting a specific place or kind of environment also is unlike the art of classical Greece. Behind Pilate we see a portion of a building with an embattlement across the top. The trees in the scenes of the Fall and in Jesus' Entry into Jerusalem, and the rushes in the scene where Paul is led to his execution, are all environmental; they are

unlike Greek art of the fifth century B.C. in which a particular place or time is seldom indicated.

These characteristics which show a movement away from classical norms have a special relevance, for they represent the first tentative modifications of naturalistic style in depicting Christian subject matter. It should be noted in passing that these modifications appeared in pagan Roman art of the same period. Thus not only a new type of subject matter and a religious consciousness but also forces at work in the culture of the period itself necessitated a change in style. However, we can see that all of these modifications are particularly appropriate to Christian subject matter. For example, the proportions of the body as represented in art become less ideal when there is less emphasis on physical beauty in the culture from which it springs. Christianity with its hope of eternal life was less interested in ideal beauty than the classical world had been.

The apostle Paul reveals an attitude toward the body which is non-classical. The body, as a main ingredient of the concept of the flesh, is to him the foe of the spirit and must be pommeled and subdued so that the imperishable prize may be won. When such an attitude toward the body becomes a strong element in the religion and life of the times, ideal physical beauty is less typical in the art.

Therefore considerations in regard to proportion and the artistic canon of the human body were of less interest to the early Christian than the problems relating to the adequate representation of the subject matter of his choice. So the crowding of the space occasionally became an instrument for telling the biblical story clearly and recognizably. The details which represented the environment were part of the story, also.

Much of the art from the second and third centuries—we have nothing from the first century and very little which can be ascribed to the second century with any certainty—is of a considerably lower technical level than the SARCOPHAGUS OF JUNIUS BASSUS. In many other sarcophagi the nonnaturalistic characteristics which we just noted are even more exaggerated. The figures on them sometimes seem dwarflike; their heads

are large and their limbs thick and short. In many of the catacomb paintings the drawings, or draftsmanship, of the figures is so cursory as to seem almost cartoon-like. Yet these figures emanate a new spirit. Strangely enough the crudity of the drawings seems to be instrumental in underlining the spiritual verity of the message. The MOTHER AND CHILD from the Catacomb of Priscilla (plate 8) has the characteristic simplified forms and jagged contours of this catacomb art. Its very starkness bespeaks a spirit which is different from classical art.

There is extant, from a somewhat later date, a fresco of Jesus in the catacomb of Domitilla, which is nonclassical in spirit and style. Presumably influenced by eastern Mediterranean art, this type of Christ is more in accord with the image familiar to us—the somewhat narrower face with long hair, pointed beard, and large expressive eyes. The eyes particularly have a gaze which can be seen frequently in Christian art. This Christ seems to look directly at us; yet the longer we return the gaze, the more we feel that he gazes through us to something beyond.

Whereas the Christ of the sarcophagus was young, beardless, and looked away from the spectator, this Christ of this fresco is in mid-life, fully bearded, and gazes intently and yet without a definite focus toward us. It is thought that this more spiritual Christ derives from the eastern Mediterranean area rather than from Greek or Roman sources. It is this type of Christ which becomes the predominant one in the succeeding centuries.

We must look first to Rome, and then to the eastern Mediterranean for the setting of the development of the first cohesive style which became, almost uniquely, a vehicle for Christian art.

Byzantine Art

In 312 the Emperor Constantine gave his official support to Christianity, and almost immediately the imperial treasuries gave money for the building of the first great places of Christian worship. Chief among these was the enormous basilica of St. Peter's, built where the present St. Peter's now stands in Rome. This great church was dedicated in 326, only four-

teen years after Constantine's espousal of Christianity. It was built to hold forty thousand Christians standing in worship, this being the position used in the first centuries even when praying. Many other large Christian edifices were built in Rome during the first part of the fourth century. With the construction of these buildings, artists had their first opportunities to create works of art for places of public worship. No longer was art limited to the catacombs and cemeteries, to what André Malraux has called "an art of crypts and coffins." [7] The large Constantinian basilicas had long, well-lighted areas above the columns on the side walls, and half-domed areas above the altar for works of art.

Within eighteen years after the official sanction of Christianity, Constantine moved the capital of the empire to an insignificant town on the Sea of Marmora, called at that time, Byzantium. The name was changed to the new founder's name, and in May of A.D. 330 Constantinople officially became the capital. Constantine's reasons for effecting the change were probably chiefly political, but one of the results of the change of location was that a change in the history of the arts was initiated. The style which resulted from the bringing of Greco-Roman art into an essentially Eastern and Oriental cultural orbit resulted in a style we designate as Byzantine.

By the fifth century Ravenna had been made the capital of the western part of the empire. Elaborate palaces and churches were built by Justinian, who had made Ravenna the seat of the government of Italy. Consequently, the connections between the capital of the empire, Constantinople, and Ravenna were very strong.

In the churches of Ravenna there are magnificent examples of early Byzantine art.

The two principal techniques used were *fresco* and *mosaic*. Of the two, fresco was the less costly kind of decoration. A fresco is painted on masonry which has been coated with layers of plaster of increasing thinness. The artist paints the uppermost layer of fine plaster with mineral colors while the plaster is still wet, *al fresco*, or after it has dried, *al secco*. The surface of the painting is opaque and nonreflective, and

[7] *Voices of Silence* (New York: Doubleday, 1953), p. 175.

the range of colors is somewhat limited. Frescoes lack intensity of color, tending to be more like watercolor than oil paint. The brush can move rapidly over large areas of plaster, giving a spontaneous quality to the drawing. The catacomb paintings (plate 8), Giotto's paintings at Padua (plates 13, 24-28), Fra Angelico's TRANSFIGURATION (plate 29), Piero's RESURRECTION (plate 2), and Michelangelo's paintings (plate 40) are all frescoes.

In the medium of mosaic, tiny cubes of colored stone or glass are pressed into the plaster while it is still wet. Mosaic is dependent upon an experienced glass industry capable of making brilliant colors. Gold-faced cubes are made from ordinary glass onto which gold leaf is laid and then protectively coated with transparent glass. Because of this process the gold mosaics made a thousand years ago retain their shimmering glory unchanged. Whereas the forms represented in frescoes are characteristically flowing, the forms used in mosaics tend to have emphatic outlines. Subtle gradations of color which might, for instance, suggest the roundness of an object are difficult to achieve in mosaic. The forms tend therefore to be flat and decorative rather than naturalistic.

The mosaic CHRIST BLESSING THE LOAVES AND FISHES (plate 9) in San Apollinare Nuovo, Ravenna, is representative of early Byzantine art. In this mosaic we see the figure of Christ at the center of a symmetrically balanced composition, his arms outstretched, one hand upon the loaves and the other upon the fishes. On each side of Christ are two apostles and a bit of rocky terrain with a shrub. The figures stand solemnly side by side, all gazing fixedly at us. Behind them a plain gold background shimmers and glitters. If we reread the Gospel passage on which this mosaic is based, we are somewhat perplexed by the artist's interpretation of the event:

When it was evening, the disciples came to him and said, "This is a lonely place and the day is now over; send the crowds away to go into the villages and buy food for themselves." Jesus said, "They need not go away; you give them something to eat." They said to him, "We have only five loaves here and two fish." And he said, "Bring them here to me." Then he ordered the crowds to sit down on the grass; and taking the five loaves and two fish he

looked up to heaven, and blessed, and broke and gave the loaves to the disciples, and the disciples gave them to the crowds. And they all ate and were satisfied.[8]

Matthew's Gospel notes details regarding time and place which might have stirred the artist's imagination—it was evening, a desert place. Jesus' disciples and a seated multitude were among the dramatis personae. Jesus himself is described as looking up to heaven, blessing, and breaking the bread. These factual materials are ignored by the artist.

The artist has not given us a scene with identifiable, documented detail, but an event which has a significance beyond time and place. The solemn act of the Christ who looks out at us, meeting our eyes, is related to the event of the Last Supper and the meaning of the Eucharist. Both the bread and the fish are symbols for Christ. Jesus spoke of himself as the "bread of life." We recall that from the earliest days of Christianity the fish was a symbol for Christ, because the Greek letters for fish (*ichthyus*) in acrostic form give the first letters of *Jesus Hominum Salvator* (Jesus, the Savior of Mankind). The symbol of the fish was used also in earlier days as a cryptic sign for Christ when Christians were still persecuted. The fish was a symbol of the Eucharist in the art of the catacombs, and the five loaves and two fishes also were used as a secret symbol for the Holy Communion—the connection being found in the story of the miracle of the loaves and fishes.

Thus the Christ figure with his outstretched arms and hands touching the fish and bread has a sacramental significance, recalling the words used in the service of Holy Communion, "This is my body which is given for you." The centrality of Christ's position and his ample dark robes, as well as the great round halo and large dark eyes, make his figure stand out from the background and away from the four disciples. We note that here again we have the unbearded Christ, like the Apollo-type Christ on the sarcophagus.

Stylistically, this mosaic shows an interesting mixture of classical and Eastern features. The ponderous monumentality of the Christ is de-

[8] Matt. 14:15-21.

rived from classical art. The evidence of remnants of an interest in space links it with late classical art. The feet of Christ convincingly stand on the ground and do not levitate, as do figures in later Byzantine art. A figure which levitates seems to float in the air, its feet hanging downward and having no support on the earth. Only supernatural beings—holy persons, angels, and demons—are given freedom from gravity and can levitate. When a being is represented as levitating, it has other characteristics, also. It does not have a material body in the usual sense, and so it does not cast shadows. Note that the disciples and Christ *do* cast shadows; that is, patches of darker mosaic are behind their feet. This interest in depth and space, and the way in which the artist has depicted the draperies as describing the posture of the body, are late classical elements in the style of the mosaic.

But most important in determining the style of the mosaic are its Eastern and Byzantine characteristics. The hieratic way in which the figures of the Ravenna mosaic stand side by side staring out at us, performing this sacred solemn ceremony in our behalf, derives from the East. The amorphous gold background which symbolizes eternity is also an Eastern feature of the style as is the subordination of the human body.

It is significant that the nude figure is rarely treated in Byzantine art. And as the style developed, the draperies and garments of clothed figures lose their clinging character, no longer underlining the body. They are rendered with numerous exciting folds and lines, and covered with patterns and borders. The garments seem to be elaborate sheaths which deny the presence of a body. Instead of studying the human body and working from models, artists studied the previous works of other artists. Whenever this happens—and it will be recalled that this was the method of the artists in Egypt also—art tends to get further and further from the usual visual forms of peoples, places, and things. As the artist copies other artists' works, generation after generation, he tends increasingly to move toward *abstraction;* his shapes become more geometric and his lines tend to have a special interest in and of themselves, which is more important than their function in describing the contours of an object. As an example, note the twelfth-century CEFALU CHRIST

(plate 10), where the lines which describe the contour of the cheeks and shadowed areas under the eyes have a precision, balance, and repetitive rhythm that is not naturalistic but abstract.

We have seen that many of these tendencies away from naturalism are present in the Ravenna mosaic, CHRIST BLESSING THE LOAVES AND FISHES, which was made about A.D. 520. It was about that time that the naturalism which had prevailed in the Western world since about 500 B.C. began to be dominated by a nonnaturalistic style. E. H. Gombrich remarks that the "power of observation of nature, which we saw awakening in Greece about 500 B.C., was put to sleep again about A.D. 500." [9]

Between the time when the Ravenna mosaic was made, about A.D. 520, and the awesome Christ of the Cathedral of Cefalù, Sicily (plate 10), about the twelfth century, the Byzantine world suffered a wave of iconoclasm. In 726 an edict had been issued forbidding the representation of divine forms in art. Except for a very brief time, this edict was effective until 843. At that time, however, the church provided the occasion for the creation of many works of religious art by declaring officially that effigies of Christ and the saints contained a spark of the "divine energy," and that a reverent contemplation of them was beneficial to the soul. This sanction of the representation of sacred personages and the elevation of works of art to a kind of participation in divinity had a gloriously fruitful effect on the production of Christian art in the succeeding period.

Artists in all periods have been confronted with a problem in representing Jesus Christ because of his dual nature—his humanity and his divinity. He lived and breathed, preached and healed at one time, but his meaning for the Christian worshiper resides in his divine-human role. Jesus Christ had been man *and* God. Throughout the centuries artists sometimes emphasized the human aspect, at other times the divine. In Byzantine art the divine and transcendent Christ is put before our eyes. This is especially true of the period after A.D. 843 when it was believed that representations of Christ reflected a "divine spark."

[9] *The Story of Art* (London: Phaidon Press, 1950), p. 96.

By what means does the Byzantine artist achieve his image of Christ? First, the choice of subject matter is of great importance. In a mosaic such as the CEFALU CHRIST we do not have the Jesus of Nazareth who called his disciples, preached in the temple, healed the sick, the halt, the blind; instead, we have the Jesus Christ beyond time, the "Ancient of Days" of the vision of Daniel in the Old Testament, the creator of the universe, and judge of all men. In his left hand he holds the Book of Life inscribed in both Greek and Latin with the words, "I am the Light of the World. He that followeth me shall not walk in darkness." His right hand is raised in the solemn, liturgical gesture of blessing. His eyes peer at us with an intent yet sorrowful gaze. This is the type of Christ, noted previously in the catacomb fresco, with the long, narrow face, flowing hair, and pointed beard. The double forelock is, however, a Byzantine addition.

The tremendous size of this Christ (similar mosaics represent the Christ's head alone as about eight feet in height) and its placement on a concave area above the altar gives the image an impact that is overpowering. The size of the figure here is related to the area it actually covers in two dimensions rather than to any suggestion of depth or massiveness. The repeated jagged lines of the draperies move back and forth over a flat surface in an intricate pattern that denies rather than affirms a material body beneath it. In comparing the draperies of this Christ with those of Piero's resurrected Christ (plate 2), it will be seen that the draperies are depicted decoratively and abstractly in the first instance, whereas Piero used naturalistic means in painting his drapery. The lines of the draperies and the hair, and the lines of the face of the CEFALU CHRIST are all unnaturalistic and therefore suggest an immaterial and transcendent Christ.

The shimmering golden background also underlines the otherworldly nature of this Christ. Gold, always associated with preciousness and wealth, became the color for symbolizing eternity. The tiny gold cubes, or tesserae, are set into the moist plaster at varying angles, so that the spectator standing below sees with every move of his body a different group of tesserae reflect the light. Thus the resplendence of the mo-

saics seems a vital, living thing, but glorious beyond earthly splendor.

Byzantine artists set their sacred figures against golden backgrounds, empty except for the sacred monograms on either side. In Byzantine art the figures are usually identified by lettering in the mosaic or in the painting, but whereas the names of mortals and saints are fully spelled out, Christ and Mary are identified by their signets; that is, only the first and last letters: IC XC=Jesous Christos. These contractions are not made in order to save space but from reverent awe of the name. In our present culture we seldom find anyone who feels a religious reverence, or perhaps a magical power, attached to a name. But this was characteristic of the Jewish tribes of the Old Testament, and it was especially true of the Byzantine world. Byzantine theologians believed that whoever pronounced the name of another took possession of him. Thus to name the Godhead in full would be to lay hands on him. So the sacred names are merely referred to through the signets noted above. Awe of that which is holy, and the absolute otherness of the holy, are part of Byzantine theology, and thus of their religious art.

Byzantine art was not restricted to the hieratic and powerful image of Christ. Most of the Gospel events as well were represented but in a nonnaturalistic way. THE NATIVITY (plate 12) in the Palatine Chapel at Palermo shows the kind of iconography and style used for such scenes. Beginning with the focal area of the mosaic, we see Mary the Mother of Jesus Christ seated, or perhaps reclining, on an oval mattress. Between her hands she clasps the Christ Child (note the cruciform halo) who is wrapped diagonally in swaddling clothes and half reclines against his mother while lying in a strange, architectural structure, more nearly like an altar than like a crib. With their heads arched over the child but their eyes on the spectator, an ox and an ass adore the child. The star is directly above this central group and sends a shaft of radiance directly down on the child. The figure next in size to that of Mary is the elderly man seated on a lattice-work chair in the lower left. He rests his cheek upon one hand contemplatively, but he too, like almost every person in the mosaic, gazes out at us. This is Joseph, who is always represented as an old man in Byzantine and medieval art. Here he is

given dignity, and though he is placed at one side, he seems physically and spiritually related to the main event. It is interesting to note that in late medieval and early Renaissance art Joseph is often depicted as senile and dottering, and frequently is fast asleep. It was thought that only a very old and senile husband could have a young and lovely wife who bore a child which he had not begotten. The kind of thinking which resulted in this fanciful yet essentially human embroidering of the stark records in the Gospels is seen in a number of pseudo-gospels in the early centuries. These writings—The Proto-evangelium of James and the Gospel of Pseudo-Matthew—come to us from Oriental sources. Despite the fact that they had been generally rejected as being outside the New Testament canon, artists continue to draw upon them for details in filling out the Gospel narratives.

It is from these sources that the artist derived the image of the cave. Also, the episode shown in the lower right, where the Christ Child is seated in a peculiarly unchildlike fashion upon the knee of the midwife Salome (whose story is told in detail in the Proto-evangelium of James) while a second midwife pours water into the basin, is entirely from these apocryphal sources. In the upper left we see three angels, and beneath them three men on horseback with small round crowns upon their heads—the three Magi from the East. The Magi appear again at the middle right, presenting their gifts. Only two are visible in our plate, but the scene continues on the adjacent wall and the third Magus, as well as the shepherds to whom the angel in the upper right is announcing the divine birth, is also present in the continuation of the composition. Thus in one composition several events are depicted—the Nativity, the Washing of the Child, the Journey of the Magi, the Adoration of the Magi, and on the adjoining wall, the Adoration of the Shepherds.

Both the visible and invisible worlds are represented as adoring the Christ Child. The ox and ass, which are closest to the child, represent the recognition by the animal kingdom of the Incarnation. The three Magi coming from the East were presumably Gentiles and represent that part of the ancient world. The Anglican Church calendar commemorates this event as "the Epiphany, or the Manifestation of Christ to the Gentiles,"

and in the *Book of Common Prayer* the collect for the day starts, "O God, who by the leading of a star didst manifest thy only begotten Son to the Gentiles." As for the shepherds, they were no doubt Jewish shepherds from the nearby hillside, and they represent this segment of the religious populace of the ancient world. The angels are, of course, "the heavenly host praising God and saying, Glory to God in the highest, and on earth peace among men with whom he is pleased!" Jew and Gentile, the animal kingdom and the heavenly hosts, join in adoring the only begotten Son.

These events could not have been contemporaneous, and yet here they are depicted within one composition. Time is again shown as the time of eternity, and it is not confined to time as we experience it in terms of past, present, and future. Space, in the mosaic, like time, is in no way related to our experience of it. The Magi appear far away as their horses prance on the green hillock at the left, but when they appear at the crib with their gifts, they are no larger in size than when they were far distant. They are, in fact, very little larger than the Christ Child. Each separate episode has its defined space, and the separate spaces are put together like a picture puzzle. The result is a most interesting pattern but one lacking spatial unity. The rounded line denotes a hill, the jagged dark opening a cave, and the queer anvil-topped shapes such as we see above the cave derive from ancient manuscripts, and came to symbolize mountains and rocky terrain. Many of the symbols for natural forms are as abstract as the inscriptions and monograms that appear in the composition itself. These symbolic forms are a key to this art; it is a kind of pictograph—an assemblage of symbols with specific meanings which must be interpreted to fully receive its meaning.

However, if our enjoyment of Byzantine art depended wholly upon our reading of its symbolic content, this art would not have been admired by theologians, scholars, and the visitors to the Byzantine centers of Ravenna, Istanbul (Constantinople), and Palermo, as one of the greatest styles of Christian art. Aside from its very special language of forms, it communicates to us through the grandeur of its imagery and

the glory of its color and design. We shall see too that Byzantine art kept alive in the eastern part of the Western world some of the heritage from Greece at a time when the rest of the world was embroiled in conflicts that caused the period of cultural quiescence which we popularly call the Dark Ages.

THE ART OF THE MEDIEVAL PERIOD

Romanesque Art

Turning from the majestic CEFALU CHRIST (plate 11) with his sorrow-
ing, compassionate gaze to the Christ in THE PENTECOST, a tympanum [1]
at Vézelay, France, (plate 15), we seem to enter another world. The
suavity and grandeur of Byzantine art make some examples of Roman-
esque art seem crude, yet full of a vitality which almost bursts the limits
of the composition. Byzantine art presents groups of figures as so many
isolated beings near each other but with no relationship to each other be-
yond that of gesture. In Romanesque art the groups are bound by in-
tense emotional reaction to the event. Here in the scene of THE PENTE-
COST, or the Descent of the Holy Spirit, the power given to the apostles
is made concrete in rays emanating from the enormous hands of Christ.
The recipients of this power do not sit motionless, but rise and leap and
are physically moved by the spiritual power that is visited upon them.

The intense sense of vitality and the violent distortions of the body
which we see in the Vézelay PENTECOST are characteristic of Romanesque
art. In order to understand the art of this period we must turn for a
moment to the historical scene. Whereas the eastern empire enjoyed a de-
gree of cultural stability during the period between the founding of
Constantinople in 330 and its conquest by the Turks in 1453, the west-

[1] A tympanum is the masonry area below an arch and above a door. It is often sculptured
as is this tympanum at Vézelay.

ern part of the empire suffered the invasions of the northern barbarian tribes, weakening the political, social, and economic structure, and resulting in a period of cultural quiescence between about 500 and 1000 known as the Dark Ages. During this period the papacy took the place of the Roman Empire, and it was in the churches and monasteries that the cultural heritage of the past was preserved. Poor roads and communications led to the isolation of large areas. In this situation local differences flourished, and the national languages—Italian, French, Spanish—grew away from their Latin source. Local, and eventually national, differences are to be found in Romanesque art. As a style it is not homogenous. All Byzantine art of whatever period or place has certain common characteristics. But in Romanesque art we see to varying degrees classical, barbarian, and Byzantine elements welded together to create new forms of expression, which manifest different characteristics in different localities.

We define Romanesque architecture as resulting from a mixture of northern barbarian and Mediterranean classical elements. This is true of some of the sculpture, also. However, we have only to look again at the classical Apollo of Olympia and then at the northern Christ of Vézelay to realize that, in every respect, one is the antithesis of the other. There is no classical influence whatsoever to be found in the ecstatic and violent composition of the descent of the Holy Spirit. Whereas Apollo has an urbane air of dignity and command, this Christ is a kind of dynamo of energy. Apollo is a freestanding figure of carefully calculated, ideal proportions. Christ of Vézelay has a body—if one can call it such—of pipestem construction; if he were to stand erect, he would be immensely tall, and tubelike in form, with hands which are larger than his small oval head. Whereas a minimal amount of the body of Apollo is covered, the Vézelay Christ is entirely swathed in garments. The toga has folds which cascade about the shoulders and form exciting vortex-like patterns as they sweep across the thigh, creating a whirlpool of movement there, and fanning out into a myriad of folds below.

The apostles grouped about the Christ on either side show the same distortions and similar intense and unnatural positions. Time has ob-

literated some of the faces, but we can recognize Peter at the right of
Christ by the two immense keys which he carries. They recall the words
of Jesus to Peter, as recorded in Matthew's Gospel: "I will give you the
keys of the kingdom of heaven, and whatever you bind on earth shall
be bound in heaven, and whatever you loose on earth shall be loosed
in heaven." [2] Two keys have become symbolic of Peter's role and he can
usually be identified by this attribute. Another detail of iconography,
now encountered for the first time, is the *mandorla,* or large oval-shaped
area which encloses the figure of the Christ. It has the same significance
as the halo or nimbus, a radiance which shows the glory of the Lord. It
is used in medieval and Renaissance art in events such as this where
Christ's presence at the event is not to be interpreted as a physical
actuality.

We noted in connection with Byzantine art that the choice of sub-
ject matter was indicative of the particular religious focus of the age
represented. Byzantine art represented the Christ of all time, the Alpha
and Omega, the beginning and the end. The CEFALU CHRIST has the
majesty of the creator of the universe and the power of him who, in the
words of the Te Deum Laudamus, we believe "shalt come to be our
judge." The Christ of Romanesque art is either the dominant and
transcendent presence in a scene such as THE PENTECOST; or the Christ
of the Apocalypse seen in glory in heaven and surrounded by the sym-
bols of the four Evangelists; or the Christ who as judge rules over the
separation of the elect from the damned at the Last Judgment. All
of these subjects are supernatural subjects of visionary and mystical
events.

The nonnaturalistic character of the style is appropriate to this type
of supernatural subject matter. The most obvious unnatural element in
the Romanesque style is the *distortion* of the forms. Since we shall meet
varying degrees of distortion in each period, it is important to discuss
the significance of this means of artistic expression for a moment.

All art has a degree of distortion within it. One could argue that the
way in which the Greeks composed their ideal figures is a distortion of

[2] Matt. 16:19.

the particular models which they used, and this would be quite true. But is there *any* norm in nature? If we could establish, after studying the proportions of many persons in a particular culture, the average height, weight, waist measurement, et cetera, we would still have only average calculations which would not be true of one individual in a thousand. Thus an average or representative figure is as abstract a concept as an ideal figure. Each age has its own vision of beauty of proportion, that is, its own ideal figure. Each of these changing ideals is, to some extent, a distortion of the human form as we see it in everyday experience.

The Byzantine Christ too is distorted, with its immense size, the flattening of all the forms, and the abstract pattern made by the lines which give *modeling;* that is, the rounding out or hollowing in of the shapes. These are nonnaturalistic and distorting. But none of these characteristics is carried as far as the distortions of the Christ at Vézelay. All Byzantine art retains a kind of recollection of classical art which gives a unity to the figure and restrains the tendency to distortion.

When radical distortions of the human figure are employed, it is usually because the artist intends to communicate an *idea* or an *emotion.* If this is his intention, the human figures are not important in themselves but only as bearers of the artist's intended idea or emotion. If the artist is more interested in conveying an emotion or an idea to us than in describing the figures and objects naturalistically, we call his style *expressionistic.*

When we are confronted with distorted forms, we must judge their aesthetic value in terms of their effectiveness in expressing the underlying idea or emotion which the artist intends to communicate. We must not judge them by comparing them with naturalistic art or with the data of our visual experience. Thus, the objection made by many to radical distortion—"But people don't *look* like that!"—is entirely irrelevant.

Radical distortions of the human figure, particularly when coupled with a heightened religious fervor on the part of the artist, often result in an intensity and dynamism in the work of art that grips and

shakes the beholder. This dynamism makes its impact on us through our emotion rather than through our intellect. Examples of distortion and dynamism in modern art, as in Emil Nolde's ENTOMBMENT (plate 72), parallel the techniques which we see in the Vézelay tympanum. Indeed, we might say that the abstractions and distortions exhibited by modern artists have made it possible for us to see and to appreciate Romanesque art in a way that was not possible for nineteenth-century critics whose ideals were nurtured on naturalistic norms. Byzantine and Romanesque art are appreciated and understood far more in our day than they were in the nineteenth century.

Most of the Romanesque sculpture extant today is related to architecture, like the tympanum at Vézelay which spans the double portal of the Church of La Madeleine. A few sadly damaged Romanesque frescoes remain in the churches built in the eleventh and twelfth centuries, or have been removed and placed in museums. The other pictorial art form extant from this period is the brilliantly colored illustrations for prayer books and Bibles created in the monasteries of the various religious orders.

A beautiful example of this kind of illuminated manuscript is the Berthold Missal, made in the early twelfth century at the Weingarten Abbey scriptorium. Weingarten Abbey was located in the Diocese of Constance in central Europe near the lake of Constance. There in the scriptorium carefully trained scribes copied the prayers used for celebrating the Mass. The scribes adorned their pages with decorations of all kinds, more correctly referred to as illuminations. Rather than "illustrating" the text, these small paintings illuminate or "light-up" the gray parchment and black ink of the text. The purpose of an illustration is to clarify the text, but that of the illumination is to beautify the text. To this end the illuminator used all of the colors of the rainbow and burnished gold and silver as well.

THE LAST SUPPER from the Berthold Missal (plate 16) is an example of such an illumination. The iconography of this scene is interesting. Christ, located at the top center of the composition, is clasping with one hand the head of a figure which reclines against him, and

with the other is placing a light-colored object in the mouth of a figure leaning tensely forward. Turning to the Gospel of John, we read:

When Jesus had thus spoken, he was troubled in spirit, and testified, "Truly, truly, I say to you, one of you will betray me." The disciples looked at one another, uncertain of whom he spoke. One of his disciples, whom Jesus loved, was lying close to the breast of Jesus; so Simon Peter beckoned to him and said, "Tell us who it is of whom he speaks." So lying thus, close to the breast of Jesus, he said to him, "Lord, who is it?" Jesus answered, "It is he to whom I shall give this morsel when I have dipped it." So when he had dipped the morsel, he gave it to Judas, the son of Simon Iscariot.[3]

The disciple whom Jesus loved has always been thought to be John himself, that is, John the Evangelist. Legends have told that John was a younger blood relative of Jesus, and consequently we often find John represented as a young and handsome man whose features are almost the same as those of Jesus. In this manuscript illumination we see that John is the only one of the group whose hair, like that of Christ, falls smoothly from a center part with a double forelock at the part, the latter being a detail showing Byzantine influence. The CEFALU CHRIST also has a double forelock. The type of Christ here represented is nearer to the Byzantine CEFALU CHRIST than to the Romanesque Christ at Vézelay.

Why should a manuscript illustration made in Weingarten in central Europe about fifty years after the CEFALU CHRIST in Sicily show similarities to this Byzantine mosaic? The ways in which style and iconography migrate from one part of the world to another are never fully known to us, and we are often in the position of having to accept hypotheses to explain the connection between specific works of art, rather than being able to document the connections. In general we may say that because illuminated manuscripts were relatively small in size, and therefore portable, they could be taken from one monastery to another and were sometimes rather freely copied, thereby increasing their dissemination. The church in the West was still one church, and knowledge and skills passed as freely from one part of the church to another as the poor roads

[3] John 13:21-26.

and difficult transportation would allow. It is quite possible that the artists of the Berthold Missal had seen Byzantine manuscripts which were like those that the artist of the Cefalù mosaic knew.

The apostle at Christ's right hand is Peter here without the keys, but identifiable by his tonsured hair and short beard. His hand is raised as he beckons to John to ask him of whom Jesus had spoken. John is indeed "close to the breast of Jesus." The figure who leans intently forward with mouth open to receive the morsel must, of course, be Judas. Note how the artist has differentiated the apostles. Each has a pose and gesture unlike the others, and hair color and style varies throughout. Rather delightful is the way in which the apostle at the lower right seems to finger his beard thoughtfully, and the one at the middle of the table at the right clasps his hands as he sits quietly and broodingly by himself, isolated from the turbulent and crowded circle about him.

Conspicuous among the objects on the table are two serving dishes with fish. It will be recalled that the miracle of the feeding of the five thousand with two fish and five loaves of bread was interpreted by the early church as a symbol of the Eucharist. Here we see the fish in THE LAST SUPPER. If we reread one of the last events described in John's Gospel we encounter a reference to the fish:

Just as day was breaking Jesus stood on the beach. . . . The other disciples came in the boat, dragging the net full of fish for they were not far from the land, but about a hundred yards off. When they got out on land, they saw a charcoal fire there, with fish lying on it, and bread. . . . Jesus said to them, "Come and have breakfast. . . ." This was now the third time that Jesus was revealed to the disciples after he was raised from the dead.[4]

The connection between this post-Resurrection event and the Last Supper, and its commemoration in the Eucharist, was made by the early church. Prosper of Aquitaine spoke of Christ as "giving Himself as food to the disciples by the seashore, and offering Himself to the whole world as *Ichthys* [fish]." [5]

[4] John 21:4-14.
[5] Walter Lowrie, *Art in the Early Church* (New York: Pantheon Books, 1947), p. 74.

Another interesting detail of iconography is the halos of the apostles. Note that only four of them have halos. What could be the reason for this seemingly arbitrary decision on the artist's part? If we look for a moment at Giotto's fresco of the same subject (plate 24), an answer is suggested. Giotto wished to be consistent in his use of halos and in his spatial arrangement. With a naïve and delightful ingeniousness, Giotto put the halos of those with their backs to us in front of their faces rather than behind them as was customary. The medieval artist, who had none of the penchant for consistency and none of the interest in depth which distinguishes the art of Giotto, simply did not use halos where they would overlap with other figures or the table.

The artist of the Berthold Missal represented space arbitrarily rather than naturalistically. The table top is tipped up before us so that we see almost its complete circumference; it looks as it would if we the spectators were above the table. Yet each one of the apostles and the Christ are seen as if directly in front of us. This device allows the artist to present as much as possible of each person or object. This clarity of individuals and things is more important to the artist than representing the group as we would see them were we in the same room.

As a matter of fact, the idea of representing a group as we see them in relation to a specific environment is rather sophisticated, and it is a late development in the history of Western art. Giotto's first attempts in this direction were made a hundred years after the Berthold Missal, and it was three hundred years after this missal before Leonardo da Vinci achieved a harmonious and coherent illusion of reality in his LAST SUPPER in Milan, with its life-size figures and perfect rendering of mechanical perspective.

The unity of composition which Leonardo achieved was accomplished through an exceedingly skillful use of mechanical perspective and the balancing of forms around the central point of his painting. The unity of the little manuscript illustration is derived from the wheel-type design. The table has several concentric gradations of color around a central light area. This light area is a kind of vacuum around which are focused the expressive gestures and intense attitudes of the figures.

The heightened intensity of feeling which we have seen in the illumination of THE LAST SUPPER from the Berthold Missal and the Vézelay PENTECOST is characteristic of Romanesque art. In the thirteenth century this intensity gave way to a new harmony and serenity in the art of the Gothic period.

The Gothic Age

In the thirteenth century a new spirit entered Christian art. The violent distortions and robust vitality of Romanesque art were replaced by the majesty, the serenity, and the lyricism of Gothic art. The subject matter of Romanesque sculpture was mystical and ecstatic whereas the Gothic sculptor created scenes which showed the earthly events of Jesus' life, dwelling especially upon the events in which Mary the Mother of Jesus participated. Mary's life prior to the Annunciation was also depicted, and all the infancy scenes were frequently represented.

This shift in subject matter is somewhat related to the fact that in the Romanesque period religious life and leadership were most typically represented by the monastery, while during the Gothic era the focus of religious life shifted to the cathedrals and city churches. Visionary and mystical scenes were appropriate to the monastery. However, with the beginning of the Gothic period, the construction of the great cathedrals was undertaken. These cathedrals visually and spiritually dominated the towns and cities serving the surrounding populace. The events from the life of Jesus and of Mary and the stories of the Old and New Testament were closer to the lives of the farmers and millers who lived near Chartres or the townspeople of Reims and Amiens than were the mystical scenes of the monastic churches.

The art of the medieval cathedral was a great encyclopedia of religious thought symbolized in stone. The Gothic cathedral has been called the Bible of the poor, for those who could not read could yet see the content of the Bible in the wood and stone carvings and in the stained glass of the cathedral windows.

The identification of many of the figures and biblical scenes is difficult

for most of the visitors to these cathedrals now. But at the time of the
cathedrals' construction and throughout the medieval era the symbolism
was familiar to most worshipers. Émile Mâle speaks of how the fa-
miliarity of successive generations with the Bible, and with the interpre-
tations of the theologians, led to a situation in which the imagery of the
works of art was the result of a collaboration between "the mind of the
theologian, the instinct of the people and the keen sensibility of the
artist." [6]

The façades of the great cathedrals have large triple portals, and often,
as at Chartres, the two transepts have elaborate entrances. The north
porch at Chartres, for instance, has a triple portal with the Triumph
of the Virgin in the central tympanum. This scene, which is related to
the Assumption of Mary as described in a letter traditionally attributed
to St. Jerome, had multiple meanings for the medieval church. Medieval
theology established a parallel between Mary and the church. She was
both Virgin and Mother of Christ. And since she was chosen as the
vehicle of the Incarnation, she was considered to be the bride of God.
The early fathers of the church had interpreted the Song of Songs as
the loving union between Christ and the church, or between Christ and
the faithful. And later the bride in Solomon's nuptial song was taken to
refer to both the church and the Virgin Mary. Thus we must interpret
Mary's position in the tympanum above the central door at Chartres
in this wider context of meaning. On either side of the doorway which
Mary's triumphal scene dominates are ranged a row of solemn figures
(plate 17). Whereas she represents the church, these Old Testament
figures foreshadow the New Testament, and tell of the coming of Christ.
Thus, as Mâle said,

On the very threshold [of the cathedral] the saints of the Old Testament
proclaimed the Messiah and became, as says St. Augustine, "heralds of God."
In the north porch at Chartres Melchizedek, Abraham, Moses, Samuel and
David stand at the entrance to the church. These great figures must be counted
among the most extraordinary of mediaeval statues. They seem to belong to

[6] *The Gothic Image* (New York: Harper Torchbooks, 1958), p. 4.

another and a more than human race, primitive beings coeval with the dawn of the world. The art of the beginning of the thirteenth century, unskilful in rendering individual character, gave noble expression to all that there is of universal or eternal in the human form. The patriarchs and prophets of Chartres seem like true fathers of the race, pillars of humanity, but how much do they gain in grandeur and mystery as precursors of a greater than themselves. They form as it were a *via sacra* which leads up to Christ.[7]

Each of these figures was taken to be a type of Christ. The medieval theologians followed the tradition of Old Testament interpretation which had originated in the early centuries in Alexandria, was expressed in the writings of Origen and Clement, and then in the sermons of Ambrose and the writings of Augustine. A compilation of the traditional allegorical explanations of the verses of the Bible was issued in the tenth century, the *Glossa Ordinaria.* This book, which was an important source for the medieval theologians and artists, is helpful in understanding the ABRAHAM AND ISAAC statue (plate 18) at Chartres in accordance with the intention of the statue's anonymous creator.

The *Glossa ordinaria* teaches first of all that Isaac is a figure of God the Son, as Abraham is a figure of God the Father. God, who gave His Son for mankind, willed that the people of the Old Covenant should catch a faint gleam of the sacrifice yet to be. . . . The three days' journey which separates Abraham's dwelling from Mount Moriah signifies the three epochs in Jewish history— from Abraham to Moses, from Moses to John the Baptist, and from John the Baptist to the Saviour.[8]

At Chartres, Abraham is seen at the moment when "the angel of the Lord called to him from heaven, and said, 'Abraham, Abraham, . . . Do not lay your hand on the lad or do anything to him; for now I know that you fear God, seeing that you have not withheld your son, your only son, from me.' "[9] The angel is seen in the canopy above the neighboring statue of Melchizedec. The urgent gesture of the angel's arm and the downward thrust of his head, as he beckons to Abraham, communi-

[7] *Ibid.*, p. 152.
[8] *Ibid.*, p. 141.
[9] Gen. 22:11-12.

cate something of the drama of the biblical text. The upward glance of
Abraham and his expression of deep sorrow are movingly delineated
(plate 19). Abraham's gesture with the hand which holds the knife
convincingly suggests an interrupted movement. The other hand tender-
ly clasps the head of Isaac, whose small body is pressed against the old
patriarch's body. The biblical passage tells of how Abraham bound his
son Isaac, and it is of interest that the Chartres sculptor shows the
boy's ankles as bound by a double cord, and carefully knotted. But
Isaac's hands are not bound. They are placed one across the other, as if
in obedient preparation for binding. Whereas the old Abraham's face is
full of sorrow, the young Isaac's expression is serene, and even has a
suggestion of a smile. The two figures (plate 19) stand upon the ram
"which was caught in the thicket by his horns," and which was pro-
vided instead for the burnt offering.

The essential columnar shape of the ABRAHAM AND ISAAC group was,
of course, dictated by the architectural complex of which it is a part.
The earlier sculptured figures which decorate the west portal of Chartres
and come from the Romanesque period have even more simplified and
column-like bodies, whereas the figures sculptured in the later thirteenth
century, after the ABRAHAM AND ISAAC statue, are almost free-standing
sculptures, though they still have an architectural canopy and base.
But their proportions are no longer dictated by the columnar shape, and
their bodies move more freely in an open composition. The statue of
ABRAHAM AND ISAAC is halfway between these two developments. Their
narrow bodies are contained within an essentially simple vertical shape,
and though the lines of the folds in their garments have a pleasant
variety of direction, they too echo the verticality of the whole. We have
only to look again at the Abraham and Isaac panel of the SARCOPHAGUS
OF JUNIUS BASSUS (plate 6), and examine the same episode as told by
figures in a rectangular composition, to see to what extent the sculptor
of Chartres has compressed his drama into a pillar-like form. This
simple vertical form is appropriate for the group, inasmuch as it is part
of an iconographic and architectural whole.

The ABRAHAM AND ISAAC statue at Chartres cannot be fully under-

stood without reference to the patriarchs and prophets who stand next to them, flanking the entrance to the north portal. Each of these figures bears a symbol

which announces Jesus Christ, which *is* Jesus Christ. Melchizedek has the chalice, Abraham rests his hand upon the head of Isaac, Moses holds the brazen serpent, Samuel the sacrificial lamb, David the crown of thorns . . . and Saint Peter, at the end, also has the chalice. Thus the mysterious chalice which appears at the beginning of history in the hands of Melchizedek reappears in the hands of Saint Peter. The circle is closed. Each of the figures is a Christ-bearer, a christophorus, transmitting from generation to generation the mysterious sign.[10]

One of the most famous Gothic sculptures, the statue of Christ known as the BEAU DIEU (plates 20, 21), is also part of an architectural complex. His majestic figure, which is considerably larger than life-size, stands at the entrance of Notre Dâme at Amiens. He raises his right hand in the ancient gesture of blessing. In his left hand, he holds the Bible, and beneath his feet are four creatures symbolic of evil: the thirteenth verse of Psalm 91 is the source for these creatures:

> You will tread on the lion and the adder,
> the young lion and the serpent you will trample under foot.

This subject is known as the Christ Triumphant, the Christ who by his sacrifice of himself triumphs over evil. We find representations of this Christ in early Christian and Carolingian[11] art as well. It is interesting to note that these earliest examples of Christ Triumphant are related to Egyptian representations of the god Horus, who tramples upon the crocodiles, which are also symbols of evil. Carved upon some of these reliefs of Horus is the inscription, "Trample under foot the crocodiles and master without effort the lion, serpents. . . ." So the literary

[10] Émile Mâle, *Religious Art from the Twelfth to the Eighteenth Century* (New York: Pantheon Books, 1949), p. 77.

[11] The art of Charlemagne's time. He ruled as king of the Franks 768-814, and as Charles I, Emperor of the Holy Roman Empire 800-814.

source too bears a resemblance to the psalm that inspired the Christ Triumphant.

In this "Beautiful God" we find a wonderful balance between naturalism and abstraction. The features are almost exactly symmetrical, but the face has just enough variation between one side and the other to prevent its appearing geometric. And yet there is a definite tendency toward abstraction, toward the triangular or pyramidal form in the eyes, the nose, and the mouth. But this tendency is not carried so far that the shape of the eye, for instance, is perceived as a triangle rather than as an eye.

In this balancing of the conflicting tendencies toward naturalism and abstraction the BEAU DIEU is similar to the Olympian APOLLO (plate 4). Whereas the triangle is the abstract form suggested by the contours of the BEAU DIEU, circular and oval forms are suggested by the APOLLO. We note that the APOLLO's drapery merely provides an angular contrast to the curves of the nude body, but the Christ of Amiens is completely sheathed in heavy garments, only his head, hands, and feet being visible.

The Christ here represented (plate 21) is also the bearded type with flowing hair and large eyes directed toward the beholder. Originally, of course, the pupils were painted, as were the garments and the book. His expression is serene. Although there is a suggestion of severity about the sharp nose, the potentiality of movement in the mouth with its fine, soft mustache, and a beard which clings about the full and rounded chin beneath, gives a human warmth to the face.

Though the BEAU DIEU stands at the portal of the Cathedral of Amiens, this cathedral, like so many Gothic buildings, was dedicated to Mary, the Mother of Jesus. Mary was the most honored and loved of all the biblical figures by medieval man. Artists and poets chose the most precious and most exquisite things in nature as metaphors for her. For some centuries the fathers of the church had identified Mary with the sensuous Sulamite in the Song of Songs, and so the Eastern imagery of this Old Testament love poem became connected with Mary. Yet as Mâle remarks, what is sultry in the Song of Songs became as chaste as water in the Christian interpretation,

and the contrast between text and illustrations is at times so sharp that it has the impact of great poetry. "A bundle of myrrh is my beloved," [the *Song of Songs* declares,] "he shall abide between my breasts." And the [artist's rendering of this passage] shows us the Virgin standing, clasping to her breast her crucified Son.[12]

There is a great range of types in the representations of Mary in Gothic art. But peculiar to this period is the slender, maidenly Mary who with an unmixed, celestial joy embraces or lightly holds the laughing child (plate 22). The two seem to exist only in and for each other. All remembrance of the recognition of the old prophetess Anna or the prediction of Simeon ("A sword shall be thrust through your heart")[13] is banished from the young mother's mind. The recollection of the anguish of birth and the pangs for the tenuousness of life, which cast shadows over the most joyous moments for the mortal mother, are unknown to this young mother. She exists in a perpetual springtime, without knowledge of past or future, a smile on her face "which is born from within and seems the reflection of an inward blessedness."[14]

All of the meaning of the BEAU DIEU is concentrated in the fine face, and we are entirely unaware of the physical body which supports the simple heavy garments he wears. But the small ivory MADONNA AND CHILD of Orleans (plate 22) possesses a marvelous unity of being. The body is not subdued by the spirit, nor the spirit degraded by the flesh— the whole is luminous with spiritual and physical grace. Her entire body undulates as she moves lightly forward toward us. And lightly in the palm of her hand she holds the Christ Child, who with a playful and tender gesture caresses her chin. Her head is turned toward the child and in her heart-shaped face we see a type of feminine beauty quite unlike the classical one which predominates in Italian art. She has a Gallic breadth of brow, small eyes wide-set, high cheekbones, and a small round chin.

She, like the BEAU DIEU, is heavily garbed. But the deeply undercut

[12] *Religious Art from the Twelfth to the Eighteenth Century*, p. 134.

[13] Luke 2:35.

[14] Wilhelm Worringer, *Form in Gothic* (New York: Shocken Books, 1957), p. 176.

cloak provides a counterpoint to the poignant crescent curve of the fragile and girlish figure. We are aware of her body through its movement as a vital, graceful, delicately balanced organism; this is in marked contrast to the understanding of the Italian sculptors of the body. The early Italian sculptures emphasize the body as a three-dimensional volume, and later, at the time of Donatello's PENITENT MAGDALENE (plate 30), the body is seen as an anatomical structure of bone and muscle and flesh.

If we contrast the open right hand of the Orleans Madonna with the hand of the Mary of Michelangelo's PIETA (plate 39), we see interesting differences. The Orleans Madonna's hand is childish, both in proportion and in its simplicity of gesture. Michelangelo's Mary is also very young. Yet her hand is complex in the differing curve of each finger and in the clarity of the joints. But more than this, her gesture has depth of expressiveness. We may see an analogy in the difference between the experienced actress who gives maximum meaning to each gesture and the inexperienced but charming young actress whose spontaneity lends an overall grace to her movements. Each is expressive, but in a different way.

The tender radiance of the Orleans MADONNA AND CHILD is a characteristic often found in Gothic representations of Mary. The Byzantine artist pictured Mary in her theological role as Mother of God. In the mosaic at Palermo (plate 12) she and the Christ Child both stare out at us impassively, and, though she holds his body between her hands, there is no emotional relationship between the two. If we contrast the Orleans Madonna with a modern work of art such as Henry Moore's MADONNA AND CHILD (plate 23) the inner meaning of each is made more clear. The expression of anxiety on the face of the Moore Madonna, the way in which the mother holds the child protectively back against her body, is underlined when we look from it to the Orleans Madonna, who holds the child with such playful assurance, so lightly in the palm of her hand. In the little Gothic statue the two seem to have their being in each other in a paradisal oneness.

Style and Its Significance

The term "style" has been used with considerable frequency without definition. Since it is difficult to give a succinct yet meaningful definition, it is well for us to have a specific group of works in mind for our generalizations. C. R. Morey speaks of style as being "the imprint on artistic expression of a point of view, be it the point of view of an individual, an epoch, or a race." [15] For a race or epoch to have a point of view it must have a cohesiveness, such as we find in the three styles we have discussed, classical, Byzantine, and Gothic. We have also talked of early Christian art and Romanesque art, but each of these designations relates more accurately to the historical time when these works of art were created. There are many and diverse influences at work in the art of both of these periods, so that there is, for instance, no such thing as an "early Christian style," but a multiplicity of works of art which show connections with the classical or Byzantine styles but do not have enough common characteristics to form a distinctive group.

The artists of the Byzantine mosaics dematerialized the body by flattening it, by covering it with elaborate drapery, and by representing the figure and physiognomy with a tendency toward abstraction. The body is subordinated to the spirit in Byzantine art. Through the great shimmering diagrams of the human figure and the sacred signs and symbols shines the radiance of "divine energy," and the divinity of Christ soars over everything.

The Gothic artist represents the human form naturalistically, but with a spirituality which balances the sensuous elements of the body with the upward lyrical movement of the soul. In the Gothic period we see Christ and Mary in their humanity, as in the Orleans MADONNA AND CHILD.

Style is not a static thing which is born full-blown. It is ever evolving and changing. In its great historical manifestations it seems to develop and decline in a kind of cyclical pattern. In Greek art a period of primitive and abstract art preceded the classical fifth century art—repre-

[15] *Christian Art* (New York: W. W. Norton & Co., 1958), p. 45.

sented by the APOLLO (plate 4)—in which formal and abstract elements perfectly balance the naturalistic elements. This is followed by a period of greater sensuousness, then by an interest in psychic and emotional states, and finally by a period of the dissolution of forms. Analogously, in Gothic style we can view Romanesque art as the abstract phase of this cycle, the balance of abstraction and naturalism achieved in LE BEAU DIEU as the point analogous to fifth-century Greek art, and the Orleans MADONNA AND CHILD as a lyrical counterpart of the sensuous phase of Greek art. Along these lines the analogy could be continued.

The interesting point here is the metamorphosis which takes place in styles as such, the artist being the instrument for this change. He is a determining factor in the development of style, but his art is determined by past and prevalent styles.

In the Gothic era one of the most dramatic evidences of the growth principle which seems to exist in the development of a given style is seen in the sculptured architectural detail of the great cathedrals. In the earliest Gothic cathedrals, artists carved the budlike forms of unopened leaves on the column capitals. The cathedrals built some years later have capitals which are decorated with the luxuriant forms of the unfurled leaves. Still later, we find autumnal leaves with their edges ruffled and sered carved on capitals. Were the successive artists conscious that these choices were related to each other, that is, to the spring, summer, and autumn of the Gothic style? Almost certainly not. The artist chooses from the infinite variety which nature puts before his eyes that which accords with his inner necessity. The sculptors of these phases of Gothic art knew the appearance of leaves in bud form, in full growth, and in incipient decay. But each, moved by what outwardly corresponded with his inner sense of beauty, chose the particular form he sculptured. The fact that these successive choices follow what seems to us a coherent line of development is an evidence of the mysterious cohesion and relatedness of that part of artistic expression which we call style.

A similar and rather delightful metamorphosis occurs in the development of tomb sculpture. In early medieval tombs the casket is covered

with a flat brass or stone slab on which the outline of the figure is incised (cut in). Somewhat later the figure is sculptured in low relief, later still in high relief. Then the figure of the deceased is shown as a "sculpture-in-the-round" and, rather than having its eyes shut, they are open, and the figure rises on its elbow and looks toward the spectator. The next chronological development is the figure sitting up, and finally in the seventeenth century the figure stands up. The coherent development which is evident within this particular art form is but one example of the structure and momentum which a particular motif or group of related motifs may possess.[16]

The relationship between a given style and a particular creative genius is exceedingly complicated. Heretofore we have been studying the style of works of art whose creators are unknown to us. The Orleans MA-DONNA AND CHILD, though the product of one man's skill and sensitivity, in a sense is the product of a corporate consciousness, the Gothic age. But in our study of the dawn of the Renaissance the style of the individual artist will be the focus. The first of these geniuses whose work we shall discuss is the great Italian artist Giotto. He lived and worked at the same time as the unknown sculptor who gave form to the MADONNA AND CHILD. But though he lived when Gothic art dominated the north of Europe, and his art shows the influence of Gothic sculpture, he initiated a new style in Florence, Padua, and Rome which was to culminate in the full flowering of the period we know as the Renaissance.

[16] This development can be interpreted as an iconographic change as well, but the coherent way in which the development occurs has to do with style, too.

THE RENAISSANCE IN ITALY

We have seen that Byzantine art was being created in Sicily, Italy, and the eastern Mediterranean, at the same time when Romanesque art was being created in western Europe. After the Romanesque period we find a differentiation between the style of the Mediterranean and the northern countries. But while the subsequent Gothic style and imagery continued in the north of Europe throughout the fifteenth century and later, Italian art, after the time of Giotto, moved in another direction.

Vasari, one of the first biographers of artists and himself a painter and contemporary of Michelangelo, tells an interesting story about the youthful Giotto. He relates how Cimabue, one of the great artists of his own day, came upon the boy Giotto

who, while his sheep were grazing, was drawing one of them from life with a roughly pointed piece of stone upon a smooth surface of rock, although he had never had any master but Nature. . . . [After this and] assisted by his native talent and taught by Cimabue, the boy not only equalled his master's style in a short time, but became such a good imitator of Nature that he entirely abandoned the rude Byzantine manner and revived the modern and good style of painting.[1]

Vasari's statement may seem puzzling today since we do not consider

[1] *The Lives of the Painters, Sculptors, and Architects* (New York: E. P. Dutton, 1927), I, 66.

the Byzantine manner rude, and we shall be disappointed if we search for "the imitation of nature" in Giotto's paintings. Yet Vasari's statement had a kind of truth to it. Though Giotto's genius is grounded in the tradition he inherited from both Gothic sculpture and monumental Byzantine art, we look upon him as the first painter of the modern epoch. A coherent line of development runs from his paintings through the art of the succeeding centuries until Manet and the impressionists of the nineteenth century. In a very special sense this coherent development has to do with "the imitation of nature." Giotto's technical developments and his contributions to composition and design were of the first order of importance. We shall explore Giotto's style by examining several of his frescoes which are in the Arena Chapel in Padua, Italy.

The Art of Giotto

In the small university town of Padua in northern Italy Giotto began work about 1304 on a series of frescoes for the Arena Chapel which was to become a milestone in the history of Christian art. Giotto was born in 1266, about the time of the creation of the Orleans MADONNA AND CHILD (plate 22). By 1300 he had already carried out several important commissions, one for the papacy at Rome, and a series of frescoes in the great basilica dedicated to St. Francis at Assisi. It is probable that Giotto left Rome in 1303 for Padua, and that he was commissioned soon thereafter by the notorious Enrico Scrovegni to decorate the walls of the chapel which Enrico had had reconstructed at the behest of the church. Enrico was the son of Reginaldo Scrovegni, whom Dante consigned to the seventh circle of his Inferno as an usurer. Since usury was a mortal sin, Reginaldo was debarred from confession while living, from burial in consecrated ground when dead, and his son lost the right to inherit his estate. Enrico, however, worked out a compromise with the authorities, part of the terms being his promise to renovate the Arena Chapel at his own expense. Since the chapel was on the site of an ancient Roman amphitheater it was called the Arena Chapel, but it is now referred to also as the Scrovegni Chapel.

Within easy walking distance of the chapel is the University of Padua, and it is probable that Dante strolled from there over to the chapel as his friend Giotto painted its walls with luminous frescoes. Dante and Giotto had been in Rome for the Jubilee of 1300, and the friendship which may have started then probably continued in Padua, where each was creatively employed. Certain of Giotto's innovations may have been discussed with Dante.

Before talking of Giotto's technical innovations, we must note the qualities which make his art not only great but imaginatively and emotionally gripping. It is appropriate that he is the first individual artist in this study. Certainly LE BEAU DIEU (plate 20) was also made by an individual sculptor, and the CEFALU CHRIST (plate 10) was the creation of one artist's vision and draftsmanship. Yet in a sense each of these works of art was a corporate production, a masterpiece created by an age and a people and a faith. There is a kind of impersonal detachment and objectivity about each of these works of art which cause our questions about each to center on the age and its faith rather than upon the individual artist who created the masterpiece. This is not the case with Giotto's paintings. We sense, and delight in, the personality of the man who created them. Deft touches of humor, imaginative storytelling additions, intensely dramatic confrontations—all the range of human emotions and human relationships are depicted in his art. We savor the wit, the insights, the skill of the artist. His style is first unique for him as an individual artist, and only after that representative of his age. We have referred to early Christian art, Byzantine art, and Gothic art, but from now on we shall speak of the art of Giotto, Leonardo, Michelangelo, El Greco. Giotto was one of the first of the great individual geniuses whose vision shaped the course of Christian art.

If we were to single out one characteristic which distinguishes all of Giotto's religious art, it would be his emphasis on human relationships. Whereas the Byzantine NATIVITY (plate 12) shows each of the participants isolated and staring out at us, Giotto in representing the same scene (plate 13) shows Mary lying upon a bed, raising herself on her elbow as the midwife puts the child into her arms. She peers into his face

tenderly, entirely unaware of our presence as spectators, or of those near her. The tenderness and the solemnity of the moment as the mother for the first time contemplates the newborn child are touchingly depicted by Giotto. Yet the epic significance of her role as the instrument of the divine will is present too. The welding together of the human and the divine dimensions of the Gospel events in a dramatic unity is Giotto's great gift to Christian art.

The Arena Chapel was dedicated to Mary of the Annunciation, and the subjects chosen by Giotto range from the apocryphal stories of Mary's early life, through the Annunciation and infancy episodes, the ministry of Jesus, and finally to the Passion and the Last Judgment. When contrasted with the Berthold Missal's LAST SUPPER (plate 16), Giotto's LAST SUPPER (plates 24 and 25) shows us his new viewpoint and objective. The most dramatic difference between the two is in their depiction of space. The artist of the Missal has as his objective the clarity of each person and detail. He is also governed by the medieval concern for the correct symbolic ordering of persons. In medieval art the highest place is the most important; thus Christ surmounts the whole composition and the other figures are lower than his. These considerations therefore determine the spatial arrangement in the manuscript painting.

But Giotto has asked himself how a group of people seated about a table in a room actually look. He has observed how a side wall recedes, meeting the back wall at an angle. There are still odd inconsistencies in Giotto's observations which jolt our sense of naturalness; for example, the spindly column at the right and the overly light roof. There are some problems which he is still incapable of solving and with which he deals quite arbitrarily. These astonish us; for example, the way in which the column at the right ceases to exist at the point where it would cover the head of the lower apostle, and the way in which the halos are placed in front of the faces of the apostles who are seated directly in front of us, with their backs to us. Nonetheless, other problems are solved by Giotto with daring. The way he places the focal area of the entire scene at the extreme left (plate 24) shows an originality and imaginative grasp of his subject matter which makes this a memorable

interpretation of the event. The heavy, repeated accents formed by the bodies and halos of the apostles move our eyes slowly to the point where a cluster of three noble heads form a foil to the fourth which is turned away from us. The fourth is Judas. Giotto has used Matthew's account of the Last Supper rather than John's Gospel, the latter having been used by the artist of the Berthold Missal. It is in the Gospel of Matthew that we read: "And as they were eating, he said, 'Truly, I say to you, one of you will betray me.' And they were sorrowful, and began to say to him one after another, 'Is it I, Lord?' He answered, 'He who has dipped his hand in the dish with me will betray me.' " [2]

The elderly Peter, the Christ at the age of thirty-three, and the young John represent three different ages of man. Though Giotto's depiction of the group may seem far from the naturalism of Botticelli and of Michelangelo, still one has the impression of a human being. The darkened area beneath the eyes and on the cheeks is achieved by shading (a gradual darkening of the color) rather than by the successive, geometric lines of Byzantine art. But more important than the technical elements is the suggestion of inner psychic life in the faces of Peter and Jesus. Peter's strong elderly features are worn by toil, and now seem drawn by anxiety and expressive of foreboding. Jesus' face shows a complexity of expression that still communicates to us that he knows and accepts the events of the hours to come.

The LAMENTATION OVER THE DEAD CHRIST (plate 26) is one of the most profoundly moving of the entire group of frescoes. Giotto has depicted the moment after the body of Jesus was taken down from the cross and returned to the arms of his mother. Mary here holds his body across her knees as she bends forward in anguish, peering into his face. With a poignant and beautiful gesture one of the other Marys leans over him lifting his lifeless hands in hers. Mary Magdalene is seated, clasping gently his wounded feet, perhaps recalling how she had washed them and dried them with her own hair. In Christian art Mary Magdalene became a compound of several of the women mentioned in the different Gospel narratives. One of these was Mary the sister of Lazarus

[2] Matt. 26:21-23.

and Martha, who, when Jesus dined with them, "took a pound of costly ointment of pure nard and anointed the feet of Jesus and wiped his feet with her hair." [3] Giotto depicts the Magdalene with the long flowing hair and the scarlet cloak which, together with the alabaster ointment jar, are her attributes in Christian art.

With a movement of overpowering beauty John the beloved disciple leans forward, his arms wingspread behind him, as he beholds the face of his Master. The dignified observer at the right is the old Nicodemus, "who had first come to him by night, [and now] came bringing a mixture of myrrh and aloes"[*] for the anointing of the body of Jesus. Giotto depicts him here in readiness with the shroud about his shoulders and across one arm.

The two figures seated with their backs to us, between us and the central group, are entirely anonymous persons whose function is to define the space between the beholder and the central group. Their heavy, massive bodies provide an effective psychological barrier also, lest we come too near the central group.

Certain characteristics of Giotto's art are sometimes disconcerting to those who meet them for the first time. The massive and sometimes graceless forms do not woo the eye of the beholder as Botticelli's figures do. Yet after studying the paintings for some time we become accustomed to Giotto's ponderous figures, and their expressiveness speaks to us.

Since Giotto was venturing into a new realm of expression, he tried some innovations which did not quite come off. Sometimes he seems bound by the restrictions of the past yet is uneasy with them; at other times he is very tentative in his exploration of new ways. In the LAMENTATION OVER THE DEAD CHRIST it will be noted that most of the faces are seen either in profile or in fullface. The slight turning of the head from the profile position exhibited by the faces of Mary and Jesus (plate 27) is a very tentative innovation. Giotto is typically and understandably more courageous in using unusual angles and foreshortenings when depicting the minor figures. In the group standing at the left note the

[3] John 12:3.
[*] John 19:39.

face of the woman between the open hand and the halo of the unveiled woman above Jesus. This face is turned obliquely down and away from us. In the sleeping soldiers of the NOLI ME TANGERE (plate 28) similar foreshortenings are explored with varying success. But even the unsuccessful attempts (the word "unsuccessful" is used here in regard to perspective rendering, *not* in regard to aesthetic worth) have a candor, an honesty, and an earnestness which make them touching and even expressive in their awkwardness.

The type of physiognomy Giotto uses is derived from ancient types. Even the women have mannish profiles reminiscent of the APOLLO of Olympia, with his long, straight nose and full, rounded chin line. The expression of grief on most of the faces derives from late classical sculpture. But this drawing back of the corners of the mouth is not the cliché that most of us are inclined to think. We base our notions of what a suffering face looks like on movie and television close-ups. But news photos taken as human beings experience the extremes of grief and pain show that the classical expression of grief is nearer actuality than the movie and television simulation. In the face of the dead Christ Giotto has achieved an image of pathos. Though the features seem based on sculptural form rather than on a living model, the half-open mouth and the eyes which are open yet sightless communicate an impression of death's finality.

The form or composition of the fresco is masterful. The entire design focuses about the point at the lower left where the heads of the mother and son meet and their halos intersect. Since every person in the scene is looking at these two, the beholder's eyes also are compelled to this point. But there are technical as well as psychological ways in which Giotto compels our eyes; the rocky ledge behind the group rushes downhill, pointing our gaze to mother and son. The persons at the right, the two Marys and John, direct us to the Christ by their impetuous movements. The solid group of mourners behind Mary and Christ halt our gaze and keep it fixed in this area.

The persons in Giotto's painting are represented on a narrow shelf of earth behind which a rocky ledge ascends sharply to the right. The

figures have a sense of breadth and of volume totally lacking in Byzan-
tine art. It is this characteristic which must have seemed most startling
and original to Giotto's contemporaries. It was not until over a hundred
years later that painters achieved the effect of a figure surrounded by
space. But Giotto's relief-like figures give a sense of monumentality and
massiveness which makes them "real" in one sense.

Giotto's greatness as a religious artist lies in the profound understand-
ing of the events which he depicts and in his inventiveness in expressing
this understanding. With breathtaking originality he invents the gesture
of John, which is as beautiful as it is expressive of unutterable grief. The
posture of Mary, with her arms entwined about her son's shoulders, her
fingers caressing his throat, seems almost an inevitable expression of
her anguish.

The grandeur of the painting is like the climax of one of Bach's great
Passion oratorios. A cosmic and universal disaster has taken place. The
intense passions of the participants are depicted and yet contained by
the grandeur and dignity of the art form. Bach and Giotto both show us
events through the hearts and minds of the followers and witnesses of
the event, rather than by focusing our attention solely upon the sacri-
ficial victim. By identifying ourselves with the followers and witnesses,
we imaginatively experience the events.

Equally moving, but in another emotional range, is the fresco known
as NOLI ME TANGERE (plate 28) or the appearance of Christ to Mary
Magdalene.[4] John's Gospel tells of Mary Magdalene's visit to the tomb
early Easter morning:

And she saw two angels in white, sitting where the body of Jesus had lain,
one at the head and one at the feet. They said to her, "Woman, why are you
weeping?" She said to them, "Because they have taken away my Lord, and I
do not know where they have laid him." Saying this, she turned round and
saw Jesus standing, but she did not know that it was Jesus. Jesus said to her,
"Woman, why are you weeping? Whom do you seek?" Supposing him to be
the gardener, she said to him, "Sir, if you have carried him away, tell me

[4] The words of Christ to Mary Magdalene are given in Latin in some translations of the
New Testament. "Touch me not," or "Do not hold me" are translations in common use today.

where you have laid him, and I will take him away." Jesus said to her, "Mary."
She turned and said to him in Hebrew, "Rabboni!" (which means Teacher).
Jesus said to her, "Do not hold me, for I have not yet ascended to the Father." [5]

Giotto shows us the tomb and an angel in white "sitting where the
body of Jesus had lain." And what a solid substantial angel this is, its
body like a great sack of meal! We also see the sleeping soldiers in front
of the tomb. And here Giotto's wrestling with the problem of fore-
shortening is conspicuous because he simply hasn't managed it success-
fully. The two soldiers who lean back against the tomb with their chins
in the air are not convincing. And the soldier who lies in the foreground
is like a department store dummy, lacking life or organic unity. But
there is a seriousness of intent in the depiction of the soldiers and angel
which gives them nobility despite the technical oddities.

The climax of the composition is the encounter of the two figures
at the right. It is the moment when Jesus makes himself known to Mary
Magdalene, and she, having fallen on her knees before him, reaches out
to him with a gesture of impetuous yearning. Giotto expresses this
through the gaze of the two, and perhaps even more by the three
beautiful hands—the hand of Jesus with its wound evident, outstretched
in a motion of gentle withdrawal, and Mary's two hands directly below
his. Hers are open and searching, with the gesture of a blind person
who would see and know with her hands. The absolute simplicity of
Mary's posture adds to the expressiveness of her profile and hands.
Her body makes an almost perfect equilateral triangle, and the line of
her draperies falls in a severe unbroken vertical from which the arms
and hands emerge beseechingly. She "out of whom he had cast seven
devils" tremulously greets her Master.

Roger Fry remarked that this fresco shows a power possessed by Giotto
more than by any other Italian artist, and more indeed than by any
other artist except Rembrandt—"the power of making perceptible the
flash of mutual recognition which passes between two souls at a moment
of sudden illumination." [6]

[5] John 20:12-17.
[6] *Vision and Design* (New York: Peter Smith, 1947), p. 109.

Although Dante and Giotto were friends, there is little evidence in the art of Giotto of the theology of the Dominican who influenced Dante, Thomas Aquinas. Giotto was far more influenced by the thought and the life of another great Christian leader, Francis of Assisi. Francis died in 1226, less than fifty years before the birth of Giotto. So great was his influence and the gratitude of the people that within twenty-five years of his death a great church had been built in his honor at Assisi. It was decorated with incidents from the life of Francis, and we know that Giotto was commissioned to create many of these frescoes, some of which were painted by his assistants. Assisi had been the home of Francis and later the location of the first Franciscan monastery. Living there while working on the frescoes, Giotto must have seen the very places where Francis had renounced all his wealth and espoused his "Lady Poverty," where he had preached to the birds, where he had converted the wild wolf of Gubbio, where he had received the stigmata, or wounds of Christ, upon his own body.

The followers of Francis brought out the human and poetical significance of the New Testament. It is these aspects of the New Testament stories that are emphasized in Giotto's art. He brings out the drama and the pathos of each of the events depicted in the Arena Chapel frescoes. Yet the humanization of the events is never at the expense of their ultimate significance. The human Jesus of Nazareth, who loved the young disciple John who "was lying close to the breast of Jesus," is also the Christ, "the lamb slain before the foundations of the world."

Giotto was born at Colle, but most of his artistic life was spent in Florence. He, like several other Renaissance artists, was an architect as well as a painter. Visitors to Florence are familiar with his famous bell tower that stands near the cathedral and baptistry in the heart of the city. Florence, as Berenson once said, was to continental Europe what Athens had been to the ancient world. Florence was to the fifteenth century what Paris was to the nineteenth century, and what New York is today to the intellectual and cultural world of the West. Indeed, all artists of whom we shall speak in this chapter except Piero della Francesca counted themselves Florentines.

For many decades after Giotto's death the art of Florence moved along the paths Giotto had first trodden. A little more than a hundred years after Giotto completed his Arena Chapel frescoes, a devout Dominican monk, known affectionately as Il Beato Angelico, painted a series of New Testament subjects on the walls of his convent, San Marco in Florence.

Fra Angelico's Frescoes at San Marco, Florence

San Marco had been recently rebuilt under the direction of the Florentine architect, Michelozzo, in a style which must have seemed strikingly modern to the eyes of his contemporaries. Rather than being massive and fortress-like, the new buildings were light in structure and appearance. The inner court of San Marco, with its curving, springing arches sustained by slender columns, was the expression of a new style of architecture. While it was in harmony with the classical architecture of the past and used the Roman architectural orders, it employed these elements with a freedom of design which heralded a new chapter in the history of architecture.

Over the lintels of the doors, in the corridors, on the refectory walls, and on the walls of the small closet-like cells, each used by a monk as a bedroom and study, Fra Angelico and his assistants painted scenes from the life and passion of Jesus Christ. Representative of this cycle of early Renaissance paintings is THE TRANSFIGURATION (plate 29). Mark's gospel relates how

Jesus took with him Peter and James and John, and led them up a high mountain apart by themselves; and he was transfigured before them, and his garments became glistening, intensely white, as no fuller on earth could bleach them. And there appeared to them Elijah with Moses; and they were talking to Jesus. . . . And a cloud overshadowed them, and a voice came out of the cloud, "This is my beloved Son; listen to him." [7]

Luke's Gospel says that Peter and those who were with him were

[7] Mark 9:2-4, 7.

heavy with sleep. And Mark relates that "Peter did not know what to say, for they were exceedingly afraid." These accounts provide the information we need regarding the subject matter of Fra Angelico's majestic painting. Angelico represents Christ with his arms outstretched as if already upon the cross, and the Gospel account supports this allusion too, since we read that as they came down the mountain Jesus spoke of his coming death.

Luke's Gospel reports that at the moment of the Transfiguration Jesus' countenance was altered, and Matthew's account says that his face shone like the sun. Fra Angelico translates these verbal descriptions into visual image by highlighting the forehead and nose of Jesus' face, by placing a great sunlike, golden nimbus behind the head of Jesus and a white aureole of light about his entire body. Furthermore, he used the same means to denote transcendance that had been used by the Byzantine artist (plate 10)—though the Byzantine style as a whole was quite different from that of Fra Angelico. The frontal pose of the body and the frontal position of the head give a commanding stillness and dignity to the figure. The features are exactly the same on either side of the face, lacking the idiosyncrasies and imbalance that make for individuality; the hair and beard both parted in the middle are details which come into Renaissance art from earlier Byzantine art.

The frontal stillness and majesty of Jesus' face is underscored by its contrast with all of the others. Peter, John, and James, who are *physically* involved in the event, are caught at a moment of spontaneous and troubled movement. Peter, the spokesman for the group, is seen in the lower left with both arms raised in distress, his brows knit together, his face the only other one seen frontally, but differing from Jesus in that his head is at an angle. Note also that if Peter and the other apostles were to stand they would be somewhat smaller in size than Jesus.

At either side of Jesus Moses and Elijah are represented as literally bodiless. We see only their heads and a wraithlike cloud about their shoulders. Moses is identifiable by the shafts of light [8] emanating from

[8] This being a reminder to us that "when Moses came down from Mount Sinai . . . his face shone because he had been talking with God" (Exod. 34:29).

his head. Elijah is represented with a long slender nose, a flowing beard, and bald head—a type similar to that associated with Paul. The two figures kneeling at either side are not intended to be interpreted as members of the *dramatis personae*. Mary the Mother of Jesus kneels at the left and St. Dominic at the right. They are in the position often occupied by the donor, who frequently is pictured in late medieval and Renaissance art.[9] Though in one sense *in* the scene, the donor or devotional figures like these are never involved in the scene or action. They appear to meditate, unaware of their surroundings, their eyes dreamily fixed upon an inward vision.

Turning now from the iconography to the composition of this work of art, we note first that the full, overarching curve which encloses the upper part of the painting provides a basic harmonious shape which centers and accentuates the figure of Jesus. The shape is repeated in the ellipse that encircles his body, and it is again repeated in the more compressed shape of the circular halo or nimbus. Within this nimbus we find the compressed shape of the second major compositional theme, the cross which forms a triangle that is repeated in the body of the Christ. We note also the strong vertical accent of Jesus' body as opposed to the horizontal of his arms and the horizontal of the mountain edge which is continued by the tops of the heads of two of the apostles. These elliptical and triangular shapes, and these horizontal and vertical lines, form the basic structure which unifies all of the elements in the picture. Yet they also unerringly bring our attention back to the central figure and the altered countenance of Jesus which "shone like the sun."

Turning back, for the moment, to the Ravenna mosaic of CHRIST BLESSING THE LOAVES AND FISHES (plate 9), let us compare its composition with THE TRANSFIGURATION. It is at once apparent that Fra Angelico's composition has a more consciously wrought structure, that he intended the head of Jesus as the focal point of his composition and used a diversity of means to direct our eyes to it. The unknown artist of the mosaic achieves a similar end but by more direct and less subtle means. Here we are not distinguishing between the excellence or ef-

[9] The donor is the person who paid for the work of art.

fectiveness of the two designs. Both are masterpieces. But in order to underscore the new and typically Renaissance preoccupation with complex and consciously ordered designs, the contrast with the less sophisticated composition of the Ravenna mosaic is helpful.

Not only the Ravenna Christ but all the earlier representations we have seen thus far seem less "natural" than Fra Angelico's depiction. We might say that a very tall man could pose in the position of Fra Angelico's Christ, and with skillful lighting and some retouching a somewhat similar picture could be recorded by a camera. This is not to say that the photographer could create the masterpiece Fra Angelico has put before our eyes! It is an analogy given merely to point to the fact that for the first time in our study we encounter an artist who consciously bases his work on the data of his own visual experience.

Look closely at the garments of the transfigured Christ; they fall with a succession of natural, graceful folds about the figure. Not only in overall effect do they seem "natural," that is, in accord with our own visual experience, but also in many little details. Note the way the garment over Jesus' left foot breaks as it touches the ground. This is the kind of detail which gives evidence that the artist had made studies of actual drapery rather than having studied how artists of the past had depicted it. The shift from the artist's use of other earlier art as a prototype or model to his *study of actual persons and things as he experiences them visually* is one of the most pervasive and significant of all the driving forces within Renaissance art. Giotto began dealing with problems of this kind. Fra Angelico more than a hundred years later carried forward what Gombrich termed the Renaissance "conquest of reality."

Having examined the subject matter and the composition of Fra Angelico's TRANSFIGURATION, we now have some information which provides a basis for answering our last question: What did the artist wish to communicate through this painting? We noted that, for the most part, he represented the figures naturalistically. Can we conclude that he intended to re-create the event, placing it before our eyes as it might have appeared to us, had we been present? We can imagine our-

selves looking through an arched opening and witnessing the scene. The position of Peter, who is turned toward us as if his gesture of fright were on our behalf, would seem to support this suggestion. But the presence of Mary and St. Dominic in the scene suggests another interpretation. If we return to the New Testament, we shall find a passage in the Second Epistle of Peter where the author meditates on the event of the Transfiguration and writes:

> We were eyewitnesses of his majesty. For when he received honor and glory from God the Father and the voice was borne to him by the Majestic Glory, "This is my beloved Son, with whom I am well pleased," we heard this voice borne from heaven, for we were with him on the holy mountain. And we have the prophetic word made more sure. You will do well to pay attention to this as to a lamp shining in a dark place, until the day dawns and the morning star rises in your hearts.[10]

The author of these words is concerned, not with the description of the event as we find it recorded in the Gospels, but with the meaning of the event for himself and his contemporaries; that he had been an *eyewitness* of the event when God affirmed that Jesus of Nazareth was his son.

Fra Angelico describes the event, as do the Gospels, but also provides an interpretation of the *meaning* of the event in visual terms. The passive figures of Mary and St. Dominic kneeling in the attitude of prayer are present in the scene only symbolically. Mary is not mentioned in any of the Gospel narratives as being present at the Transfiguration. St. Dominic, of course, lived long after the event. Both of these figures are shown with no visible means of support, suspended in midair. Since they were not historically present, they can be imaginatively identified with us. They, like ourselves and the artist Fra Angelico, were not eyewitnesses. But they, like Fra Angelico, accepted the affirmations of the eyewitnesses. The admonition of the author of the Epistle, "You will do well to pay attention to this as to a lamp shining in a dark place, until the day dawns and the morning star rises in your hearts," might

[10] II Pet. 1:16-19.

well have been words spoken by the artist as he put down his brushes at the completion of the painting of THE TRANSFIGURATION.

This fresco, like all of Fra Angelico's paintings, radiates a serene affirmation of faith. To him painting was an act of worship. One of his biographers attributes to him the statement, "To paint the things of Christ, one must live as Christ," and Vasari, writing in the sixteenth century and using legends still current in his day about Beato Angelico, says,

Fra Giovanni was a simple man and most holy in his habits. . . . He was most gentle and temperate, living chastely, removed from the cares of the world. He would often say that whoever practised art needed a quiet life and freedom from care, and that he who occupies himself with the things of Christ ought always to be with Christ.[11]

The Art of the Later Fifteenth Century

The serenity which characterizes the art of Fra Angelico is present in much of the art of the first decades of the Renaissance. But as the driving forces within the cultural upsurge which we term the Renaissance move forward, the conflicts within the culture emerge and find expression within the art. Historians, philosophers, and theologians find the sources of these conflicts in the basic incompatibility of the two strongest elements in Renaissance culture, classicism and Christianity.

We speak of the rediscovery of antiquity in this period. We tend to think of it as being akin to Picasso's discovery and use of African masks, or the recent interest in Zen Buddhism. There is no parallel here. Classical sculpture and architecture surrounded the Renaissance artist. There had been revivals of interest in classical art periodically during the two thousand years between the creation of the Olympian Apollo and Michelangelo's youthful works. They were revivals, however, not a renaissance. A revival appropriates a part of that which is rediscovered.

[11] *The Lives of the Painters, Sculptors, and Architects,* I, 342.

In art such reappropriations usually consisted of iconographic motifs or formal attributes such as gestures, postures, or groupings of figures.

Only when the *spirit* or the *content* of a previous culture is made a part of the present culture is it a rebirth or renaissance. That was precisely what happened in Italy in the fifteenth century. We can understand the shock of recognition Michelangelo must have experienced when he first laid eyes on the Greco-Roman Belvedere Torso, unearthed in his day,[12] if we can imagine our own response were we to find that one of the planets is indeed inhabited with beings like ourselves who have their own Bach, Shakespeare, and Michelangelo. Let us further imagine that we ourselves live in a society whose structure is based upon the church. If the human beings on the supposed planet know nothing of Christianity yet possess highly developed art forms, their culture would present a powerful and perhaps frightening challenge to our own. This was something of the effect which reborn classic art had upon the Renaissance artists and their culture. Tensions and a somber mood are to be seen in much of the art of the latter part of the fifteenth century.

Piero della Francesca's RESURRECTION (plate 1) is one of these works. In this fresco the somber Christ has known agony, but is now beyond feeling pain as he looks out at us with his darkened, intense, yet unfocused gaze.[13]

Another work of art from the latter part of the century which expresses the depths of psychic and physical suffering is Donatello's PENITENT MAGDALENE (plates 30, 31). This extraordinary sculptured figure has a startling modernity. When we recall the Magdalene of Giotto, with her supremely simple kneeling posture and beseeching hands, this gaunt ascetic with tangled hair and sunken eyes shocks the sensibilities. What has she to do with the "Mary, called Magdalene" of whom the Gospel of Luke tells us:

And behold, a woman of the city, who was a sinner, when she learned that he was sitting at table in the Pharisee's house, brought an alabaster flask of

[12] This torso, now in the Vatican Museum, influenced Michelangelo, particularly when he was working on his sculptures for the Medici Chapel, Florence.
[13] See Chap. II, p. 16.

ointment, and standing behind him at his feet, weeping, she began to wash his feet with her tears, and wiped them with the hair of her head, and kissed his feet, and anointed them with the ointment. Now when the Pharisee who had invited him saw it, he said to himself, "If this man were a prophet, he would have known who and what sort of woman this is who is touching him, for she is a sinner." And Jesus answering said to him, "Simon, I have something to say to you." And he answered, "What is it, Teacher?" "A certain creditor had two debtors; one owed five hundred denarii, and the other fifty. When they could not pay, he forgave them both. Now which of them will love him more?" Simon answered, "The one, I suppose, to whom he forgave more." And he said to him, "You have judged rightly." Then turning toward the woman he said to Simon, "Do you see this woman? I entered your house, you gave me no water for my feet, but she has wet my feet with her tears and wiped them with her hair. You gave me no kiss, but from the time I came in she has not ceased to kiss my feet. You did not anoint my head with oil, but she has anointed my feet with ointment. Therefore I tell you, her sins, which are many, are forgiven, for she loved much; but he who is forgiven little, loves little." And he said to her, "Your sins are forgiven." [14]

There continues to be scholarly debate about the identity of Mary Magdalene. The question is whether there are three different persons referred to in the Gospels—one in the Martha, Mary, and Lazarus episodes, one in the anointing of Jesus' feet quoted above, and one the Mary "from whom seven demons had gone out." Or are they all references to one person? This point has been argued since the days of the early church fathers by Augustine, Gregory, and Clement, Origen and Chrysostom. But for Christian art the argument is irrelevant, for the conclusion was reached long ago. Christian art drew together not only these three women, but also the woman taken in adultery. This Mary epitomizes the sinner who, through forgiveness and awakened faith, becomes the saint.

Her recognition of Jesus, and her anointing of him, and her self-giving ablution—"she has wet my feet with her tears and wiped them with her hair"—present the image of a woman of passionate and sensitive nature. In Christian art she has been depicted with long flowing hair, often

[14] Luke 7:37-48.

red or golden red. She and Mary the Mother of Jesus often appear in the scenes of the Crucifixion and Passion, and they represent two contrasting aspects of grieving womanhood. The Magdalene usually wears a flame-red cloak, whereas the red used for Mary the Mother of Jesus is usually a softer cherry red. The Magdalene's gestures and attitudes are always more passionate in their expression of grief whereas Mary the Mother's grief is usually more contained and more inward.

Mark's account of the supper in Simon's house differs somewhat from Luke's, and tells of "an alabaster jar of ointment of pure nard, very costly." When she anointed Jesus she was rebuked because of the waste, but Jesus said, "Let her alone; why do you trouble her? She has done a beautiful thing to me. For you always have the poor with you, and whenever you will, you can do good to them; but you will not always have me. She has done what she could; she has anointed my body beforehand for burying." [15] Deriving from this passage, the alabaster jar in art became the symbolic attribute of Mary Magdalene. The fact that the ointment had been costly suggested that she was wealthy to the corporate folk-imagination which shaped the early iconography, and thus she is often dressed in elaborate and richly embroidered garments.

Legend further relates that she, Martha, and Lazarus came of aristocratic parentage, and that after the Ascension of Jesus heathens caught the three together with the blind man whom Jesus had healed and put them in a rudderless boat which, divinely guided, landed in what is now Marseilles, France. Lazarus became the first bishop of Marseilles, and Mary Magdalene preached there. Soon after this, the legend tells, Mary became an anchorite and "sought a right sharp desert," and there she lived as a penitent for thirty years in vigil, prayer, and fasting.

Donatello has re-created for us the penitent sinner consumed by fasting and abstinence. Confronting the statue, one experiences a shock of surprise. This Magdalene could be exhibited in a gallery with modern sculpture. The furrowed form and emaciated limbs would be harmo-

[15] Mark 14:6-8.

nious with Rodin's late sculpture and some of the reduced and attenu-
ated sculptures of our own day.

There would, however, be significant differences—and it is these
differences which make it a typically Renaissance work. This Magdalene
had once been a very beautiful woman. No mere prettiness was hers,
but aristocratic and classic beauty. Nowhere is this more evident than in
her hands, which are still exquisite in proportion as they are held trem-
ulously in the attitude of prayer. Though THE PENITENT MAGDALENE
stirs intense emotional responses in us, its impact is achieved not through
distortion but from a kind of fiery fidelity to nature. Beneath the
angular, drawn lines of the facial flesh, one feels the hardness and sees
the contours of the skull. The thin arms show a masterly knowledge of
anatomy. Bone and muscles are knit together, giving the illusion of in-
cipient movement. Even in their thin and flaccid state, one sees the linea-
ments in the arms of what had been beauty.

The posture of the Magdalene is interesting. There is a touching un-
certainty, almost a hesitation, about the way she steps forward on un-
even ground. But what the Magdalene lacks in physical force is more
than balanced by the spiritual power of her ravaged face and tender
hands. She might have been a woman of Dachau or Buchenwald, and
there we could have found her twentieth-century antetype, but having
said that, we are again arrested by the profundity of her essential being.
The Magdalene embodies infinitely more than a courageous and noble
endurance of suffering. With incredible sensitivity the artist shaped her
hands to express both pleading and acceptance, the central Christian
experience of faith and grace. This Magdalene, though physically emaci-
ated, was spiritually ravished.

Donatello's PENITENT MAGDALENE is prophetic of the religious fer-
vor which was to sweep Florence at the end of the century. Stirred by
the preaching of the fiery reformer, Savonarola, the sophisticated and
luxury-loving people of Florence repented of their excesses and extrava-
gances. For a time they submitted to the leadership of the Dominican
monk in civic as well as in moral and religious matters. Savonarola's
sermons thundered from the pulpit of the Cathedral of Florence, were

heard by two of Florence's most gifted artists, Botticelli and Michelangelo. Both artists were influenced in their own way by Savonarola's cry for repentance and amendment of life. Michelangelo was a young man of twenty-two in 1497, when Savonarola was virtually dictator of Florence. Botticelli, then fifty-two, was already famous. He had painted decorations for the town hall of Florence and frescoes for the villa of Lorenzo the Magnificent and for the Sistine Chapel in Rome. He had also painted a great altarpiece for San Marco in Florence, the convent where Fra Angelico had lived and painted some fifty years earlier. In one of the cells of San Marco with a fresco by the gentle Beato Angelico on its walls, the monk Savonarola lived during the turbulent years of his leadership.

Vasari, in his biographical essay on Botticelli, wrote that the artist was a follower of Savonarola.[16] Other early sources say that Botticelli threw some of his own paintings into the bonfires of worldly goods and "vanities" which Savonarola's followers started in the streets of Florence. Present-day scholars question Vasari's statement and minimize the influence of Savonarola on Botticelli. However, it is apparent to those who study the development of Botticelli's art that he must have experienced a profound spiritual crisis in the latter 1480's. In his younger years Botticelli depicted the classical myths with lyric grace, poetry, and a sense of nostalgia. Many religious subjects, too, were painted at this early period of his life, but these emanate a different spirit from the later works. The early religious works are either of winsome Madonnas holding a plump Christ Child, or of large religious spectacles, such as the Adoration of the Magi where the grandeur of the kings and their retinue, and the elegance of the assembled crowd, somewhat diminish the true focus of the work of art on the Madonna and Child.

Botticelli's later works show a dramatic intensity and breathtaking religious fervor. His ANNUNCIATION is believed to have been painted about 1490, at a time when Savonarola's influence in Florence was powerful.

[16] "Of this sect he was an adherent, and this led him to abandon painting, and, as he had no income, it involved him in the most serious trouble." *The Lives of the Painters, Sculptors and Architects*, II, 87.

In this painting (plate 32) we see the ecstatic line and compressed intensity which characterize Botticelli's later art. Botticelli depicts the moment when the angel Gabriel's words are fulfilled:

> And the angel said to her,
> "The Holy Spirit will come upon you,
> and the power of the Most High will overshadow you;
> therefore the child to be born will be called holy,
> the Son of God." [17]

Botticelli vividly contrasts the assured urgency of the angel's forward movement with the yielding, trancelike bending of Mary. The hands, too, suggest the contrasted roles of the angel and the Virgin—the angel's hand erect and commanding, Mary's hands yielding, receiving. Mary's hips sway to one side as her head tilts forward like a flower on a wind-bent stem. The angel's garments are a complicated mass of folds and involuted contours, whereas Mary's garments are more sinuous, described with lines which are more slow-moving and by areas which are larger and less complicated.

The fact that the symbols depicted by the artist are naturalistically rendered as part of the scene is a Renaissance characteristic. The details which have symbolic meanings do not claim our attention as symbols only, but seem plausible as a part of the setting. The stalk of white lilies which the angel holds is botanically correct and is in the proper scale in relation to the figures. The white lily is one of the symbolic attributes of Mary, and it is a reference to her purity and virginity. It is a symbol often seen in paintings of the Annunciation. But at the time of the Renaissance the symbols are naturalistically incorporated into the pictured scenes, losing their signlike character. The signlike use of symbols can be seen in earlier works of art, such as the Vézelay tympanum (plate 14), where Peter is identified by the two keys he holds; they are enormous in relation to his body and their function is clearly to identify him.

[17] Luke 1:35.

Botticelli's room opens upon a terrace and beyond it is an enclosed garden with a single slender tree rising gracefully from the center of the walled-in area. Here again, although this scene (plate 33) can be enjoyed in itself as a poetic background setting, it can also be interpreted symbolically. The closed garden is a traditional symbol of Mary's virginity and the tree rises in fulfillment of Isaiah's prophecy, "There shall come forth a rod out of the root of Jesse and a flower shall rise up out of his root." [18]

Ambrose interpreted this beautiful poetic image: the root as meaning the family of the Jews, the stem as Mary, and the flower as Christ. The tree received an additional meaning in medieval and Renaissance times. Not only did it recall the genealogical tree of which Christ was the flower, but also the means of his death. In the book of Acts Paul speaks of Christ "whom they slew and hanged on a tree." [19] The tree thus became a symbol for the cross. Here, at the joyous moment of the Incarnation, Botticelli reminds us of the sacrificial death to come.

Once the imagination is quickened by this kind of symbolic reference, it tends to expand the possible interpretations. The little vista beyond the garden suggests further meanings. We see a river undulating along sloping banks, with a sailing ship afloat and reflected in its calm waters; we see crenellated city walls which terminate at the arched river bridge, and a many-towered edifice at the left. This complex of buildings crowned by many spires and set amid rocky pinnacles is behind Gabriel and could refer to the heavenly Jerusalem, whereas the darker, more solid, walled city at the right might refer to the earthly Jerusalem. Gabriel, the heavenly representative, and the heavenly Jerusalem are then at our left; Mary, the earthly handmaiden of the Lord, and the earthly Jerusalem are at the right.

The event of the angel's announcement takes place in a room which is empty except for a lectern. Botticelli has constructed this room with great skill and accuracy in terms of depth perspective. The tiled floor provides our eyes with a kind of template for determining exact rela-

[18] Isa. 11:1. Douay Version.
[19] Acts 10:39 KJV.

tionships within space. The awkwardness in regard to depth which we observed in Giotto's painting is absent from this carefully constructed painting. Botticelli, like his contemporaries, had achieved an understanding of the rules governing mechanical perspective, and he used his knowledge with skill and consistency. His command of space relationships is interestingly demonstrated in the way in which he depicts the halos. The Madonna's head is seen in three-quarter view and slightly bowed, and her halo is depicted as being at exactly the same angle as the head. The angel's halo is seen in profile, as is his face. If we return to Giotto's LAST SUPPER (plate 24), it is apparent that he intended a similar relationship between halo and head but was not quite able to master the perspective problems.

Today the rules for mechanical perspective are so well known that art students now can achieve effects that would have dazzled Giotto, Fra Angelico, and Botticelli. But the winning of the knowledge that permits an artist to render convincingly a depth dimension on a flat surface was a slow process. Though we tend to think of mechanical perspective as a mere tool used principally in academic or advertising art, for the Renaissance artist the rules of perspective served as the spelling out of the natural harmony of the laws of perception. Vasari recounts how Paolo Uccello, a contemporary of Fra Angelico,

being endowed by Nature with a sophistical and subtle disposition, took pleasure in nothing except the investigation of difficult and impossible questions of perspective. . . . When engaged upon these matters Paolo would remain alone, like a hermit, with hardly any intercourse, for weeks and months, not allowing himself to be seen.[20]

Such intensive devotion to the study of laws and principles is typical of the artist of the Italian Renaissance. The sculptor Ghiberti wrote a treatise on the scientific study of optics; the architect Alberti wrote a treatise on the representation of reality in painting through the scientific study of vision. Piero della Francesca wrote *Of the Perspective of Paint-*

[20] *The Lives of the Painters, Sculptors and Architects,* I, 232.

ing, and Leonardo da Vinci also contributed to the literature on the subject. Two characteristics pervade all of these writings: first, their air of discovery and intense intellectual excitement; second, their use, sometimes tentative and sometimes skillful, of what we now call the scientific method of investigation. The facts or data of vision were studied with as much objectivity as the artist or writer was capable of using, and hypotheses were formed on the basis of the observations made.

This striving for the definition of principles is a characteristic of the Italian Renaissance artist as opposed to his contemporary in the north of Europe. There, too, perspective was being investigated but through the scrupulous examination and recording of the artist's optical experience. The little painting, the ANNUNCIATION by Jan van Eyck (plate 44), shows how exceedingly skillful the northern artist was in his representation of space. But his procedure and the results are quite different. Botticelli constructed his room first, and then placed his figures in it. His figures are integrally related in size and placement to the architecture. In Van Eyck's panel the amount of exquisite detail may obscure for us a fact which is nonetheless true. The figures and objects in the foreground would have to be immense in size and the nave of the church would have to be tiny in order for us to see these relationships as Van Eyck has painted them. The northern artist focuses first on the individual details of persons, places, and things. The Italian artist focuses on the relationships between persons, places, and things.

This is true of the way in which the human body is depicted also. An Italian artist like Botticelli conceives of the body as an organic structure which possesses the potentiality for movement. The urgent movement and gesture of his angel contrasts with the quiet, static posture of Van Eyck's angel. We are in no doubt about the position of Botticelli's angel beneath its complicated garments, but the body of the Van Eyck angel is difficult to discern. Is Van Eyck's angel kneeling or standing? The posture of his Mary is even more ambiguous. The textures of the ample robes of Van Eyck's figures have been the focus of interest for the artist rather than the body's position beneath these garments. But Botticelli is interested in the human body as an organic unity capable of

movement, and in his painting the garments accentuate rather than conceal the postures of Mary and Gabriel.

Botticelli's Mary and Gabriel have an ease of posture which is typical of the later Italian Renaissance as a whole. Peculiarly a characteristic of all of Botticelli's painting is the ballet-like grace of gesture of these figures. But the austerity of the empty room, the nervous intensity of the angel, and the exaggerated movement of Mary are characteristics of Botticelli's late works, created after a spiritual crisis which we cannot document but can hypothesize.

Conclusion

The works by Fra Angelico, Piero della Francesca, Donatello, and Botticelli all have certain characteristics in common. They show an increasing interest in naturalistic means for depicting persons, places, and things. The artists looked at the world about them and endeavored to represent it on a two-dimensional surface with a convincing illusion of the depth dimension. Each artist made studies of anatomy, of the movements of the human body, and of the fall of draperies—details of the panorama presented to his eyes by the world about him. These drawings from nature were the basis for the images which he later used in his paintings. This constant study sharpened his eye and trained his hand for the representation of the visible world.

In contrast to this, the procedure of the Byzantine and Romanesque artist had been to use concepts about things and other earlier art as his point of reference, rather than trying to represent a visual counterpart of things. Each method of working is equally fruitful and valid, but whereas the Byzantine method leads toward abstraction, the Renaissance method leads toward naturalism. The general implications of the two different methods for religious art are that whereas conceptual, non-naturalistic abstract art emphasizes the otherworldly character of Christ and the biblical figures, naturalistic art emphasizes the this-worldly, human aspects of Jesus and of the biblical persons and events.

The Renaissance artist does not present an awesome Christ who is

ruler of the world as the Byzantine artist did, nor the ecstatic-demonic Christ of the Vézelay tympanum. His Christ is the God-man depicted by Fra Angelico (plate 29) in THE TRANSFIGURATION, or the Christ who has known spiritual and physical suffering depicted by Piero della Francesca (plate 2). Botticelli's Virgin Mary (plate 32) has the wistfulness and nostalgia of expression which the Venus of his earlier paintings had. But she does not possess the Paradise Garden ethereal tenderness of the Gothic Madonna (plate 22).

The Renaissance artist was interested in the dramatic climax of the event he depicted in paint, stone, wood, or bronze. To this end he usually observed the unity of time, place, and action typical of classical drama; that is, he usually depicted only one action occurring at one time in one place. There are exceptions to this practice in later fifteenth-century art in Italy, but generally speaking the development is toward this kind of unity. Thus, although earlier paintings of the Resurrection show Mary Magdalene's encounter with Jesus in the background, Piero della Francesca, like the later Renaissance artists, eliminated everything which did not contribute to the essential communication of his painting.

The symbolism of Renaissance paintings, as well as the persons and settings, is more naturalistic. It has been noted that Botticelli's symbols— the white lilies and the tree—are accurate in size relationships, and that the nearby flowers are painted in botanically accurate detail. Similarly, the symbol of the flag of victory held by Christ in Piero's RESURRECTION is naturalistically rendered. Paradoxically, for modern eyes this means the symbols are "hidden" inasmuch as our knowledge of the symbolic elements of the Christian heritage is so meager. But the Renaissance artists and laymen were still alive to the language of allusion and affirmation inherent in symbols, and they "naturalized" the symbols of their medieval and Byzantine heritage with great skill and inventiveness.

They also added another dimension to symbolic expression. We noted the way in which Piero depicted the trees in THE RESURRECTION. On the immobile side of Christ which is still within the tomb we see two barren trees; on the side with the emerging leg of Christ and the awakening soldier we see trees in full leaf. The returning life seen in the major figures

is mirrored in nature, giving an analogy of rebirth. This too is symbolism. But it is more profound than that used by the medieval artist, to whom a symbol was often mainly a label for identifying a person or an event.

In looking back to the work of Fra Angelico, we see that the serenity and assurance which characterize his depiction of Christian subject matter contrasts with the somber work of Piero della Francesca and the intense creations of Donatello and Botticelli. The tensions inherent in the developing Renaissance style were briefly resolved in the period that is known as the High Renaissance. For about twenty years, from 1500 to about 1520, the developing naturalism flowered. Many of the popularly known masterpieces of religious art were created during this period. Leonardo da Vinci, Michelangelo, and Raphael created works of art during the last years of the fifteenth century and during the High Renaissance. We turn first to Leonardo's paintings for an example of the ideals of this period.

THE HIGH RENAISSANCE IN ITALY

The eruption of creative activity in the period called the High Renaissance is a kind of miracle. It cannot be accounted for in rational terms alone. The art historian can speak of the development which began in the early fourteenth century with Giotto, and was furthered by Fra Angelico, Masaccio, Piero della Francesca, Donatello, and a host of similarly great artists of the fifteenth century. He can review the architectural developments which led to a new style, and the masterpieces of sculpture which were made before Michelangelo created his sculptured works of genius. The historian can speak of the rediscovery of the classical heritage. And he can point to the discovery of the world of nature, seen for the first time from the new scientific viewpoint. All of these factors are relevant and important. Yet, when taken together, they do not account for the astonishing flowering of creative genius at this time.

The year 1500 is a convenient round-numbered date to associate with this amazing productivity. The mature works of Leonardo, the last works of Botticelli, the youthful works of Michelangelo were created about this time. A meeting of artists in the city of Florence was held in 1504 in order to determine the best location for Michelangelo's enormous statue of David. The record of those who were present on this occasion is a kind of *Who's Who* of Italian Renaissance art. The number of extraordinarily gifted artists who were there is a measure of the astonishing artistic productivity of this era. In the northern part of Europe, too,

this was a period of great creativity, as shall be seen in the following chapter.

Leonardo da Vinci

Whereas the art of the Gothic and Byzantine periods was the product of a corporate consciousness, with the early Renaissance and Giotto we encounter a succession of individual artists. These artists are known to us not only through their works but through documents and biographical accounts and apocryphal tales. With delightful candor these records underline the personality of the artist, savor his idiosyncrasies, and exalt his achievements. Through many of the writings of the artists runs an excited awareness of involvement in a coherent, progressive development which began with Giotto. The artists saw themselves as related to and dependent on the achievements of the earlier artists of the Renaissance. Yet they were conscious of, and articulate about, their own contributions in carrying forward discoveries into new realms. Leonardo da Vinci wrote of Giotto with reverence, for he thought of him as the first artist who ceased imitating the work of other artists and turned "straight from nature to art." But Leonardo himself expanded the study of nature far beyond anything that Giotto could have conceived. He wrote:

It would seem to me that he is but a poor master who makes only a single figure well. For do you not see how many and how varied are the actions which are performed by men alone? Do you not see how many different kinds of animals there are, and also of trees and plants and flowers? What variety of hilly and level places, of springs, rivers, cities, public and private buildings; of instruments fitted for man's use; of divers costumes, ornaments and arts?— Things which should be rendered with equal facility and grace by whoever you wish to call a good painter.[1]

This passage is a kind of table of contents of the hundreds of drawings and sketches made by Leonardo. Paging through the drawings, we find

[1] Edward MacCurdy, ed., *The Notebooks of Leonardo da Vinci* (New York: Charles Scribner's Sons, 1908), p. 167.

sketches of a warrior wearing an antique helmet and breastplate, a page with the Madonna and Child represented in different positions with sketches of lions' heads along the margin, and drawings of the male nude in every conceivable posture. There is a page where Leonardo shows a double man—his arms outstretched horizontally, his feet together, his body enclosed within a square; superimposed is the same man with arms upraised and feet widespread, his hands and feet on the circumference of a circle. These two figures are illustrations of the proportions of the human body. Significantly, this study of proportions is after Vitruvius, a first-century Roman writer on art and architecture. Thus we again encounter the influence of the classical world upon the Renaissance artist.

Leonardo drew studies of rivers, wooded landscapes, and ravines, numerous drawings of a great deluge and the mortals engulfed by it. There is a beautiful page with flowering rushes, and we see how the artist combined an Oriental sensitivity to the shapes of things with a feeling for the dynamic growth of plants. Another page shows a drawing of a foundry in which a cannon is being assembled. Apropos of this drawing, Leonardo wrote a letter to Ludovico Sforza of Milan in 1493 applying for employment; he listed his capabilities, several of which run as follows:

In case of need I will make big guns, mortars, and light ordnance of fine and useful forms, out of the common type. Where the operation of bombardment might fall, I would contrive catapults, mangonels, trabocchi and other machines of marvellous efficacy and not in common use. And in short, according to the variety of cases, I can contrive various and endless means of offence and defence.[2]

The first nine items which Leonardo lists in this letter tell of his engineering acumen and of his skill as a contriver of instruments of war. Only the tenth and last item speaks of his artistic gifts:

[2] Elizabeth Gilmore Holt, ed., *A Documentary History of Art* (New York: Doubleday, 1957), I, 274.

In time of peace I believe I can give perfect satisfaction and to the equal of any other in architecture and the composition of buildings, public and private; and in guiding water from one place to another. I can carry out sculpture in marble, bronze, or clay, and also I can do in painting whatever may be done, as well as any other, be he whom he may.[3]

Of the artistic mediums which he mentions, the last and the most briefly mentioned is the one for which we remember him particularly. His MONA LISA and LAST SUPPER are two of the most frequently reproduced and written-about paintings of the Western world. Yet this extraordinary man did not see himself primarily as a painter. A contemporary who visited him in April of 1501 reported, "He is entirely wrapped up in geometry and has no patience for painting." [4] It is conceivable that if he were living today he would be at one of the Institutes for Advanced Studies at a large university in the capacity of research physicist, painting occasionally as a peripheral activity.

The number of paintings by Leonardo is small when contrasted with that of artists whose life-span was about the same length as his. Leonardo died at the age of sixty-seven. There are less than a dozen paintings indisputably by his hand. The total works of Botticelli who died at sixty-six, Fra Angelico who died at sixty-eight, and even Dürer who died at fifty-seven, are all very much greater in extent. Compensating somewhat for the small number of finished paintings is the large number of extant drawings. One of the most beautiful of these is the drawing of the VIRGIN AND CHILD WITH ST. ANNE AND ST. JOHN THE BAPTIST (plates 35-37), now owned by the National Gallery in London. This kind of study, made in the same size as the finished painting, is called a cartoon. Since Leonardo made many changes in the final painting, the composition has come down to us in two rather different forms. Let us consider the cartoon first.

The subject matter is foreign to contemporary thinking. St. Anne, who was the mother of Mary, is known to us only through apocryphal tales. In Christian art she often symbolizes the church. Theologically in-

[3] *Ibid.*
[4] Ludwig Goldscheider, ed., *Leonardo da Vinci* (London: Phaidon Press, 1943), p. 19.

terpreted, Anne represents the world of Christian believers; Mary, the handmaid chosen of God, is the vehicle for the Incarnation; and Jesus Christ is the Son of God who turns with the gesture of blessing toward the young John the Baptist. John the Baptist, we learn from Luke's Gospel, was a few months older than Jesus and was related to Jesus, since Mary and John's mother Elizabeth were kin.

Though Jesus is the younger of the two, his gesture of blessing toward the youthful John (plate 37) reminds us of the relationship which John himself pointed to when in their mature years they met

in Bethany beyond the Jordan, where John was baptizing. The next day he saw Jesus coming toward him, and said, "Behold, the Lamb of God, who takes away the sin of the world! This is he of whom I said, 'After me comes a man who ranks before me, for he was before me.' " [5]

Leonardo has drawn these four figures into a compressed and intricate grouping. A full-grown woman, holding a young child, is seated upon the knees of another mature woman. Indeed, the description sounds ludicrous. We have only to imagine what a group of four persons posed in these attitudes would look like in order to realize the extent to which Leonardo has transformed them into ideal beings, ideally interrelated. The interrelationships are so skillfully and subtly handled that we are unaware of any awkwardness.

The intricate yet perfectly lucid way in which the figures are compressed into a triangular grouping has been achieved through Leonardo's use of contraposto. The term means the twisting of the human body on its axis. Imagine a figure standing erect and frontal before us. Were it to drop one shoulder, advance the opposite leg, and allow the weight to fall on the back leg, the spinal column would form a gentle S-curve. The resultant relaxed yet stable posture was one which delighted late classical sculptors. A similar S-curve is to be seen in the Orleans Madonna (plate 21), and it is typical of Gothic sculpture. But the High Renaissance in-

[5] John 1:28-30.

novation was twisting the figure into three-dimensional curves. Imagine the figure described above standing frontally with the S-curve of the body evident. Now if the shoulders are rotated in one direction, and the hips in the opposite, we have maximum variety and a complexity of movement, while maintaining stability, ease, and grace of posture. This is what Leonardo has done with his seated figures in this drawing. Looking at the figure of Mary, for instance, we see that her shoulders slant down slightly while her hips slant up slightly to our right. Her hips and shoulders are rotated in opposite directions. Her thighs present two different planes, as do her legs. Her head tilts to the side and is somewhat rotated, too. Yet how supremely relaxed, easy, and stable is her posture! Similar observations could be made about each of the other three figures.

Leonardo lived and painted at a time when the tradition of Renaissance naturalism came to full flower. Investigations into the correct representation of the human figure had been carried to such a point that Leonardo's own further studies gave him an effective grasp of anatomy. We know from his own statement that he dissected ten cadavers to learn the structure and function of the human body:

I, to get accurate and complete knowledge of the blood-vessels, have dissected more than ten human corpses, cutting up all their other members and removing with the greatest care all the flesh from around them, without spilling any of their blood other than that from the imperceptible bleeding of the capillary veins. Since a single corpse did not last a sufficient time, I had to proceed from corpse to corpse and thus collect complete information; and this I repeated twice to see the differences.

Even if you had a love for such a thing, you would perhaps be prevented by your stomach; if this did not stand in your way, you would perhaps be prevented by the fear of living at night in the company of such quartered and skinless corpses which are frightful to see; if this did not prevent you, perhaps you would lack the ability to draw well, which is necessary for such illustration; if you could draw, you might not have the right perspective, you might not know the method of geometric proofs and the method of calculating the strength and capabilities of muscles; or you might lack patience and therefore fail to exercise diligence.

Am I endowed with these attributes? The one hundred and twenty books composed by me will render a verdict of yes or no.[6]

We have his drawings of organs of the body and even one detailed and accurate sketch of a woman's body showing a fetus in the womb. This kind of thorough, firsthand knowledge of the body gave Leonardo a competence and assurance in representing it which allowed him to compose figures in complicated postures without sacrificing a feeling of suppleness and ease.

Looking back at the works of art which we have discussed previously, we observe that until the time of Giotto the major figures were always presented frontally or in profile. Giotto began to represent the human body in a variety of positions. But Giotto still had a limited repertoire of postures and gestures, and one which was based essentially on the frontal or profile view. Piero della Francesca's art, too, was essentially peopled by persons in these two basic postures. Botticelli, a contemporary of Leonardo, shows some of his figures in a graceful contraposto. The Mary of THE ANNUNCIATION (plate 33) bends in a graceful arclike movement, but her shoulders and hips are rotated on a crescent curve. The resultant contraposto gives an impression of incipient movement. However, the most complex yet subtle use of the device was made by Leonardo in such compositions as the VIRGIN AND CHILD WITH ST. ANNE AND ST. JOHN THE BAPTIST.

Apparently Leonardo was not satisfied with the lower part of this cartoon, with its grouping of legs and feet. In the final version of the composition (plate 34) he changed the posture of Mary so that her body, her right leg, and the child she holds, form a diamond shape which bisects the vertical made by the body of St. Anne. In this final painting the young St. John is no longer present. The Christ Child plays with a lamb, clasping one of its ears, while having one leg thrown over the animal's back. Although the lamb is painted with convincing naturalism, its significance is symbolic. Its function is to remind us that the Christ Child is the Lamb of God.

[6] Wade Baskin, ed. and trans., *Leonardo da Vinci: Philosophical Diary* (New York: Philosophical Library, 1959), p. 53.

Both the cartoon and the finished painting in the Louvre show Leonardo's consummate skill in the use of light and shade. Looking back at the paintings of Giotto, we note the overall, uniform light which surrounds his figures, clearly defining them, rather like the light at noon on a cloudy day. At such a time, light fully reveals the contours of the things it strikes, and with the sun hidden we do not see deep shadows and sharp contours. Leonardo chooses another time of day and another kind of day—a moist, misty day in the late afternoon when light no longer falls upon objects, but rather seems to gleam from some of them, allowing others to slip into mysterious shadow. The beautiful face of Mary glows softly with light across the temples. The light touches her eyelids, the bridge of her nose, and the upper curve of her cheeks. But the lower lids and cheeks are enveloped in velvety shadow. Soft shadows cling about the mouth, accentuating the smile which plays about her lips. This mysterious smile is similar to the one which we know from his portrait of the MONA LISA.

The final painting was executed by Leonardo and his pupils[7] and now hangs in the Louvre. It has a beautiful landscape setting for the figures. In the immediate foreground we see a rocky, pebbly ledge. Its function is clearly to define the position of the figures in regard to the beholder and the picture plane. The picture plane, it will be recalled, is the plane represented by the surface of the picture itself. It is the imaginary point chosen by the artist as his own and as the beholder's position in relation to what is pictured in the work of art. Perhaps the easiest way to see its function is to think of it as the framed opening through which we, the beholders, view the scene which the artist has depicted. The artist can move this frame close to the persons he is representing (as Michelangelo did in the TEMPTATION AND FALL) and the result will be that the figures fill most of the picture area with little space left for landscape or setting. Or, like Bruegel in his CHRIST CARRYING THE CROSS (plate 56), he can move the frame far away from the scene, allowing us to see a panoramic view with the figures small because seen from afar.

[7] Critics believe that Leonardo himself did the landscape, the figure of St. Anne, and the right arm of the Virgin.

It is possible for an artist to present the illusion that some of the persons or objects push through this picture plane, projecting out of the picture. In his grappling with these problems for the first time since antiquity, Giotto achieved this result rather accidentally and awkwardly in his LAMENTATION OVER THE DEAD CHRIST (plate 26), where the figure seated in the center at the edge of the composition seems to project out of the picture plane along her lower back and buttocks. Leonardo achieves a similar effect in the cartoon for this painting in that the left knee of Mary seems to invade our space rather than remaining within the space defined by the picture plane. Leonardo could have eliminated this effect of projection had he shown more of the foreground, therefore pushing the figures back into depth. The painting in the Louvre has a wider and more exactly defined foreground. Consequently even if Leonardo had retained the same position of the legs in the painting that he used in the cartoon, there would be no projection beyond the picture plane.

If we note the variety in size, shape, and texture of the stony foreground of Leonardo's painting, and contrast this with Giotto's depiction of a stony ledge, the difference between the two artists' depiction of nature is dramatically underscored again. Giotto has constructed a kind of papier-mâché stage set which serves its function by symbolizing a natural setting and locating the scene in space. But Leonardo has carefully studied actual stones. Yet it is not a photographic study of the texture of rock and pebble. He wrote: "The painter who copies with his hand and his eye but without reason is like the mirror which mechanically reflects everything placed before it." [8] And again,

The divine element in the art of painting changes the painter's mind into a likeness of the divine mind, giving him the power to evoke the manifold forms of different animals, plants, fruits, regions, and cleft mountains; fearsome and awesome places that terrify their viewers; gentle, peaceful landscapes that delight the eye with their colorful meadows in flower, softly undulating as the gentle wind moves fleetingly over them; streams swollen by heavy rains

[8] Baskin, *Leonardo da Vinci: Philosophical Diary*, p. 56.

descending from high mountains, driving before them uprooted plants mixed with rocks, roots, earth and scum, and carrying along with them whatever is in their path of destruction; and the sea as it struggles with the tempest and scuffles with the wind that assails it—as it mounts superb waves that are splintered and converted into foaming froth by the wind which they imprison as they fall.[9]

Although this poetic passage is descriptive of nature, it abounds in terms which have emotive significance—fearsome and awesome, peaceful and gentle—and which describe the effect of nature on the spectator. In Leonardo's painting in the Louvre, the landscape slopes down behind the figures and rises again at the right, and we see "meadows . . . softly undulating as the gentle wind moves fleetingly over them," and behind are "cleft mountains" with "streams swollen by heavy rains descending from high mountains."

A photograph of the painting, however excellent, can only partially suggest the mystery and magic of the glorious mountain scene in the background. The rugged forms gleam sharply, then melt into the surrounding mist. It is the kind of view for which men risk their lives climbing mountains or flying planes through hazardous mountain passes. Yet it is not the wild and solitary beauty of nature alone; it is beauty as viewed through the alembic of Leonardo's art. It is therefore more than a skillfully depicted mountain scene; it also embodies the vision of this extraordinary man.

Aesthetically, the cartoon and the painting alike are acknowledged masterpieces of art. But what of their religious content? Are they also great works of Christian art? This question presents us with a serious problem of interpretation, and it underlines how time-bound we are in such judgments. Two types of present-day viewers do not see any Christian substance in these works of art. First, there are many who tend to identify suffering with religious experience. Born into a century that has known two immense and catastrophic wars and lives in dread of a third and final holocaust, they see Christ as the Suffering

[9] *Ibid.*, p. 54.

Servant on whom "the Lord hath laid the iniquity of us all." To these believers the ISENHEIM ALTARPIECE Crucifixion (plate 52) evokes more religious awareness than the mysteriously beautiful faces and bodies which Leonardo puts before our eyes in his VIRGIN AND CHILD AND ST. ANNE.

The second and most inadequate judgment is that of the person who relates the excellence of the work of art solely to its obvious content. Thus, an identifiable and faithful picturing of the prodigal son is by virtue of these characteristics a fine work of Christian art, and an "uplifting" sentimental painting of Jesus such as that of Sallman or Hofman, is a fine painting of Christ. Those who use such partial and superficial criteria will not be able to discern the complexity of meaning in Leonardo's painting, any more than those who equate depth of feeling with violence of feeling.

How did Leonardo's own contemporaries see the painting? We are fortunate in having a letter written by Fra Pietro da Novarella after he had visited Leonardo and seen the cartoon for the painting of the VIRGIN AND CHILD AND ST. ANNE. The letter was a kind of report on Leonardo's activities written to Isabelle d'Este, who wanted Leonardo to paint a Madonna and Child for her. The letter is dated April 8, 1501. It reads in part,

Since he [Leonardo] has been in Florence, he has worked just on one cartoon, which represents an infant Christ of about one year, freeing himself almost out of his mother's arms and seizing a lamb and apparently about to embrace it. The mother half rising from the lap of St. Anne is catching the child to draw it away from the lamb, that sacrificial animal which signifies the Passion. St. Anne, just rising from her seat, as if she would wish to hinder her daughter from parting the Child from the lamb; which perhaps signifies the Church that would not wish the Passion of Christ to be hindered. The figures are life-size, but they fill only a small cartoon, because all are seated or bent, and each one is placed before the other, to the left. The sketch is not yet complete.[10]

This blending of the human and divine, in which the human becomes

[10] Ludwig Goldscheider, ed., *Leonardo da Vinci*, p. 19.

emblematic of the divine, is characteristic of one side of Renaissance religious art.

Leonardo adds another ambivalent meaning, one which is peculiar to him. In the mysterious smiles, in the slow circular movement of many of the forms, and in the wild and visionary mountainous background, we experience a sense of the primeval power and beauty of nature as an ancient earth-mother goddess who presides over the cycle of birth, growth, death, decay and rebirth, ever changing, yet ever immutable.

Michelangelo's PIETA in St. Peter's, Rome

On August 7, 1498, a contract was drawn up by Jacopo Galli stating that Maestro Michelangelo had agreed,

at his own proper costs [to] make a Pietá of marble; that is to say, a draped figure of the Virgin Mary with the dead Christ in her arms, the figures being life-size, for the sum of four hundred and fifty gold ducats in papal gold, to be finished within the term of one year from the beginning of the work.[11]

Michelangelo was then twenty-three years old. The contract goes on to promise "that the said Michelangelo will complete the said work, within one year, and that it shall be more beautiful than any work in marble to be seen in Rome today, and such that no master of our own time shall be able to produce a better." [12]

The boastful assurance of Signor Galli to the prospective owner of the work gives us evidence that Michelangelo's reputation was already rather well established. His prediction turned out to be entirely justified. Michelangelo's PIETA (plate 39), completed when he was not yet twenty-five years of age, is one of the great masterpieces of Christian art.

There is no scriptural basis for the subject matter. John's Gospel states that Mary was standing by the cross of Jesus at the time of the Crucifixion. It is assumed that she would have been there when Jesus was

[11] Holt, A Documentary History of Art, II, 3.
[12] Ibid., pp. 3-4.

lifted down from the cross, and that she, like any other grief-stricken mother, would have enfolded the body of her son in her arms. It is an event depicted often in Christian art, and one which is known by the Italian word *pietá*, meaning pity. In Italian art we usually see St. John and Mary Magdalene as part of the group. But Michelangelo eliminates them, isolating the mother and son who are physically close for the last time.

Mary is seated on a rocky ledge with her knees apart, the leg which supports the upper part of Christ's body being slightly higher. Her head is pensively bowed. One arm encircles the shoulders of the Christ, supporting his head. Her right hand with fingers widespread holds his body against her own. Her left hand with palm up gestures in mute acceptance. Her full flowing robe cascades about her body and legs, providing an ample breadth and depth of support for the limp body she holds.

Mary's face is exquisite in proportion and in the delineation of the delicate features. The rounded forehead arches above a patrician nose and tender mouth. Michelangelo has carefully wrought the intricate and intimate details of physiognomy—the corners of the eyes, the contours of the lids, the curves of the nostrils, the corners of the mouth. He suggests the differences of texture between the brows and cheeks and even slight and subtle differences of color. The lips, for instance, appear a darker tone than the cheeks. This effect is achieved by the modeling of the mouth and the way it receives the light, not by the use of color. Michelangelo is the first major sculptor to eschew the use of color in sculpture. Many of his contemporaries had gold added to the patterns which edged the garments of the Madonnas and angels. Donatello worked in wood and terra-cotta, both mediums that were painted afterwards. And the della Robbias, with their brilliantly polychromed terracottas, were contemporaries of the youthful Michelangelo. Michelangelo seemed to have an affinity for the beauty of the tone and surface of marble; he suggested texture and color by his direct handling of the surface of the marble.

Michelangelo's Mary, in her pensive submission to the death of Jesus,

differs from other artists' depictions of this subject in which Mary is shown in shock and fainting, or racked by grief. This Mary, with her indrawn expression, seems to recollect the many times when she had held this body in her arms during his childhood days. The expression on her face is very like the Bruges MADONNA AND CHILD which Michelangelo sculptured only a few years after he completed the PIETA. In this group, where the Madonna holds the child Jesus between her knees, her face, far from radiating the celestial assurance of the Gothic MADONNA AND CHILD (plate 22), has a brooding look of foreboding. She seems to know that a sword shall be thrust through her heart. So the expression of the mother of the PIETA, who holds her dead son in her arms and recalls his childhood, is very like that of the young mother who restrains the vigorous movement of the infant in a moment of insight and fore-knowledge of the events and meaning of his life.

The body and face of the Christ are delineated with consummate skill. The lifeless limpness of the figure is underlined by the way in which each member of the body sags back against a support of some kind. The contours of the neck, as the head falls back against Mary's arm, have beauty of line. The complete relaxation of the muscles is shown by the way in which the flesh about the armpit rolls back as Mary's hand offers support. The nude torso is also of great beauty. All of the intricacies of the muscular structure of the body are visible beneath the layer of fine flesh. Yet each is subservient to the whole, with the result that we are aware of the beauty of the whole rather than of the complexity of the parts. Even in such details as the veins of the hand we note that their prominence, which is quite natural when the hand is below the heart, is not overstressed, and does not draw our attention away from the position of the fingers, which fall languidly against a protruding fold of drapery.

The body is that of a young man, and its proportions are delicate and patrician. The cloth drawn across the loins covers a minimal area of the body. With conscious intent Michelangelo has draped this cloth in such a way that its upper edge emphasizes the juncture of the hip with the muscles of the torso above, while the lower edge of the loin cloth

emphasizes the inward curve of the buttocks. Like the Greek sculptors, whose reverence for the human body is born anew in this genius of the Renaissance, Michelangelo subtly emphasizes all the areas of the body which are related to our capacity for movement. All of the joints of the body—elbows, hips, knees—are delineated in such a way as to emphasize their potentiality for action and movement. In the case of this dead Christ, the potentiality for movement has just ceased, and all of the joints—elbows, wrists, knees, and neck—sag against a support. Of particular beauty and expressiveness is the backward, convex line of the neck. It creates the first part of the S-curve which continues in a crescent line from throat to knees, and in an inverted curve from knees to feet. But the S-curve (as was the case in Leonardo's painting) is given *torsion,* or a third-dimensional twist, which creates a contraposto. Again the impression is that of a complexity of relationships which are perfectly organized into an easy and stable composition. In this group, as in Leonardo's VIRGIN AND CHILD WITH ST. ANNE AND ST. JOHN THE BAPTIST, the dominant overall form is the triangle, indeed, a very stable triangle, with a broad solid base rather than the attenuated triangle used by such artists as El Greco (plate 62).

The physiognomy of Christ (plate 38) is different from any we know in Michelangelo's subsequent work; indeed, it is unique in the history of the changing image of Christ. The breadth of forehead and the wide-spread eyes, the arch of the narrow nose, the thin but shapely lips with a slight mustache and the softly curling short beard, contribute to a youthful, fine-featured face. The slight opening of the lids, and the parted lips, and the way the flesh hollows slightly below the cheekbones, give the impression that the last breath has just been drawn.

Michelangelo minimizes the wounds of Christ, that is, the nail holes in the feet and hands and the slash made by the spear. John's Gospel tells of the official denouement of the event of the Crucifixion. The Romans and Jews wished to complete and tidy up the whole affair:

Since it was the day of Preparation, in order to prevent the bodies from remaining on the cross on the sabbath (for that sabbath was a high day), the

Jews asked Pilate that their legs [the two malefactors and Jesus] might be broken, and that they might be taken away. So the soldiers came and broke the legs of the first, and of the other who had been crucified with him; but when they came to Jesus and saw that he was already dead, they did not break his legs. But one of the soldiers pierced his side with a spear, and at once there came out blood and water.[13]

The wound made by the spear is almost always delineated in the right side of Jesus' torso, diagonally near the rib cage. Michelangelo represents this as a mere slit. Similarly, the holes in the hands and feet are tiny in size, inadequate for the kind of nail which must have been used to support the weight of a full-grown man, who in his last anguish would have hung from these extremities.

We have only to contrast the wounds, or stigmata, as depicted by Grünewald with Michelangelo's inconspicuous rendering of them to see two juxtaposed extremes. Where Michelangelo shows us a slight depression or declivity, Grünewald (plate 52) shows a ragged, gaping fissure which still holds a pool of blood. But the contrast extends beyond the stigmata to the whole conception of the body. In the one case, it is idealized and undistorted; in the other, savagely dislocated and violently distorted.

Michelangelo, like the Greeks before him, gave expression to an ideal of the human body. This must not be thought of as a beautifying of the body, that is, simply an elimination of any irregularities and a "touching-up" of the features and proportions. It is a far more profound ideal. Like the Greeks, Michelangelo felt that the beauty and harmony of the body were expressions of inner beauty.

Michelangelo was criticized by his contemporaries for representing the mother of Christ as so young. He is said to have defended himself by replying that a pure woman preserves her youth longer. This was an idea derived from the Neoplatonic thought which dominated the intellectual circles of Florence in Michelangelo's day. Michelangelo was a frequent guest in the home of the Medicis, where the litterati and intel-

[13] John 19:31-34.

lectuals of the day gathered. The revival of classical learning involved the revival of Greek philosophy and the entire scope of Platonic ideas.

The Neoplatonic philosophers of the Renaissance envisaged the painter as being unlike ordinary mortals. As Gombrich says, he was

a person endowed with the divine gift of perceiving, not the imperfect and shifting world of individuals, but the eternal patterns themselves. He must purify the world of matter, erase its flaws, and approximate it to the idea. He is aided in this by the knowledge of the laws of beauty, which are those of harmonious, simple geometrical relationships, and by the study of those antiques that already represent reality "idealized," i.e., approximated to the Platonic idea.[14]

Leonardo, as we have seen, understood the painter's role in this light. He believed that in the act of creation the painter's mind is akin to the divine mind, giving him the power to evoke all objects and aspects of the visible world. Michelangelo shifts the emphasis, but expresses the same thought, when he says: "Good painting is nothing but a copy of the perfections of God and a recollection of His painting." [15]

Michelangelo's TEMPTATION AND FALL

A decade after the creation of the PIETA, now in St. Peter's, Michelangelo began work on the vast fresco which was to cover the vault of the Sistine Chapel in Rome with "an apparition of another reality, far removed from ours in space and time and superposed above our shadowy world; vistas into 'true reality,' peopled by the very archetypes of existence." [16] The theme of this immense cycle of paintings is the history of mankind as set forth in Genesis—the creation of the world, the creation of mankind, and the origin of sin. Though deriving from the Old Testament, for the Christian interpreter the episodes show mankind awaiting the coming of Christ the Redeemer. To tell this vast epic

[14] Ernst H. Gombrich, *Art and Illusion* (New York: Pantheon Books, 1960), pp. 155-56.

[15] Robert Goldwater and Marco Treves, eds., *Artists on Art* (New York: Pantheon Books, 1945), p. 68.

[16] Charles de Tolnay, *The Sistine Ceiling* (Princeton: Princeton University Press, 1945), p. 22.

Michelangelo painted three hundred figures on an area of over five hundred square feet in a succession of events drawn from the first chapters of Genesis.

One of the most original of these episodes in iconography and content is Michelangelo's depiction of the Fall and Expulsion from the Garden of Eden (plate 40). The subject matter had been represented frequently in every major period and style before Michelangelo's time. But the usual representation was similar to the panel on the Junius Bassus sarcophagus (plate 7), where the figures of Adam and Eve stand frontally before us, separated by the tree of knowledge around which the serpent is entwined. Michelangelo instead shows us two dramatic moments in the story—the very moment of temptation and the moment of the expulsion from the Garden.

In the first of these scenes we see Eve reclining indolently upon her side, her knees drawn up, her whole body forming a sensuous question mark. She has one hand raised and receives from the serpent a fruit from the tree. Adam's legs arch over her body with a scissor-like triangle of movement. His right foot presses into the ground, and his buttocks and torso are tense as he lunges forward to seize the fruit. In the center stands the tree of knowledge of good and evil with one of the strangest of all serpents entwined about it. This serpent has two great python-like extremities coiled about each other and the tree, and these in turn are surmounted by a nude female torso and feminine physiognomy crowned with long flowing reddish hair. The corkscrew-like movement of her body terminates in an impetuous and imperious gesture as she offers the fruit to Eve. On the right side of the composition the cherubim with a sword gestures in command as the two sinners depart into the arid and empty plains of earthly existence.

Characteristic for Michelangelo's interpretation of the theme is the depiction of nature in such a reduced and minimal way. If we reread Genesis, the description of Eden offers images of an abundant and beneficent natural setting—

And the Lord God planted a garden in Eden, in the east; and there he put the man whom he had formed. And out of the ground the Lord God made

to grow every tree that is pleasant to the sight and good for food, the tree of life also in the midst of the garden, and the tree of the knowledge of good and evil.[17]

The rocky shelf of ground at the left with its one low, lopsided tree is not consonant with the garden the Lord God planted in Eden as suggested by the above passage. The barren wasteland at the right seems appropriate enough as the territory given over to the two exiles. But it contrasts only minimally with the garden which Genesis describes as "pleasant to the sight." Michelangelo, like many another Mediterranean artist, has ignored the description of the clothing of Adam and Eve. We see neither the fig leaves sewn together as an apron to hide their nakedness, nor the garment of skins the Lord God made for them.

Directly behind and to the right of Eve we see a dead stump with a pronged leafless branch outlined against the sky. Could this desiccated stump be the tree of life referred to in the quotation? The branch of the stump echoes the lines of the upward-reaching arm of Eve. Could the artist be telling us that with the fall of man the tree of life becomes a tree of death? This is possible, but it is also likely that we see here an allusion to a messianic passage in Isaiah—

> There shall come forth a shoot from the stump of Jesse,
> and a branch shall grow out of his roots.
> And the spirit of the Lord shall rest upon him.[18]

To the medieval world the branch here referred to was Jesus Christ, and Mary the Mother of Jesus was a counterpart of Eve. Eve was "the mother of all living," and Mary was the Mother of God. Paul wrote in his First Epistle to the Corinthians: "For as in Adam all die, so also in Christ shall all be made alive." [19] For the Christian interpreter Eve and Mary had roles analagous to Adam and Christ. So the presence in Eden of a stump with a shoot is a reference to the branch, Jesus Christ, which shall grow out of its roots.

[17] Gen. 2:8-9.
[18] Isa. 11:1-2. See also the discussion of the tree in Botticelli's ANNUNCIATION, p. 98.
[19] I Cor. 15:22.

As a composition Michelangelo's fresco the TEMPTATION AND FALL is an excellent example of the High Renaissance skill in presenting a very stable yet complex balancing of forms. The tree is almost in the center of the composition, but the two pairs of figures on either side are not frontal and similar in position as is the case in the mosaic of CHRIST BLESSING THE LOAVES AND FISHES (plate 9). They are differentiated in their positions, and therefore in line and mass. The two figures at the left have a complexity in their physical relatedness, like two pieces of an intricate puzzle which lock together when properly placed, but here are shown asunder. They are placed nearer the tree than the departing couple. But what could have resulted in imbalance is made to balance, because the group at the right have less weight than the two at the left. Here the principle of the fulcrum is at work. Balance can be achieved either by having two objects of equal weight equidistant from the fulcrum, or by putting the lighter weight further from the fulcrum and the heavier nearer. In this instance some of the effect of weight is given by the tension of Adam's stance and the closer compression of the two bodies on the left. By contrast the almost frontal, empty bodies which move slowly away at the right have less psychic weight.

The artists of the Italian Renaissance inherited from their classical forebears a tendency toward the observation of the unity of time, place, and action in a work of art, that is, a single composition would represent one event which takes place in one setting at one moment in time. The High Renaissance artist would not have represented four different episodes (the Nativity, the Journey of the Magi, the Adoration of the Magi, and the Washing of the Christ Child) in one work of art as did the artist of the Byzantine mosaic (plate 12). Chronological time does not exist in the Byzantine mosaic, nor does space accord in any way with our experience of the world about us. The time and space of Byzantine art is that of a realm separate from earthly existence, one governed by eternal relationships, not the transitory relationships of our time- and space-bound existence.

Time and space for the Renaissance artist, however, accord with our experience of reality in their coherence and veraciousness, but both have

an ideal character. All that is momentary and particular and peculiar is eliminated. The result is a kind of space and time which we dream of and which we glimpse occasionally, and know only as a hope or expectation—a space and time ordered and harmonious as a setting for the drama of human existence. We see this kind of naturalistic space in Piero's RESURRECTION, Leonardo's VIRGIN AND CHILD AND ST. ANNE, and in Michelangelo's TEMPTATION AND FALL.

Oddly enough in this fresco Michelangelo disregarded the unity of time and action which characterized most High Renaissance masterpieces. We see two actions involving the same couple in two discreet moments in time. And yet the entire composition has a compelling unity of rhythm and psychic communication. This unity is achieved by two closely interknit means. First, there is the formal way in which the two couples are related to each other by the dissonant tilted arch made by the arms of the couple and the outreaching arms of the cherubim and the serpent. Secondly, their relatedness is psychic, as if we saw one half of the nature of Adam and Eve at the left and the other, complementary half on the right. In the tense rapaciousness of Adam in Eden, with his face significantly shadowed, we see one phase of his being. In the empty body of Adam at the right, whose hands automatically rise in a listless gesture of withdrawal (plate 41), we see the utter hopelessness of one who has sinned and knows no possibility of forgiveness. His face, here seen in full light, is deeply furrowed with the lineaments of suffering. Eve, on the other hand, changes from an attitude of indolent voluptuousness to a cringing self-protective shielding of her body as she peers somewhat curiously, somewhat slyly, back at her lost Paradise.

It is interesting to note that the unity of Adam and Eve is greater in sorrow than in the act of gratifying desire. Despite Adam's erotic posture with his buttocks swung back and his feet pressing the soil as he eagerly grasps the fruit, and despite Eve's langorous recumbent receptivity, they are *individually* attracted by the source of temptation, but they are oddly unrelated to each other. When they experience the expulsion from the Garden, they are bound together psychically as well

as physically, and are united by their mutual experience of rejection and suffering.

One of the strangest and most fascinating aspects of the composition is the curious interrelatedness of the serpent and the cherubim. Not only are their gestures similar; the puzzling second limb of the serpent as it thickly encircles the tree just below her breast provides a suggestion of a curving arching line which the eye sees as continued in the right arm of the cherubim. In formal, linear terms the symbol of evil, the serpent, and the symbol of good, the cherubim, seem to spring from one source. Is Michelangelo expressing an insight into the ambiguity of good and evil?

As we have seen, many of the characteristics of Michelangelo's Adam and Eve are unique to his interpretation of his chosen subject matter. His originality is another evidence of the individualism so a part of Renaissance culture, expressing itself in ever-changing forms from the time of Giotto through the whole cycle of this period. The revival of classicism in the life and thought of the Renaissance is evident in Michelangelo's masterful naturalistic depiction of the human body. And at the level of content the profound and complex psychic and dramatic meanings are part of the High Renaissance interpretation of thematic material.

Michelangelo's total emphasis is on the dramatic transformation which takes place in the psyches of his two protagonists, Adam and Eve. It is the dramatic occurrence and epic event which the High Renaissance unveils before our eyes, compelling our participation in the meaning of the event as clarified and crystallized by the artist.

Michelangelo's Last Sculpture, the RONDANINI PIETA

> Through many years and many trials searched,
> The right conception of a living form
> To the wise man will come
> In tough hard stone, when he is soon to die.

For only late we reach
Strange and exalted things, and do not stay.
—From a late sonnet by Michelangelo [20]

In the last years of Michelangelo's life he turned again to the subject he had depicted three times previously in marble—the PIETÀ. At first glance it is hard to comprehend that the sculptor of the finished perfection of the St. Peter's group could also be the creator of the so-called RONDANINI PIETA, now in Milan (plates 42, 43). The statue from the hands of the twenty-five-year-old artist glows with a soft luster, and is gentle and harmonious in its communication of sorrow and suffering. As we turn to the rough, unfinished surfaces of the late RONDANINI PIETA we see strange dissonances and disproportions, facial features which are only vaguely suggested, an unexplained disjunction of the arm at the side of Christ's body, and finally, the quivering unterminated arc of the two fragile bodies. What was the dying sculptor trying to express?

It is important to note that Michelangelo had originally conceived of the group in quite another position. After roughing out the group he made major changes, but he did not live to complete the new conception. Thus we have a work-in-progress before us in the RONDANINI PIETA. This fact explains the arm which hangs parallel to the slender body of the Christ, but could never have been related to it. Indeed, the true right arm of the Christ has been roughed out and hangs diagonally back along his body and along that of Mary. It is interesting that Michelangelo himself and subsequent owners of this Pietá have left the obtrusive third arm of Christ in place. Could he, and they, have retained that truncated limb because of its function in the design of the whole? The unstable crescent of the two figures moves upward through a succession of diagonal lines like the broken wing of a bird of passage. But the listless, weightfulness of the disconnected arm, like the lower legs with their diagonal sag, anchors the group to the base. Despite the fact that so much of the statue is rough-hewn, the legs are carefully, even naturalistically executed, and the genitals, as is characteristic with

[20] Holt, *A Documentary History of Art*, II, 23.

Michelangelo's sculpture and painting, are fully modeled. The thighs and knees are highly polished and seem chrysalis-like, as if emerging from an envelope of rough form which is slipping back, revealing the smoothly finished limbs.

The content of the RONDANINI PIETA is at once more elusive and more profound than his youthful statue of the same subject. It too speaks of acceptance, but at a level which is not that of harmony and a submission of act and will to an external reality. Here the reality is internalized, and we see the epic and eternal in the way the beloved son is pressed tenderly against the mother's frail frame. The fruit of her womb has indeed become the sword thrust through her heart, and in her anguish and his emptiness she presses his body to hers in a final closeness of flesh to flesh, beyond tears, beyond lamentation. All that is particular and individual has lost its identity in eternal suffering and self-giving.

The classical view of man and the harmonious and rational view of the world implied in Michelangelo's early works and his Sistine Chapel frescoes are transformed and transcended in the final sculpture of the dying master. Seen from one viewpoint, the RONDANINI PIETA is the final and agonized expression of the greatness and the limitations of the Renaissance coalition of classicism and Christianity. From another viewpoint it is an initial thrust in another direction, one which offers new and profound possibilities of expression for Christian content. Such diverse artistic talents as those of El Greco and Rembrandt and the twentieth-century expressionists are the rightful heirs of Michelangelo's late style. Before turning to these religious paintings, however, we must step backward in time and northward in space to encounter the art of the contemporaries of Fra Angelico, Botticelli, Piero della Francesca, Leonardo, and Michelangelo—that is, to the artists who lived and worked in Flanders and in the Netherlands and Germany.

THE ART OF NORTHERN EUROPE

Separate from, and in some ways opposed to, the art of the Italian Renaissance is the art of northern Europe. The Homeric, classical understanding of man which was so much a part of the environment and of the thinking of the Mediterranean people was not part of the background of northern man. His art tradition goes back, not to the idealized naturalism of the Greek gods, but to the abstract, intricate, vital patterns of the earliest northern' manuscript illustrations and to the later medieval illuminated manuscripts, which are small in size, exquisite in execution, and an adjunct to the text. Behind Michelangelo is the tradition of the APOLLO of Olympia (plate 4) but behind the Van Eycks is the unknown master of the Berthold Missal (plate 16).

Never have there been painters who have recorded the details of their environment more faithfully and lovingly than the artists of northern Europe in the fifteenth century. But their skill was not dedicated to mere reporting. These artists saw references to the world of the spirit in all reality. For them the visible world as the work of the hands of God reflected and referred to its Maker. Their assured faith in the rightness of the world and the righteousness of its Maker led to an acceptance of and reverence for visible reality. Fifteenth-century painting from the north of Europe provides us with an intimate and detailed picture of the persons, places, and things of this reality.

It is not by accident that some of our finest and most detailed portraits, landscapes, and genre paintings come from this place and this

time. We have portrait heads painted with searching honesty. The artist records the lines and wrinkles of aging donors' faces with unflinching candor—idiosyncrasies such as the differences in size and shape of the two eyes, irregularities such as warts and moles, or the stubble of a day-old beard. Yet with all their frail humanity these faces have a stalwart dignity.

These donors are often depicted in their everyday surroundings, or they may be part of a scene in a grand hall or an arched church. But even in these latter portrayals we almost always find a scene from everyday life tucked away in a corner or visible from a balcony or window—a burgher and his wife peering over an embattlement onto a canal below, a medieval street scene with Flemish ladies wearing their stiff white coifs and men riding on horseback, or a view of a kitchen garden where a servant gathers vegetables for dinner. This type of everyday subject matter is called genre. The Flemish artists of the fifteenth century delighted in these little scenes and left charming records for us of many intimate moments of the busy daily life of their people.

Landscapes were also painted with skill and poetry. Many of these are composed of the individual studies of various details of nature. The paintings were not executed as a whole outside in nature in a natural setting as the nineteenth-century impressionist landscape paintings were done. The individual ingredients of the fifteenth-century northern landscape paintings were studied separately, the artist making drawings of a hillock, a tuft of grasses, or distant buildings. These were then incorporated into the final painting, forming a series of vignettes in a continuous landscape setting. The separate details which make up the whole have a verity which comes from the careful observation of nature.

Northern art is not only distinguished by its faithful rendering of the visible world but also by its depiction of the invisible. Fantasy, ranging from the most insubstantial and ethereal images of heavenly glory to the horrors of hell, is the special province of these artists. The demonic and angelic forces are represented with a gripping believability. The extremes of our emotional experiences are depicted melodramatically.

The artists painted subjects which express the violent, the grotesque, the sadistic aspects of our being and our experiences. But they also painted with understanding the intimate, the pathetic, and the poignant moments of existence.

In these characteristic features the art of the north differs from the art of Italy and the Mediterranean basin. Whereas the art which springs from Mediterranean sources is typically epic and dramatic, northern art tends to be more narrative, more episodic, and more static. Whereas the art of Italy tends to ennoble man by emphasizing his finest potentialities, the art of the north underlines the finiteness, frailty, and fallibility of man. Whereas for the Mediterranean artist nature is often only a foil for man and a stage for his exploits, to the northern artist man is enmeshed within the structure of nature and his attitude toward it is a compound of wonder, awe, and fear. The northern artists' vivid depictions of heaven and hell reflect an attitude toward nature experienced as a force for good and for evil.

For the southern artists the more benign climate makes nature the stage setting and background for the acts of men and the gods. We recall that the classical artists, whom the Italian artists followed, did not depict nature until late classical times, and then often in summary fashion. Of the Italian artists whose works are included in this book, only one was deeply absorbed in the observation of nature, Leonardo da Vinci. The rest reduced the natural setting to stage-sized limits and used it as a kind of counterpoint for the action represented in the painting. By contrast, the northern artists purposely chose a panoramic view which enlarged nature and reduced man. This is especially the case in the works of Bosch and Bruegel.

The texture and surface of all the objects they saw and touched fascinated northern artists, and they painted these objects with an immediacy and brilliance of technique that astonishes the beholder. Wools, fur and brocade, and the sheerest of transparent silk quite literally "fool the eye." [1] Wood, stone, marble, brass, and jewels are

[1] This is the translation of "Trompe l'oeil" which is the French term to describe illusionism in painting.

painted with incredible verisimilitude. Our impulse is to touch the painting itself, with the expectation of feeling the cold smoothness of marble or the metallic filaments which make up the brocade. But were these paintings to be touched, the fingers would be greeted by a glassy, undifferentiated surface, as smooth as a mirror. Unlike the paintings of the late nineteenth and twentieth centuries whose brushstrokes are three-dimensional, and give the painting a relief-like surface, these paintings are smooth, the sense of depth and texture being achieved through an illusion.

Jan van Eyck's ANNUNCIATION

The startling immediacy of these textural effects was made possible by the discovery of oil painting in the early fifteenth century. The Van Eyck brothers are generally accredited with this innovation, and it was one of the great technical discoveries in the history of painting. Prior to this time tempera was the medium generally used for panel paintings. For tempera painting the pure powdered pigments are mixed with egg yolk as an adhesive. Since the egg mixture dries quickly, the artist has little opportunity for changing the colors and the tones. Tempera colors have a nonreflective opaque surface and tend toward a pastel range. Oil, on the other hand, is a very slow-drying adhesive and allows the artist to add one transparent layer upon another, thus giving him the possibility of achieving strikingly accurate records of rich and differentiated surfaces.

The ANNUNCIATION by Jan van Eyck (plate 44), now in the National Gallery in Washington, exhibits the exquisite detail which a master's hand can achieve using the medium of oil paint. In contrast to the open, empty room in which Botticelli places his Gabriel and Mary (plate 32), Jan van Eyck encloses the two figures in a narrow apselike end of a church. At the left Gabriel, who seems to have just appeared, is richly garmented in a heavy brocaded, bejeweled mantle. His wings glow with the intensity and range of color of peacock feathers. He wears a crown and carries a scepter, both adorned with gems, and both sym-

bols of earthly rulership. Gabriel does not look at Mary, but as he speaks the words of greeting, "Ave Gr[ati]a Plena," his lips curve into a cryptic, blissful smile (plate 47). Mary, who has been reading from the Scriptures open before her, raises her head and hands in a gentle gesture of reverent and bemused acceptance. The words of her reply to the salutation of Gabriel are visible in the painting. But they seem uttered involuntarily and to the heavens above, rather than to the angelic messenger whose presence Mary hardly perceives. Neither Mary nor Gabriel are haloed, as Botticelli's Annunciate pair are, but the dove, symbolic of the Holy Spirit, is seen descending upon rays of light from a clerestory window above. The rays fan out in a clearly balanced pattern and are seven in number, a reference to the seven gifts of the Holy Spirit which at the moment of the Incarnation are communicated to Mary.

Mary is simply garbed in a deep blue, heavy garment. We assume that she is kneeling before the bench which holds the book. Yet only her relative height in relation to the steeply angled floor is evidence for this conclusion. Her body is swathed in concealing folds, and the only indication of proportion and posture is given by the belt which seems to encompass her narrow torso just beneath the highly placed, small breasts. Delicate and lovely are the narrow little hands raised in a gesture of surprise and acceptance (plate 45). Her head, inclined to one side, is a narrow oval with a high forehead and small features which neither protrude generously nor recede deeply from the essentially egg-shaped surface. By contrast, the features of Botticelli's Madonna are more sculptural and three-dimensional.

Directly above Mary a stained-glass window is illumined and a representation of the Lord God of the Old Testament is seen, his feet resting on the globe symbolizing the earth. Thus this painting has additional subject matter, namely, the Trinity—God symbolized in the window above, the Holy Spirit as the Dove descending, and Mary, the bearer of the incarnate Word of God in the church. But the symbolic meanings are by no means exhausted by this description. Every inch of this little painting has details which refer to the central mystery of the Incarnation. The tiles of the floor (plate 46) have Old Testament subjects,

but in every case the subject is seen as a prefiguration of events of the New Testament. David's victory over Goliath (foreground tile) is understood to be a prefiguring of Christ's victory over Satan, and Samson's death, a prefiguring of the crucifixion of Christ.

In spite of the interest shown by some present-day scholars in typological interpretation this understanding of Old Testament events is foreign to present-day thought. It is difficult for those who inhabit twentieth-century space and time to understand the significance, the power, and the comfort which this kind of symbolic allusion had for late medieval man. To medieval man the Gospels were indeed the fulfillment of the Old Testament. Jesus had said, "Everything written about me in the law of Moses and the prophets and the psalms must be fulfilled." [2] In searching the Old Testament the Christian saw analogies to the events in the life of Christ. The events of the Old Testament thus had a special relevance and a kind of poignancy for the Christian believer.

The vase of lilies in the foreground is a symbolic reference to Mary's purity. It is interesting to note that whereas Botticelli's Gabriel holds a stalk of lilies, Van Eyck places the lilies in a vase in the foreground near a brocaded footstool and includes them with a group of objects making a very charming, exquisitely executed still life. In his detailed and painstaking way Jan van Eyck is depicting "naturalized symbols," that is, symbols which are so a part of the total environment that they can be understood either as a still life, or interpreted in their symbolic function in pointing beyond themselves to a meaning known to the Christian believer. Botticelli also used this kind of disguised symbolism, as we saw in the case of the tree in the garden in his ANNUNCIATION.

The composition of Van Eyck's small ANNUNCIATION is organized around repeated perpendiculars. The high, narrow shape of the panel itself defines the space and confines our view of the scene. The two figures are essentially vertical in their emphasis and are enclosed by the repeated perpendiculars of the columns. The deviations from the vertical, such as the slender scepter held by Gabriel, only serve to ac-

[2] Luke 24:44.

centuate the solidity of the perpendicular structure of the whole com-
position. By contrast, the room in Botticelli's painting seems wide and
barren.

Botticelli used a single, unifying vanishing point for our view. In
his painting the vanishing point is approximately where the turreted
tower in the background projects upward a little to the right of a bridge
over a winding river. The tile floor of Botticelli's room is laid out so
that the parallel lines receding from our eyes draw together at that
point. The figures are also seen from the same viewpoint. In Van Eyck's
painting, however, there is no single point from which the architectural
setting and the figures are seen. We as the spectators seem to be above
the floor looking down on it, yet each of the figures is placed before us
as if directly in front of us. Going far back into the earlier art of the
north, we encounter the same kind of spatial relationships in the
Berthold Missal. In the Missal LAST SUPPER (plate 16), it will be noted
that there, too, the space for the figures is seen from above, whereas
the figures themselves are each seen as if we were directly in front of
them. Since Jan van Eyck, with his love for descriptive detail and
verisimilitude, fills every inch of his panel with realistic detail, the
pecularities of his perspectival depiction are not as apparent as they
are in the earlier manuscript. Perhaps the most arresting point in the
disjunction that exists in Van Eyck's art between the figures and the
space they occupy is their difference in scale. How tiny the church would
have to be that had columns only slightly taller than Mary and Gabriel!
But because of the incredible realism of the many details which capture
our attention and delight our senses, we only see the basic lack of
realistic space relationships when it is called to our attention.

This single-mindedness in regard to space relationships has an analogy
in the lack of emotional relationships between the figures. Gabriel smiles
his secret eternal smile and points heavenward. But his expression, ges-
ture, and even his posture have an inner completeness. None of the
urgency or drama of Botticelli's angel is present in this angelic mes-
senger. Mary, although her head inclines toward Gabriel, seems unaware
of his presence. She looks dreamily at us, and beyond us, seemingly at-

tentive only to her own inner stirrings. If we imagined the words of the angelic salutations, *"Ave Gr[ati]a Plena,"* [3] and Mary's reply, *"Ecce Ancilla D[omi]ni,"* [4] which are in Van Eyck's painting added to that of Botticelli, we would see how utterly inappropriate and incongruous they would be. Yet they are in no way jarring in Van Eyck's detailed little panel. Indeed, Van Eyck's ingenious literal-mindedness extends to a delightful detail. The words of the angel are given as if inscribed in front of our eyes, but Mary's reply is not only in mirror-image but upside down, as if seen and read from the heavens above, from God's eye-view.

It is a strange and wonderful little painting, showing an appetite for endless detail and a delight in the sensual—the texture and feel of exquisite fabrics, the gleam of precious jewels, the luster of fine marble and tile. The complicated symbolic references which we have here only partially explored are part of the northern tendency toward didacticism and storytelling as opposed to the Mediterranean bent toward the dramatic. The unrelatedness of the two figures is another northern characteristic; Van Eyck's Mary and Gabriel think their own thoughts and dream their own dreams, the agent of the Incarnation being the dove. In Botticelli's painting the urgent, tense movement of the angel is the occasion for the tender submissive movement of Mary. The angelic messenger and the handmaid of the Lord are bound together by their reciprocal roles and the high significance of the moment. Botticelli dramatizes the event, whereas Van Eyck describes the event in endless beautiful detail, and points to the symbolic significance of this timeless moment.

Hugo van der Goes's *Nativity*, from the PORTINARI ALTARPIECE

About fifty years after Jan van Eyck painted his ANNUNCIATION, a follower, Hugo van der Goes, was commissioned by Tommaso Portinari,

[3] "Hail, [Mary] full of grace" is the translation of the Latin words which are used liturgically. The RSV translation is "Hail, O favored one, the Lord is with you." Luke 1:28.
[4] "Behold, I am the handmaid of the Lord." Luke 1:38.

the Florentine agent for the Medicis, to paint an altarpiece for his family chapel in Florence. The painting, completed about 1475, is a triptych or three-paneled altarpiece. The subject of the central panel is the Nativity with the shepherds approaching the holy family at the right (plate 48). In the two wing panels the donors, Maria and Tommaso Portinari, and their three children gravely kneel in prayer in the presence of their patron saints.

Though the very structure of the triptych makes these wings separate paintings, and though the central panel is self-enclosed by the ponderous figure of Joseph at the left and the wooden beams supporting the manger entrance at the right, the artist has made the Portinaris part of his dramatis personae by placing them in landscape settings which are a continuous part of the central panel. Maria and Tommaso and their children kneel in quiet and thoughtful solemnity, facing inward toward the hallowed ground on which the naked child lies. If we study their faces, however, we discover that they are not involved in the scene as participants or spectators. Rather they are present at the level of prayer and meditation. Whereas the shepherds' faces show varying degrees of understanding and involvement, the donors' faces show a dreamy absorption in an inner vision, and the patron saints behind their kneeling figures also seem self-absorbed. Except for St. Anthony at the extreme left, the saints are oriented as much in the direction of the donors as toward the central event.

In the right-wing panel of the altarpiece (plate 49) the lean and elegant Maria Portinari and her wistful daughter occupy the foreground with their patron saints, Margaret, who stands upon a serpent-headed beast, and Mary Magdalene, with her long tresses stylishly coiffed and her ointment jar held daintily in her fingertips. In the background is an enchanting landscape of rolling hills punctuated by leafless trees, and in it we see three wayfarers pausing to get their bearings, having sent an attendant ahead to make inquiry. "Where is he who has been born king of the Jews? For we have seen his star in the East, and have come to worship him." [5]

[5] Matt. 2:2.

It is indeed the wise men from the East. As in the Byzantine NATIVITY (plate 12) we see three of them, the traditional number. Matthew's Gospel, however, simply speaks of them in the plural, and in early Christian mosaics or sculptured reliefs we often see two or four wise men. Very soon thereafter the three Magi became the uniformly accepted number, relating no doubt to the three gifts named in Matthew's Gospel. Many fanciful tales grew up about these mysterious figures who came from the East and were guided by a star. An ancient legend names the three:

The first of the Magi was Melchior, an old man with long white hair and a long beard. . . . He it was who offered the gold, symbol of divine royalty. The second Wise Man, named Gaspar, young, beardless, and of ruddy complexion, . . . presented the incense, an offering manifesting Christ's divinity. The third, Balthasar, brown-skinned, wearing a full beard, testified by his presentation of the myrrh that the Son of Man must die.[6]

The tradition of three differing ages for the Magi was scrupulously followed by artists. Even the early mosaic in the Palatine Chapel shows the kings as being young, middle-aged, and elderly. But the custom of representing one of the Magi as "brown-skinned" and with Negroid features is largely characteristic of the art of northern Europe. The significance of this iconographic development is certainly that Christ came to all races, ages, and conditions of men.

Turning now to the main panel (plate 50), our eyes are riveted at once on the focal point, the puny, naked child who lies isolated at the center of a barren floor. Even the angels stay at a distance from the stiff little body. The hem of Mary's skirt falls diagonally behind the child but she, too, keeps from any contact. Rather than clasping the newborn tenderly between her hands as the Byzantine artist represented her, or radiantly drawing him to her as Giotto pictured the scene (plate 13), Van der Goes's Mary somberly broods as she kneels with fingertips touching in the attitude of prayer. Her position, but not her mood, derives from the famous *Meditations on the Life of Christ*, an influential

[6] Mâle, *Religious Art from the Twelfth to the Eighteenth Century*, p. 81.

thirteenth-century text formerly attributed to St. Bonaventura. After an intimate and circumstantial description of the birth of Jesus,[7] the unknown Franciscan author writes, "The mother also knelt to adore Him and to render thanks to God saying, 'I thank you, most holy Father, that you gave me your Son and I adore you, eternal God, and you, Son of the living God, my Son.' Joseph adored Him likewise." [8]

It is fascinating to contrast the thirteenth-century Franciscan meditations on the Nativity with the writings of another monk who was born about eight years after the completion of the PORTINARI ALTARPIECE— Martin Luther. Luther also entered imaginatively into the events:

> The birth was still more pitiable. No one regarded this young wife bringing forth her first-born. No one took her condition to heart. No one noticed that in a strange place she had not the very least thing needful in childbirth. . . . And now think what she could use for swaddling clothes—some garment she could spare, perhaps her veil—certainly not Joseph's breeches which are now on exhibition in Aachen.[9]

This latter clause cannot help but draw a chuckle from twentieth-century readers who enjoy Luther's poking fun at the veneration of relics. Luther further writes, and it is this passage which parallels the passage just quoted from the *Meditations,* "Mary was not only holy. She was also the mother of the Lord. With trembling and reverence, before nestling him to herself, she laid him down, because her faith said to her, He will be 'the Son of the Highest.' " [10] Luther imagines Mary as using an Old Testament expression, "the Son of the Highest," whereas

[7] "At midnight on Sunday, when the hour of birth came, the Virgin rose and stood erect against a column that was there. But Joseph remained seated, downcast perhaps because he could not prepare what was necessary. Then he rose and, taking some hay from the manger, placed it at the Lady's feet and turned away. Then the Son of the eternal God came out of the womb of the mother without a murmur or lesion, in a moment; as He had been in the womb so He was now outside, on the hay at His mother's feet. Unable to contain herself, the mother stooped to pick Him up, embraced Him tenderly and, guided by the Holy Spirit, placed Him in her lap and began to wash Him with her milk, her breasts filled by heaven." I. Ragusa, trans. (Princeton: Princeton University Press, 1961), pp. 32-33.

[8] *Ibid.*, pp. 34-35.

[9] This translation is from *The Martin Luther Christmas Book,* trans. and arranged by Roland Bainton (Philadelphia: Muhlenberg Press, 1948), p. 38.

[10] *Ibid.*, p. 39.

the longer statement of the thirteenth-century Franciscan is couched in the terms of adoration used in the liturgy.

Hugo van der Goes shows Mary kneeling with the infant Jesus laid before her, reverently recognizing his role, before nestling the babe to herself. This is as the *Meditations* of the pseudo-Bonaventura describe, and as Luther also imagined it. But the Mary in the painting by Hugo is not the "holy childlike Lady" of the Franciscan, nor "the poor girl" that Luther delineates. Her small features are delicately modeled, and the fine skin is drawn tightly across the high, broad forehead and thin neck. There is refinement in every line of her face, her thin hands, her long tresses, and the concealing folds of her simple dark garment. She is not a girl, nor is she childlike. She is a woman, who ponders deep thoughts within her heart. Luke's Gospel relates how the shepherds, obedient to the announcement of the angel, "went with haste, and found Mary and Joseph, and the babe lying in a manger. And when they saw it they made known the saying which had been told them concerning this child; and all who heard it wondered at what the shepherds told them. But Mary kept all these things, pondering them in her heart." [11]

Joseph, who kneels at the left, has a stalwart dignity of bearing and reverence of mien. Whereas the Byzantine Joseph seemed physically and psychically detached from the Nativity, the PORTINARI ALTARPIECE shows him to be profoundly involved in the event. Before him on the ground is one of his clogs, a symbolic reference to God's first calling out to Moses from the burning bush: "Do not come near; put off your shoes from your feet, for the place on which you are standing is holy ground." [12] Joseph, like Moses before him, is in the presence of the divine, and it is holy ground upon which he kneels.

Much of the character and spirit of the old Simeon, who witnessed the presentation of the infant Christ in the temple, is present in this Joseph:

This man was righteous and devout, looking for the consolation of Israel and the Holy Spirit was upon him. And it had been revealed to him by the

[11] Luke 2:16-19.
[12] Exod. 3:5.

Holy Spirit that he should not see death before he had seen the Lord's Christ.
. . . He took him [Jesus] up in his arms and blessed God and said,

"Lord, now lettest thou thy servant depart in peace,
 according to thy word;
for mine eyes have seen thy salvation
which thou has prepared in the presence of all peoples,
a light for revelation to the Gentiles,
and for glory to thy people Israel." [13]

It was the old Simeon who blessed Mary and Joseph and said to Mary,
"A sword will pierce through your own soul also." This prophetic decla-
ration finds symbolic expression in the beautiful foreground still-life
detail of the vase of flowers. The iris, sometimes called the sword lily,
is symbolic of the piercing grief Mary was to endure. The violets strewn
about the floor in the foreground symbolize humility and lowliness. In
their natural setting, they blossom near the ground, they are literally
lowly, and they came to symbolize in medieval and Renaissance art
the virtue of humility.

The shepherds at the right are scrupulously described with forthright
realism. Our attention is too easily caught and held by the crude
peasant features and open-mouthed incredulity of the standing shep-
herd. But if we study the faces one by one we discover that the artist
has here presented three different stages in the shepherds' awareness and
understanding of the event. The standing shepherd has a slow-minded
unbelief written on his heavy features and gaping mouth. The dark-
haired shepherd who lunges forward, hands outstretched, expresses the
poignant intensity of one for whom doubt is being vanquished by faith.
The bearded shepherd who kneels with hands pressed joyfully together
in prayerful recognition is the believer who cries, "I know that my Re-
deemer liveth."

In the far background at the upper right, two of the shepherds are
seen again in a prior episode:

An angel of the Lord appeared to them, and the glory of the Lord shone
around them, and they were filled with fear. And the angel said to them,

[13] Luke 2:25-32.

"Be not afraid; for behold, I bring you good news of a great joy which will come to all people; for to you is born this day in the city of David a Savior, who is Christ the Lord." [14]

"The Savior, who is Christ the Lord" is the center, the hub, the pivotal point in the composition of this altarpiece. The arms and hands of Mary and Joseph, the two kneeling shepherds, and the solemn angels point toward the child as the spokes of a large wheel lead the eye to its center. Of course, the fact that each of these looks toward the child and is psychically wholly involved with him is the most powerful means employed by the artist to draw our eyes to the focal center of the composition. We have all had the experience of being in a crowd and having several people glance upward, and almost at once, and quite involuntarily, the whole group will gaze upward. In works of art also our attention is drawn to the object in which the participants of the event are absorbed.

An additional emphasis is given to the child by the empty open space about him. Just as a word spoken after a long pause makes memorable the word, or a chord struck when silence has prevailed makes resonant the chord—so here the spatial interval makes poignant the tiny body which is laid at its center. When we use the word "center" in regard to this design we mean it in terms of depth, as well as with respect to the two-dimensional arrangements of the surface of the painting. If we look again at the Byzantine mosaic it will be noted that the head of the Christ Child is at the exact center of the composition. But we have no sense of depth, except for the rather arbitrary reading of one thing being behind the other because of differences in size or because of overlappings. In Hugo van der Goes's composition, on the other hand, we feel a recession in depth akin to that which we experience in everyday visual relationships.

The problem of the representation of space in paintings or mosaics is a complex one for it always involves an illusion or an interpretation. The Byzantine mosaic of THE NATIVITY in the Palatine Chapel shows two

[14] Luke 2:9-11.

ways of implying depth. First, by overlapping one object with another the artist tells us that one is *behind* the other and thus farther away from us. Mary's body is behind the Christ Child's, for his head and shoulders overlap her body; her hands are in front of his body, for they overlap the swaddled babe. Secondly, depth is usually read by a simple vertical placing of the figures and objects. In the mosaic we assume that the servant and midwife who are about to bathe Jesus are near to us whereas the Magi are far away, simply because the group with the baby are near the lower border and the Magi in the upper area. This kind of placement is sometimes coupled with changes in the scale of the figures, that is, those who are supposedly nearer are larger and those in the distance smaller in size. As we can see, the artist of the mosaic does not employ this kind of size discrimination. Size in the mosaic is related to theological considerations, not to depth relationships. Thus, Mary, the most important personage, is the largest in scale, and Joseph is somewhat smaller.

In Hugo van der Goes's painting the spatial relationships are controlled by the understanding of space which mechanical perspective systematizes. His composition is thus not only worked out in regard to the two-dimensional surface on which the painting is done, but it is carefully calculated in regard to the illusion of depth which he wishes to create. The Christ Child is the hub of a two-dimensional circle made up of Mary, the shepherds, the two groups of flanking angels in the foreground, and the ox and ass at the left. But if we imagine the ground plan for the figures, we see that his little naked body is the pivot of a larger circle arranged in depth, which includes all of the dramatis personae of the central panel.

"The Savior who is Christ the Lord" is made the very heart and center of this work of art by every compositional device and by powerful psychic means. Yet when we study that naked little body, we are startled to find it so insignificant. Leonardo's child (plate 34) has a sensuous ease in his own corporeality as he romps with the lamb. But Hugo's child is frail and puny, and defenselessly human (plate 51). The cocoon-like creases of the newborn flesh, the hands drooping and fingers

curled inward, and the unfocused eyes reluctantly open, speak of the discomfort of life in this world after the dark security of the womb. Rays of a nimbus radiate along the floor about the Christ Child. Though they give light they do not give warmth, for the little body seems chilly in its naked isolation.

The vivid contrast between the high significance of the event and the frail babe who is the bearer of its meaning in all his humanity, is, of course, intended by the artist. The Nativity stories are so well known that there is the ever-present danger of their becoming merely illustrative, saccharine, or banal. Hugo van der Goes underlines the high seriousness of the event by the solemn absorption of all the participants. But its meaning for all time is contained in his unrelenting emphasis on the fragile humanity of the child, who paradoxically is recognized as "the Savior, who is Christ the Lord."

Grünewald's Crucifixion from the ISENHEIM ALTARPIECE

This paradox so solemnly communicated in Hugo van der Goes' NATIVITY finds a more anguished expression in the great Crucifixion painted for the high altar of the church in Isenheim by an artist whom we know as Matthias Grünewald. This altarpiece is dated 1515. It is a polyptych, that is, a many-paneled altarpiece, which can present varying subject matter to the beholder at different times of the week or of the church year. The outer panels show the Crucifixion (plate 52) with the Entombment below. When these two outer panels were opened, the Annunciation and the Resurrection were disclosed on their back sides.[15] The scenes of the Incarnation and Nativity were then visible in the central panels where the Crucifixion had been. When these latter panels in turn were opened, one saw scenes from the life of St. Anthony, to whom the church and altar were dedicated. Our study however is concerned with the now separated external panels of the Crucifixion, which

[15] Today the altarpiece is exhibited in the Musée D'Unterlinden at Colmar. In order for visitors to be able to see all wings simultaneously, the altar has been taken apart and each pair of wings mounted separately so that both sides of each wing are visible.

Benesch calls "a work of such tremendous and dismal grandeur of expression that nothing on earth seems to equal it." [16]

The enormous figure of Christ looms up in the front of the painting, his body stretched upon a roughhewn cross, the tension of his torso and his weight causing the great crossbeam to arc. His fingers claw stiffly at the empty air, his head sags lifelessly in the hollow created by shoulder muscles torn from their sockets. His abdomen is sucked back toward the spinal cord. The knees buckle and the anklebones are riven from their sockets as the weight of the great body is pressed down upon them.

Jesus is shown after "he bowed his head and gave up his spirit." John's Gospel relates how the Jews, in order to prevent the bodies from being kept on the cross on the sabbath, "asked Pilate that their legs might be broken, and that they might be taken away. So the soldiers came and broke the legs of the first, and of the other who had been crucified with him; but when they came to Jesus and saw he was already dead, they did not break his legs. But one of the soldiers pierced his side with a spear, and at once there came out blood and water." [17] A great diagonal fissure in the side of Jesus gushes with scarlet blood; thus Grünewald has depicted a moment after the soldier, known in apocryphal literature as Longinus,[18] had pierced his side.

At our right John the Baptist stands stiffly before us, with the Scriptures in one hand and with the other, pointing to the Crucified. His forefinger seems exaggeratedly elongated as it gestures imperatively. The Latin words, "He must increase, I must decrease," are inscribed against the darkened sky. And, indeed, the body of Christ seems visibly to grow in size as his forerunner, John the Baptist, diminishes physically at his side. At the feet of the Baptist the Agnus Dei is seen standing with one leg supporting a slender reed cross, with his breast cut open, and

[16] Otto Benesch, *Art of the Renaissance in Northern Europe* (Cambridge: Harvard University Press, 1947), p. 29.

[17] John 19:31-34.

[18] John's Gospel records that "one of the soldiers pierced his side with a spear" (19:34), but early writings refer to this soldier as Longinus, the name probably deriving from the similar Greek word for a spear or lance.

with blood flowing from this wound into a chalice placed on the ground before him. The lamb is a symbolic reference to the sacrifice of Jesus Christ. At the left of the cross, John the beloved disciple supports in his arms Mary the Mother who has been committed to his care: "When Jesus saw his mother, and the disciple whom he loved standing near, he said to his mother, 'Woman, behold your son!' Then he said to the disciple, 'Behold your mother!' And from that hour the disciple took her to his own home." [19]

The unrelenting emphasis on physical suffering and the ghastly realism of the scene is related, we now know, to the writings of a fourteenth-century mystic, St. Bridget. A Catholic scholar found that her *Revelations on the Life and Passion of Jesus Christ and His Mother, the Holy Virgin Mary* was known to Grünewald and was a source of some of his imagery. Indeed, her vision of the crucified Christ reads like a description of Grünewald's painting:

The crown of thorns was impressed on his head; it covered half of the forehead. The blood ran in many rills. . . . Then the color of death spread. . . . After He had expired, the mouth gaped, so that the spectators could see the tongue, the teeth and the blood in the mouth. The eyes were cast down. The knees were bent to one side; the feet were twisted around the nails as if they were on hinges. . . . The cramped fingers and arms were stretched.[20]

The tiny impassioned figure at the foot of the cross is the Magdalene (plate 53). Her body is pressed backward in an anguished arc. Her interlaced fingers are locked tensely together. The painful upward thrust of her head exposes the quivering cheeks and pitiable chin in outline against the bleak landscape. Her cascading hair seems to vibrate with the grief that racks the small body. True to an ancient tradition, Grünewald shows the Magdalene as experiencing sorrow in openly physical terms whereas Mary the Mother grieves more inwardly.

The composition of this panel shows a sensitive balancing of masses along a central axis. This axis is emphasized by the shape of the painting

[19] John 19:26-27.
[20] Benesch, *The Art of the Renaissance in Northern Europe*, p. 30.

with its projecting section in the middle over the cross. We are hardly aware that the body of the Crucified is entirely to the right of the center. The entire composition, of course, is painted on two different wings which meet at the center, and thus it could be claimed that expediency dictated the artist's decision to place the cross to one side of this juncture. But if expediency had a part in the design, it resulted in a most skillful balancing of forms. Here we do not have the symmetrical balancing of forms which we saw in the mosaic of CHRIST BLESSING THE LOAVES AND FISHES (plate 9), which communicates a feeling of order and grandeur, but an asymmetrical balancing which creates a living dynamism full of tensions. The enormous Christ, the tiny lamb, and the ascetic, spindle-shanked John the Baptist are on one side of the composition and balance the solid block created by the Mary and John the Evangelist, a unit continued in the triangular figure of the Magdalene, whose head and sweeping garments lead our eyes to the group behind her. These three make a relatively solid triangle which, with the more open triangle composed of the lamb and the Baptist, form two wedge-shaped areas enclosing the resonant space about the crucified body.

In discussing the balancing of the various shapes about the central axis, we are speaking in such general terms that the unique intensity and violence contained within this extraordinary masterpiece are not touched upon. It has been noted that the asymmetrical arrangement of the shapes results in a dynamic tension in the masses. But the rhythm and quality of Grünewald's line is one of the most powerful means by which he communicates the fevered intensity of his own emotional involvement in the event he creates pictorially before our eyes. The line which delineates the great pointing finger of the Baptist expresses urgency in its tense purposefulness. The line which softens about the quivering cheeks of the Magdalene is expressive of her suffering. The line which undulates restlessly through her cascading tresses is electric with life. The extreme contrast with Grünewald's restless varied line is to be found in the ponderous, slow-moving contours of Giotto's Magdalene (plate 28).

In the foregoing discussion of line, it would have been inappropriate

and artificial to speak of line in its formal aspects only, that is, simply as a contour which describes an area. In many ways Grünewald was the forerunner of modern expressionism. The formal or design elements in his composition are so intimately an expression of his own highly personal, intensely emotional involvement with the subject matter he has chosen to represent that one is imbued with the other, and the two can hardly be spoken of separately. An appropriate analogy is the late nineteenth-century art of Vincent van Gogh; this artist too used a line so welded to the emotional meaning of the objects for him that a formal analysis of the lines and masses seems beside the point. Grünewald and Van Gogh both painted "with their guts." It should be noted that both were northern artists, who lived far from the influence of classical art with its example of the ideal man, heroic and majestic, and in command of his own life and destiny.

Not only the varied and intense line but also the many distortions in the altarpiece contribute to the overwhelming impact of the painting. The various sizes of the figures constitute a distortion related to medieval iconography. It was customary to present the most important figures as the largest, and a descending scale was used for the other dramatis personae. We have seen this kind of symbolism before in the Palatine Chapel mosaic of THE NATIVITY (plate 12), in the Christ of THE PENTECOST (plate 14), even to some extent in Fra Angelico's TRANSFIGURATION (plate 29). In none of these works, however, did this particular distortion create a disjunction which in turn caused a violent emotional reaction on our part. But here the enormous body seems to grow larger under our eyes. The greenish flesh, pitted by the scourge and still exhibiting jagged thorns within the gaping wounds, seems to multiply its sores as we look with horror upon the body. The physical distortions caused by the hanging of the body on the cross are relentlessly described and even exaggerated by Grünewald. The facial expressions of the two Marys and the two Johns, as well as that of Christ, are caught at their most intense point—extremes of despair and agony, and death only after excruciating suffering.

Distortion is one of the characteristics of an expressionistic style. In

our discussions we shall assume the kind of norm we know through naturalistic styles of art, where the human body is represented as an organic unity, and natural objects as recognizable and verifiable in terms of our own optical experience. It must be added that there is *no* art without some distortion, and often the naturalistic artist must "distort" in order for his human figure or natural setting to appear to us as "natural." The distinction is a matter of degree, and there is no doubt but that the distortion of Grünewald's Christ is much greater than the distortions of Fra Angelico's Christ, or Piero's Christ. And as a result of these distortions, as well as other iconographic and stylistic characteristics, Grünewald's crucified Christ has an agonized intensity whereas Piero's Christ has a majestic poise and stillness.

It is interesting to note that Grünewald's Crucifixion has occasioned much discussion by theologians of our century. Paul Tillich has called it "the greatest German picture ever painted." Whereas nineteenth-century criticism and scholarship had little interest in the art of Grünewald, a century which has known two world wars turns with anguished comprehension to this altarpiece. Grünewald painted it in 1513-15, when the anxiety that the world might come to an end still cast a pall of dread over parts of Christendom. The ancient and pervasive belief in the dread power of symbolic numbers created a mood of chiliasm. It was feared that the end of the world envisioned in apocalyptic literature would come around the year 1500, as it had been feared around A.D. 1000. But the twentieth century has witnessed events more devastating than the catastrophes described in the book of Revelation:

I looked, and behold, there was a great earthquake; and the sun became black as sackcloth, the full moon became like blood, and the stars of the sky fell to the earth as the fig tree sheds its winter fruit when shaken by a gale; the sky vanished like a scroll that is rolled up, and every mountain and island was removed from its place.[21]

To the twentieth-century man who has seen films of the deadly mushroom, and documentaries of the pitiful survivors of Nagasaki and

[21] Rev. 6:12-14.

Hiroshima, Grünewald's Christ is a powerful mirror of reality. But if we see it only as "the most corporeal of all Crucifixions," to use Sir Kenneth Clark's description,[22] much of its power is missed. The miracle is that through the intensity of physical suffering speaks the atoning sacrifice of "the Lamb of God who taketh away the sin of the world." There are no formal or analytical ways of describing the manner in which Grünewald has achieved this profound and paradoxical communication. Something of the same depth and range is to be found in Rouault's TÊTE DE CHRIST, or Christ in Agony, painted in the early years of the twentieth century. The early years of the Reformation and the early twentieth century have both given us notable images of a Christ who died in order that the Christian believer may live and die in him:

> He was wounded for our transgressions,
> > he was bruised for our iniquities;
> upon him was the chastisement that made us whole,
> > and with his stripes we are healed.
> All we like sheep have gone astray;
> > we have turned every one to his own way;
> and the Lord has laid on him
> > the iniquity of us all.[23]

Albrecht Dürer's THE KNIGHT, DEATH, AND THE DEVIL

The intensely emotional mysticism of Grünewald contrasts with the sober didacticism of his contemporary, Albrecht Dürer. The German artist Dürer created the engraving known as THE KNIGHT, DEATH, AND THE DEVIL (plates 54, 55) in 1513, when Grünewald was beginning work on the ISENHEIM ALTARPIECE. But whereas the writings of the fourteenth-century mystic St. Bridget and the poignant images of Second Isaiah are the literary counterparts of the ISENHEIM ALTARPIECE, the vigorous admonishments of Paul are recalled by Dürer's noble en-

[22] *The Nude: A Study in Ideal Form* (New York: Pantheon Books, 1956), p. 237.
[23] Isa. 53:5-6.

graving. Dürer pictures the Christian Knight mounted on a fine charger pressing determinedly forward in this world, though his companions are Death with an hourglass in hand and a leering bestial Devil. In the Epistle to the Ephesians, Paul wrote,

> Put on the whole armor of God, that you may be able to stand against the wiles of the devil. . . . Stand therefore, having girded your loins with truth, and having put on the breastplate of righteousness, and having shod your feet with the equipment of the gospel of peace; above all taking the shield of faith, with which you can quench all the flaming darts of the evil one. And take the helmet of salvation, and the sword of the Spirit, which is the word of God.[24]

Dürer's iconography is related to this passage and also to the writings of Erasmus of Rotterdam. In 1520 Dürer, his wife, and maid left their home in Nürnberg for Antwerp. During the year they were away Dürer kept a travel diary in which he recorded his impressions and experiences. In it he wrote his impassioned reactions to the news of Luther's simulated capture and to the rumors (without foundation) of Luther's assassination.[25] This outburst is followed by an appeal to Erasmus: "Oh Erasmus of Rotterdam, where wilt thou stop? Behold how the wicked tyranny of worldly power, the might of darkness prevails. Hear, thou Knight of Christ! Ride on by the side of the Lord Jesus. Guard the truth. Attain the martyr's crown." [26] It has been suggested by Panofsky that this salutation "knight of Christ" was inspired by Erasmus' own youthful treatise, the "Handbook of the Christian Soldier" published in 1504. In the treatise Erasmus tells of a Christian faith

so virile, clear, serene and strong that the dangers and temptations of the world simply cease to be real: "In order that you may not be deterred from the path of virtue because it seems rough and dreary, because you may have to renounce

[24] Eph. 6:11, 14-17.

[25] "And whether he yet lives, or whether they have put him to death—which I know not—he has suffered this for the sake of Christian truth and because he rebuked the unchristian Papacy, which strives with its heavy load of human laws against the redemption of Christ. . . . May every man who reads Martin Luther's books see how clear and transparent is his doctrine, when he sets forth the Holy Gospel." Holt, *A Documentary History of Art*, I, 341.

[26] Benesch, *Art of the Renaissance in Northern Europe*, p. 23.

the comforts of the world, and because you must constantly fight three unfair enemies, the flesh, the devil and the world, this third rule shall be proposed to you: All those spooks and phantoms which come upon you as in the very gorges of Hades must be deemed for nought after the example of Virgil's Aeneas." [27]

Dürer's Knight makes his way along a path which is indeed "rough and dreary." A few blades of grass are to be seen in the left foreground, but all other vegetation is dead or dormant. The trees are leafless, and scraggly exposed roots are seen stretching vainly downward along the dry earthen wall which might well be that leading to "the very gorges of Hades." "The comforts of the world" are represented by the city in the background with its turret and towers and trim, tall dwellings. The Knight is as unaware of its cozy security as he is of the presence of his two spectral companions. To his consciousness they seem indeed "spooks and phantoms."

Dürer, like Erasmus with his reference to Vergil, drew upon classical as well as Christian sources; his Knight is patterned after the equestrian statues known to us from antiquity and interpreted anew in the fifteenth century by such classically inspired artists as Verrocchio and Leonardo da Vinci. The horse is massive, and though represented in forward movement, has the stability of a sculptured equestrian monument. The Knight who wears "the breastplate of righteousness" and the "helmet of salvation" and "the sword of the spirit" is a man of middle age whose lineaments show him to be worn by the cares of life in this world but nonetheless intrepid. At his side his faithful dog leaps forward. These three—the Knight, his sturdy horse, and eager dog—are in profile, that is, parallel to the picture plane. Look now at the macabre figure of Death with snakes encircling his crowned head and meager chest. His body is slightly diagonal to the picture plane, and the neck of his dejected nag is sharply angular to it. The monstrous Devil, who is a fantastic compound of the most loathsome features of many different beasts, insinuates himself into the narrow gorge at an angle also. This

[27] Erwin Panofsky, *The Life and Art of Albrecht Dürer* (Princeton: Princeton University Press, 1955), I, 152.

contrast between the parallelism of the Knight and his faithful beasts and the diagonal or angular positions of the Devil and his companion Death is another compositional device which underlines iconography and meaning. To put it simply, that which is "good" is straightforward; that which is "evil" is crooked.

Dürer's Devil is but one of a veritable gallery of ghoulish creatures spawned by the northern imagination when it gave pictorial expression to its conception of evil. Born of the terrorful images of the nightmare world, these fantastic, bestial creatures present an amazing variety of form and feature. One of their most curious features is their functional believability. The disparate parts are put together with a sense for organic unity. The great snoutlike face, the beady eyes, the ram's horns and the single horn for impaling are all united in a believable structure. Thus what might seem merely fantastic and grotesque becomes believable and frightening.

This imaging of evil as a compound of all that is loathsome and terrifying is typical of the northern imagination and it contrasts dramatically with the Italian Renaissance conception, where the Devil usually remains basically human in figure and proportion. Michelangelo added claws to the toes and fingers of his demons in the great fresco of the LAST JUDGMENT in the Sistine Chapel, and Signorelli gave his demonic angels bat wings. But basically the Devil and his demons are human in form in the classically oriented imagination. It is possible that Dürer had reflected on the passage in Mark's Gospel [28] about the demoniac whom Jesus cleansed by sending the unclean spirits from him into a herd of swine. The predominantly swinelike character of the Devil may be related to this Gospel incident.

The composition of Dürer's engraving is organized about the simple massive horizontal of the horse's body, bisected by the grimly erect figure of the Knight. But these dominant masses and movements are cut across again and again—the reins, the Knight's leg, the scabbard. Many other diagonals radiate out from this shape—the horses' legs and heads, the Knight's lance. But these are so elaborated and have so many diverting

[28] Mark 5:1-13.

accessories that our eyes are constantly led away from considerations of composition, balance, and symmetry to a fascination with the individual items—the lizard hastily crawling away to the right, the drooping head of the weary nag ridden by Death as it contrasts with the purposeful vigor of the Knight's horse. Thus we are wooed from design and composition back to iconography. A striking contrast exists between this exquisitely conceived and detailed little print, of 10 by 7 inches, and Michelangelo's fresco of the TEMPTATION AND FALL of 96 by 204 inches (plate 40). Note how bleak and barren, and even blank, is Michelangelo's Eden in contrast to Dürer's crowded gorge where the individual stones and blades of grass and a dead stump at the left are all described with an eager appetite for verisimilitude.

Two notable details in the foreground of the etching are the skull perched precariously on the bit of rock and the slate with the letter "S," [29] the date 1513, and the monogram of the artist's initials. The skull is a reference to time but one which has a "moral" significance. It is a *memento mori,* or reminder of death. In the sixteenth and seventeenth centuries a skull is often seen in the saint's study or the hermit's secluded corner. It is a reminder that life is fleeting, and that the possibility of sudden death is ever with us.

The slate is conspicuously placed so that we may easily read the date and monogram. This is the first time in our study that we have encountered a work of art dated by its creator. Michelangelo had signed his PIETA (plate 39) not at its completion, but later as an indignant protest when he heard that another sculptor had been accredited with its creation. But the impulse which led Michelangelo to incise across the band which runs diagonally over Mary's breast and shoulder "Michelangelo Buonarroti Florentin Fecit" is similar to that which led Dürer carefully and conspicuously to incorporate his own handsome monogram in the engraving of THE KNIGHT, DEATH, AND THE DEVIL. The individualism of the artists of the High Renaissance made them feel highly identified with and proud of their masterworks. Dürer's con-

[29] The letter "S" means in the year of salvation, 1513.

sciousness of time and history is also a Renaissance characteristic. He was aware of his own development as an artist as well as the structure of the tradition which stood behind him. Both imply a sense of history in which identified points in time are important as guides to the contours of historical development. This kind of understanding of time is quite unlike that known to artists of earlier ages. Thus, to the sculptor of the Vézelay tympanum (plate 14), the apocalyptic end of time was momentarily before him as an immediate possibility. To the creator of the little ivory MADONNA AND CHILD (plate 22) with its paradisal serenity, all of time lay within the hand of God. For him awareness of time was more perpendicular than horizontal; that is, the supernatural possibilities within each moment of earthly existence were nearer his consciousness than the structure of history which relates past and present, present and future, in a horizontal progression in time.

It is this latter sense of history that the Renaissance man understood. In his draft for a book on human proportions Dürer wrote of the famous classical artists whose writings he regrets had been lost in the intervening ages: "I hear, moreover, of no writer in later times, by whom aught has been written and made known which I might read for my improvement. . . . I therefore will write down with God's help the little that I have learned. . . . If I then set something burning and ye all add to it with skillful furthering, a blaze may in time arise therefrom which shall shine throughout the whole world." [30] Dürer, like Leonardo, felt linked to the artists of the past and to those of future generations in terms of a coherent progression in time and history.

Dürer died in 1528; Leonardo, his Italian contemporary, had died nine years before. The works of these two artists are representative of the Renaissance which flowered in the early decades of the sixteenth century. By about 1520 a shift in style had begun, and what we now term "mannerism" became the dominant tendency both in Italy and in the north. It was around the year 1520 that Peter Bruegel the Elder, the greatest of sixteenth-century Netherlandish artists, was born.

[30] Holt, *A Documentary History of Art,* I, 314-16.

Peter Bruegel's CHRIST CARRYING THE CROSS

At the time when the dying Michelangelo was working on his final masterpiece, the RONDANINI PIETA (plate 42), the aging Flemish artist Peter Bruegel was painting a strange panorama peopled by a teeming multitude. The subject of this painting, signed and dated in the year of Michelangelo's death, 1564, is CHRIST CARRYING THE CROSS (plate 56). But if the reader studies it casually without knowing the title, he might well enjoy it for the fresh beauty of the dewy, sunny morning landscape, and the vigor and variety in the peasant groups which inhabit this expansive hillside, without realizing that a Gospel event is here depicted.

Our eyes are attracted to the fascinating windmill atop a circular platform on a craggy outcropping of rock in the distance, to the walls and rooftops of a medieval town that is pink and blue in the morning mist, to the children playing along the shining puddles in the background. But slowly, as we read the painting, other details bespeak another mood. The men on horseback are not purposeless or frivolous of mood. The crowd of peasants, though engaged in all kinds of momentary diversions, yet seem to move irresistibly to the right. As our eyes move curiously with them up the slope to the point that seems to be their destination, we see a dark ring made up of the people who had reached this summit first. These form a solid mass about an open circle, and suddenly, with horror, we recognize this place. It is Golgotha, where the crosses are prepared for those who are to be crucified. Now the peasant crowd, its desultory progression toward "the place of the skull," its meanderings and byplay, takes on another dimension. We instinctively seek through the crowd and then discover the wagon which bears the two malefactors to their end. But the third to be crucified, where is he? We finally locate a meager figure fallen beneath a cross just behind the wagon (plate 58). The group about him are wrangling among themselves or struggling to raise the cross. On our side a little space opens about his kneeling figure. Those nearest him turn away from him and toward us. Only one stares with cold curiosity upon the drab fallen figure.

In the left middle ground we see a group of soldiers threatening a man while his wife tries to hold him back from their armed advances. It is Simon of Cyrene, whom the soldiers are compelling to join Jesus in order to carry the cross. Typical of Bruegel is the addition of this incident in which Simon's wife bodily opposes the soldiers. Looking closely, we discover that she has a rosary with a cross attached to her bodice. The rosary is, of course, an anachronism, but of a kind very common in Christian art. The Annunciation often takes place in a room where a painting of the Crucifixion hangs on the wall, and the Madonna of the Nativity occasionally wears a rosary. In medieval and early Renaissance art time is not measured in the before-and-after terms of daily existence. But in Bruegel's painting the anachronism is implied for a specific purpose. Simon of Cyrene's wife is not known to us from biblical sources but is his own addition. She violently opposes her husband's being compelled into an act of mercy, namely, carrying the cross of Jesus. Bruegel condemns a piety expressed in outward form, symbolized here by the rosary, while the woman herself is without mercy or compassion.

In the foreground on a rocky ledge is a group which is set apart from the throng below. At the center of this group sits Mary the Mother— pale, elderly, and submissive in her nunlike coif and simple veil. John the beloved disciple seems to support and sustain her. Mary Magdalene and Mary the mother of James and Joseph kneel in contained and graceful grief at either side. The proportions of these four figures are quite different from the rotund squat figures of the peasant crowd. They are extraordinarily tall and have small oval heads with genteel features which contrast with the roundheaded peasants with their blank faces and empty eyes. The two mourning Marys are elegantly dressed in subtly colored, flowing silk garments which differ from the rough angular garments and bright color contrasts of Simon of Cyrene's wife. Yet the elegiac mood which pervades the group of holy mourners is abruptly changed as we look to the right where a stark skull—this time the skull of a horse—rests upon the hillside as a *memento mori*, and a reminder that Golgotha is the place of the skull. Our eyes are drawn upward by a wheel-pole for executions, and we see several black evil-looking birds

of prey. The sunshine which bathes the left part of the panorama has not as yet reached the right side, where layer upon layer of heavy clouds hang over the place of execution.

All that we have observed thus far has to do with the iconography of the painting, the description and identification of the important dramatis personae and actions. But there is much that has not been noted and which could only be recognized and delighted in as the eye slowly moves from person to person and group to group—the peddler with his fascinating sack seated with his back to us in the foreground, the two gray-garbed old women at the right over the edge of the hill, and so many more. We must read this painting as if it were the printed page in order to slowly accumulate a knowledge of the incidents which surround the tragedy.

The composition has an ingeniousness characteristic of sixteenth-century works of art. The figure of Christ kneels at almost the exact center of the design. The center of any work of art is where our eye tends to focus first; thus to have the most important personage and event here is logical in every sense. But Bruegel has depicted such a large, colorful, and busy crowd that the Christ, though central, is almost hidden. He is lost within the crowd which surrounds him. The crowd provides the slow but irresistible movement within the composition, an undulating movement from left to right which starts as a slow loose curve at our left, bends sharply into the distance up the hill, and terminates in the tight dark circle at Golgotha. This loose figure eight which sprawls across the canvas organizes the multiple activities simultaneously in two dimensions, on the surface of the canvas and in the depth dimension.

Bruegel's forms and figures are described in an essentially linear way, that is, the outlines of each are clearly visible, and can be traced without difficulty. We shall see by contrast that another great northern draftsman, Rembrandt van Rijn, who was born thirty-seven years after Bruegel's death, draws his figures with fluid and ambiguous contours (plates 66-71). In Bruegel's paintings the lines and contours of the figures and natural objects are always given with clarity. These lines themselves possess the same robust vitality that animates these peasant figures.

The meaning of Bruegel's painting is not easy to fathom. As in the plays of Shakespeare, we find the great historic and tragic events set amid a wealth of character and subplots and genre incidents. And again, as in Shakespeare's plays, the past is made contemporary by the use of the costume and customs of the artist's own day. The red-coated soldiers wear the uniform of the Walloon cavalry serving under Spanish rule. The walled medieval city in the background (which here represents Jerusalem), the windmill (plate 57), the wheel-poles used for executions were a part of the contemporary scene immediate to the experience of Bruegel's patrons and friends.

Aside from the mourning group in the foreground, Bruegel depicts man as vital, gross, graceless, and without individuality or spirituality. We peer into these many faces and find them all masklike and stupid, many of them having the dark focusless eyes of the idiot. What man lacks in nobility and grace, nature has in abundance. How gently the morning mist clothes the distant hills in color! The leafy branch at the upper left traces a delicate pattern against a blue sky. The very rocks are reverently depicted.

Other northern artists before Bruegel's time had depicted groups of people in biblical scenes. But he is the first to depict a crowd. The individuals who compose the mass lose their identity as individuals and are reduced to the lowest common denominator. They become subservient to and expressive of the will of the crowd. This work of art exhibits more than the ordinariness of the setting of tragedy or the heedlessness of people in the routine of their trivial daily concerns. It underlines the viciousness, perversity, and stupidity of people—Simon of Cyrene's wife being but one example.

Just below her and slightly to the right is a small white lamb, a still point in a chaos of movement. In reduced size the shape of his body echoes that of the Christ who kneels beneath the weight of the cross. Are the two connected symbolically? El Greco frequently used this symbolism in his Nativity scenes, and the Agnus Dei as we have seen was present in Grünewald's Crucifixion. We are therefore tempted to conclude that this lamb refers to the Lamb of God. But an explicit

symbolism like this seems alien to Bruegel's expression. His works are filled with ambiguities and contradictions and are infused with subjective content, requiring of the spectator a highly personal response.

If we return for a moment to Giotto's LAMENTATION OVER THE DEAD CHRIST (plate 26), we see the startling contrast between the two depictions of analogous subject matter. Giotto's stage barely accommodates the identifiable persons, and nature is but a backdrop to their anguished reaction to the death of Christ. With Bruegel we look down upon a vast scene encompassing hillsides and rocky promontories, a distant town, and the blue-clad horizon. Many people clamber about the landscape. But they are belittled by the grandeur of nature and lose their identity in the crowd. The meaning of Giotto's painting is clearly indicated by both the design and the inherent psychological expression. Bruegel's painting instead hides the central event effectively from our recognition, and all of the psychic factors draw us away from the event.

After a perusal of Bruegel's fascinating painting we are left with the perplexing question. Is it a work of religious depth? It certainly is religious in the sense of providing us with insights into what has been called the condition of man, and in its vision of the grandeur of nature. But the divinity of Christ which is implied in even such a corporeal rendering of the Crucifixion as that of Grünewald is lacking here. The real subject matter is not CHRIST CARRYING THE CROSS but the random and perverse preoccupations of an indifferent humanity. In this it is strangely modern, speaking the language of our contemporary art and literature.

Characteristics of Northern Art

Looking at these northern paintings as a whole, we note certain common characteristics. Once we are familiar with these characteristics it is possible to identify northern art even when a particular painting or artist may be completely unfamiliar. Northern paintings have a *multiplicity of detail* surrounding the central persons and events—the elaborate

attire of Van Eyck's Gabriel and the patterned floor tiles and architecture, the exquisite still life in the foreground of Hugo's Nativity, the rendering of the lamb and chalice in the ISENHEIM ALTARPIECE, and finally the exquisite detail in nature and in the genre groups in Bruegel's painting. These details are rendered with a loving attention to the sensual qualities of the objects—their feel and shine, their harshness or delicacy.

This love of common objects and the skill exercised in representing them was foreign to the Italian sensibilities. Michelangelo is recorded as saying:

They paint in Flanders only to deceive the external eye, things that gladden you and of which you cannot speak ill. Their painting is of stuffs, bricks and mortar, the grass of the fields, the shadows of trees, and bridges and rivers which they call landscapes, and little figures here and there. And all this, though it may appear good to some eyes, is in truth done without reason, without symmetry or proportion, without care in selecting or rejecting.[81]

If we look again at Michelangelo's Adam and Eve (plate 40) the difference in his artistic objectives is quite evident.

Complicated iconography also characterizes northern art. The numerous objects represented with such verisimilitude have a symbolic import as well as being a quintessential representation of that particular object. The interpretation of these objects in their symbolic role requires literary, and other knowledge, as opposed to the more predominantly aesthetic sensitivity required for classical and naturalistic art. Thus northern art tends to emphasize edification and teaching purposes. The fact that two works of art of this present group have as part of the painting itself words spoken by the protagonists—Van Eyck's ANNUNCIATION and Grünewald's Crucifixion—underscores their didactic purpose.

Realism, as opposed to the naturalism of Mediterranean art, is another northern characteristic. Naturalism sees people, places, and things at their most typical, that is, generalized in form and feature. Realism

[81] Francesco da Hollanda: Record of Michelangelo's Conversations with Vittoria Colonna, in Kenneth Clark, *Landscape into Art* (London: John Murray, 1949), p. 26.

tends to emphasize that which is particular, immediate, and finite. It also tends toward the momentary and passing—the instant caught and held by the "candid camera" rather than the tableau of naturalism which is arranged in such a way that the easy and noble postures can be sustained for a time. Michelangelo's Mary of the PIETA (plate 39) possesses the grace and ease of naturalism, whereas Grünewald's Mary who faints into the arms of John (plate 52) has a brittle angularity and an instability which is momentary. In the next instant her position will change, as will the Magdalene's extreme posture in the foreground.

The *extremes of emotional and psychic experience* are typically the province of northern art. The mysticism and violence of Grünewald, the pantheism of Bruegel, the varying degrees of emotional involvement seen in Hugo's shepherds (plate 48), point to a wide range and variety of human experience being expressed in the art of the north. Northern art reflects an awareness of the unaccountable and chaotic elements in man and nature, and what Worringer called a "strong substratum of imaginative fear." [32] Mediterranean man stood more secure in a world that seemed to him benign, a world in which he perceived a general, universal order. As we shall see, the later sixteenth-century Mediterranean art reflects a change in style which has certain parallels with the changes in northern art of the same period.

[32] *Form in Gothic*, p. 83. See the discussion of the actual (reality) of Northern culture as over against the natural of classical culture on p. 60.

THE SIXTEENTH AND SEVENTEENTH CENTURIES IN ITALY

The art of the sixteenth century from about 1520 on is usually termed manneristic in style. The term "mannerism" was first used in a derogatory way, in that it pointed to the often strained and affected exaggerations and elaborations of the artists who followed in the wake of Michelangelo and Leonardo, Dürer and Grünewald. But living in a transitional cultural period ourselves, we understand the forces at work as the Renaissance ideas and ideals lost their momentum and new impulses struggled for artistic expression. The harmonious and balanced style of Renaissance art was not adequate to express the intense spirituality of Tintoretto or El Greco, as it was not suited to the complex and ambiguous panoramas of Bruegel. For the northerner Bruegel is also a mannerist. His wide cineramic views of nature, his ingenious compositions in which the main event is far from the spectator, his highly personal interpretation of the ancient themes are characteristics of mannerist art.

Tintoretto's LAST SUPPER

Bruegel's life is encompassed by that of Tintoretto, who was born in 1518 and died in 1594. Tintoretto is related to both Michelangelo and Bruegel. His style has many of the features of Bruegel's work, though there could never be any confusion between the work of the northern artist and his Venetian contemporary. Behind the variety of

postures in Tintoretto's large paintings we sense the knowledge of anatomy and the emphasis on the body which he inherited from Michelangelo and the Renaissance. But the later works of Michelangelo, the LAST JUDGMENT in the Sistine Chapel and the attenuated and angular RONDANINI PIETA (plate 42), are closer in spirit to Tintoretto than to the early Mary with the dead Christ in her arms (plate 39).

In the year of Michelangelo's death, 1564, Tintoretto painted a CRUCIFIXION for the Scuola di San Rocco, one of the Venetian confraternities. These confraternities were private clubs supported by religious and secular bodies. Tintoretto had been made a member of the wealthy and respected Brotherhood of San Rocco and worked intermittently for it much of his life. But his major paintings were done between 1576 and 1581, when he painted many large canvases for the house of the Brotherhood using Old and New Testament themes. This group of paintings is one of the great cycles of Christian art.

Ten large canvases along the walls of the Scuola di San Rocco depict scenes from the life of Christ; corresponding themes from the Old Testament are on adjacent ceiling panels. This kind of typological arrangement, where Old Testament themes and events are understood as prefigurations of the events recorded in the Gospels, as we have seen before, is one of the most ancient and pervasive strains within the Christian interpretation of Scripture. In the art of the early church, in the Byzantine and medieval church, and in the art of the Renaissance we frequently see antiphonal representations from the Old and New Testaments. Thus Tintoretto's iconography for his paintings at San Rocco follows an ancient tradition. Corresponding to the New Testament LAST SUPPER were four Old Testament prefigurations painted by Tintoretto, the GATHERING OF THE MANNA, ELISHA MULTIPLYING THE LOAVES, ELIJAH FED BY THE ANGEL, and the PASCHAL FEAST. And directly across the hall from the LAST SUPPER was the FEEDING OF THE FIVE THOUSAND, another Eucharistic subject, but this one from the New Testament.

The LAST SUPPER (plate 60), like the other paintings in the Upper

Hall, is placed high on the wall, considerably above us, as on a stage which recedes obliquely to our left. Between us and the room depicted, we see several stairs strewn with objects and a figure seated at either side. These figures—a recumbent male figure at the left and a woman seated clasping her upraised knee at our right—are in every sense outside the scene. They seem to dream, and to enjoy a physical and psychic ease that contrasts sharply with the emotional involvement experienced by the apostles in the room above. It is the little dog between them who is aware of the commotion in the room and, alert and eager, is about to leave the steps and join the excited group before him.

Within the high-ceilinged room a long table is set diagonally, and it recedes toward two back chambers barely visible to us in the murky light. About the table an air of intense excitement prevails as the twelve men gesticulate, half arise, or reach toward one another. The two extremes of emotional expression are found at the opposite ends of the table. At the end nearer us an enormous figure kneels, his torso thrust back and arms outflung, his very garments brittle with incredulity. At the farther end of the table, deep within the room, a thirteenth figure sits serenely, his face seen in profile against an emanation of light as he looks quietly at Peter bending over him. Dimly we discern that "one of his disciples, whom Jesus loved," is indeed "lying close to the breast of Jesus." At Jesus' right side we see the one apostle without a halo with his face turned away from us. He is fixedly studying Jesus' face. The turbulent movements of the rest of the group seem to express their fear in response to Jesus' statement, " 'Truly, truly, I say to you, one of you will betray me.' The disciples looked at one another, uncertain of whom he spoke." [1] But this one apostle is studying his Master, as if in this instant of time he still has a choice, before "Satan entered into him." [2] It is Judas.

The composition of this painting shows the mastery and ingenuity of a virtuoso designer. We have only to contrast it with Giotto's fresco of the LAST SUPPER (plate 24) to see the immensely increased design

[1] John 13:21-22.
[2] John 13:27.

repertoire of the sixteenth-century artist Tintoretto over the more limited possibilities available to Giotto, painting about 270 years earlier. Giotto's figures sit stolidly about a table in an improbably small alcove, and a pained and uneasy stillness seems to hang in the air after the Master's words. Giotto's evocation of this air of pregnant stillness and the stalwart dignity of the apostles is a moving and profound interpretation of the theme. But Tintoretto's familiarity with anatomy and perspective rendering are so complete that he can freely improvise and achieve daring combinations and startling effects. There is no contrast here between the *quality* of achievement of the two artists but rather a contrast between the *means* by which the achievement is accomplished.

In Tintoretto's great canvas commotion and confusion dominate all but the small figure at the end of the table (plate 59). We seem to hear cries and mutterings and the crash of a suddenly overturned bench. The impetuous and momentary positions of most of the disciples contribute to this noisy confusion. But Tintoretto has used another artistic means to achieve this effect. Light and dark are used in such a way that a forehead and shoulder, the widespread fingers of a hand, or the buttocks of a figure are bathed in light whereas the adjacent area of the body may disappear into darkness. The effect is that of light from an uneven source, as from a fireplace, where a sudden burst of flame arbitrarily illuminates a hand, an arm, or a face in lost-profile.[3] The light also picks out details—columns and a cornice and a large hooded fireplace, and in the far background the wraithlike figures of servants busy in two upper chambers (plate 61).

But the central motif of the painting is the diagonal wedge into depth made by the table and its surrounding figures. Tintoretto makes the table and the apostles appear almost as a vortex-like mass projecting back into space. This effect is achieved by diminishing the size of Christ's figure and exaggerating the size of the gigantic apostle who

[3] Lost-profile is a term for when the head is seen from the back in three-quarter view, so that the contours of the cheek and forehead are visible, but little or none of the nose, eye, and mouth are in view.

kneels on the floor at the end of the table. This is a typically mannerist compositional device and reminds us of Bruegel, who similarly reduces his Christ-figure and places it deep within the composition. Also like Bruegel, and unlike Giotto or Leonardo da Vinci in his famous painting of the subject, Tintoretto has added genre incidents, such as the couple on the stairs, the dog, the still life on the steps, and the servants in the distant rooms.

Though Tintoretto's LAST SUPPER is shown in a room, and therefore in defined and limited space, we have only to contrast it with Giotto's cramped little alcove or Leonardo's low-ceilinged hall-like room to see how the picture space has expanded in sixteenth-century art. Again Bruegel's painting of the hillside leading to Golgotha is an analagous mannerist expansion of space in the art of northern Europe.

Thinking back over the paintings we have discussed, we will recall that the first artist to manipulate light for expressive purposes was Leonardo da Vinci. Instead of using the neutral and all-revealing light of day, he chose the time of early twilight for the VIRGIN AND CHILD AND ST. ANNE (plate 34). At that time shadows cause forms to melt into darkness, and the reduced and diffused source of light creates gleaming highlights; in Leonardo's paintings these create a sense of mood and psychic depth. But Tintoretto uses light more audaciously, with greater and more sudden contrasts between the lighter and darker areas. The source of the light can never be attributed to any natural location, a window or an open door. It is arbitrary and nonrealistic. The sudden brilliant highlights and black shadows emphasize the inner struggle of the apostles as they react to the words of their Master. The light therefore serves the communication of feeling and meaning rather than serving a purely descriptive function.

This expanded technical vocabulary—the understanding of anatomy, the skill with perspectival rendering, the brilliant use of light and dark, and the expanded spatial dimension—are used by Tintoretto to express an intense spirituality. His virtuosity never serves mere cleverness but always draws us into a deeper understanding of the meaning of the event he portrays. The steps in the foreground and the two recumbent

figures are a clever way of shaping the space in the main part of the composition into an area better suited to Tintoretto's subject matter than the vertical rectangle which the painting had to fill. But these two figures also serve an expressive role. They mediate between us and the scene behind them, drawing us into a relationship with them and thus with the scene. That scene compels an intensely emotional involvement, and yet remains visionary and sacramental, not merely dramatic.

Some critics have seen an influence from the Reformation and northern religious thought in Tintoretto's paintings. Others have considered his art to be a typical expression of the Counter Reformation. These diametrically opposed viewpoints can be investigated by those who care to do so, but for us the significant point is the agreement on the artist's deep spirituality and the power with which he expresses his understanding of the biblical texts. Almost one hundred years ago Taine wrote of Tintoretto:

It is the inner impetus of his spirit that one must describe; . . . in certain moments, confronted by a great danger, a sudden shock, a man will see distinctly in a flash, with terrible intensity, years of his life, complete landscapes and scenes, sometimes a fragment of an imagined world. . . . The active power of the mind suddenly increased tenfold, a hundredfold, makes the spirit live in this epitome of a moment, more than all the rest of its life. . . . Such are the outbursts of creative imagination in the great artists; with fewer counterbalances they were as strong in Tintoretto as in the greatest masters. . . . In comparison with him, all painters merely imitate each other. One is always surprised by his pictures; one wonders where he found all this, in what unknown world, fantastic and yet real.[4]

El Greco's BAPTISM OF CHRIST

A vision of a supernatural world, "fantastic and yet real," is presented to us by the religious paintings of a strange, isolated genius, a Greek who came from the island of Crete, studied in the Venice of Tintoretto and Titian, and moved on to Spain to settle finally in that country's ec-

[4] Quoted in Huntington Cairns and John Walker, *Masterpieces of Painting from the National Gallery of Art* (New York: Random House, 1944), p. 74.

clesiastical center, Toledo. His name was Domenico Theotocopoulos, but the Spaniards called him El Greco, and he, proud of his origin, usually signed his name in Greek characters. In his BAPTISM OF CHRIST (plate 62) we see the dynamic, elongated, intense figures, the peculiar whitish light and flamelike upward movement typical of this highly individual artist. To twentieth-century sensibilities this painting may seem the most modern that has been discussed so far. By half closing our eyes and thus eliminating all associations of subject matter we can reduce the painting to its design elements. When this is done, the composition reminds us of certain of Kandinsky's early works, or of paintings by twentieth-century abstract expressionists. Yet even the late paintings of El Greco show his relationship to the art of Tintoretto and Michelangelo. We could easily imagine the enormous apostle kneeling at the end of the table in Tintoretto's LAST SUPPER as a spectator in El Greco's BAPTISM OF CHRIST. And El Greco's lean, elongated ascetic Baptist is reminiscent of the attenuated Christ of Michelangelo's final sculpture, the RONDANINI PIETA (plate 42).

Like the RONDANINI PIETA, El Greco's BAPTISM OF CHRIST was left unfinished at the time of the artist's death. But the iconography and the composition of the painting are clearly discernible. The event depicted is recorded by all the Gospel writers; Mark's Gospel tells of the baptism of Jesus in these words:

In those days Jesus came from Nazareth of Galilee and was baptized by John in the Jordan. And when he came up out of the water, immediately he saw the heavens opened and the Spirit descending upon him like a dove; and a voice came from heaven, "Thou art my beloved Son; with thee I am well pleased."

The Spirit immediately drove him out into the wilderness. And he was in the wilderness forty days, tempted by Satan; and he was with the wild beasts; and the angels ministered to him.[5]

The second paragraph is quoted because it too speaks of the power of the Spirit, which had opened the heavens, descended like a dove,

[5] Mark 1:9-13.

and then later drove Jesus into the wilderness. Though the language is simple, sparse, and without any adjectives or interpretive comment, it speaks of a mighty vision, a supernatural event. El Greco pictures this event for us as indeed supernatural—a moment when the heavens open and God himself is seen seated above the clouds, a globe symbolizing the world held in his left hand and his right hand raised in the Greek gesture of blessing.[6] He is surrounded by cherubim and seraphim and all the heavenly hosts. Diagonally downward from God's person stream luminous clouds which focus finally about the dove descending. Light rays emanating from the dove lead us to the figure of Jesus, whose body forms a restless upward curve as he kneels at the lower left. He is surrounded by angels, the group at the left looking in adoration to the heavens. The kneeling angel at the right holds a garment in readiness for him. The Gospel text speaks of Jesus "coming up out of the water," yet El Greco represents him as kneeling on a rocky projection above the Jordan, which is a mere dark crevice between two rocky shelves of land. The Baptist steps forward from our right with a sea shell in his hand from which water issues over the head of Jesus.

John the Baptist is somewhat smaller in scale than the figure of Christ, and we are reminded of Grünewald's Crucifixion, in which a similar difference in scale exists between the Christ and the Baptist, and John speaks the words, "He must increase, I must decrease." When questioned by the multitudes and the Pharisees and Sadducees, John said he was not the Christ nor the prophet, but declared, "After me comes he who is mightier than I, the thong of whose sandals I am not worthy to stoop down and untie." [7] Christ in El Greco's painting is indeed mightier than the Baptist. His large, supple nude figure is like that of an athlete before a contest. Indeed, our text supports such an

[6] The so-called Greek gesture of benediction seen also in the CEFALU CHRIST (plate 10) is with the third finger and thumb joined in a circle, the other fingers extended. The Latin gesture of benediction, seen in the BEAU DIEU (plate 20), has the third and fourth fingers bent, the others extended.

[7] Mark 1:7.

interpretation, for immediately, being driven by the Spirit, Jesus wrestled with Satan in the wilderness.

The composition of this large altarpiece (over thirteen feet high by six feet wide) is based on an hourglass shape. The upper ovoid section is composed of God the Father and the heavenly hosts, the connecting link being the downward rushing cloud which divides and then stretches forth on either side, seeming to encompass the group on the banks of the Jordan which forms the lower ovoid. The upper and lower zones are thus linked by the propulsion of the Holy Spirit, and the spatial difference almost dissolves in the rushing relatedness of the two zones. The impetuous and momentary gestures send zigzags of movement from zone to zone. Indeed, tracing the essential movement from God the Father and his gesture of benediction, through the dove to the head of Christ, is a broken diagonal zigzag path where each of the three persons of the Trinity has his own identity and role, but also a curious unrelatedness to the others. Part of this effect may be due to the ambiguous spatial relationships. God the Father seems situated in a backward and upward curving space; the gush of lambent cloud seems to project forward, and the dove and upper part of Christ's body seem to be just at the picture plane. El Greco's event is enacted in the undefined and unnaturalistic space of the dream world and the ecstatic vision.

The effect of dynamic upward movement is achieved both by the greatly elongated figures and by the play across their bodies and faces of the peculiar whitish light which distinguishes most of El Greco's later paintings. Giulio Clovio, a painter of miniatures who knew El Greco as a young man in Rome, tells in one of his letters[8] how he went to see his friend on a fine spring day when everyone was strolling in the city streets and gardens. He was astonished, on coming into El Greco's studio, to see the curtains drawn and the room in darkness; the artist was seated, not working, and in answer to Clovio's query, said the light of day would disturb the light shining inside him. It is

[8] Theodore Rousseau, *Metropolitan Museum of Art Bulletin,* June, 1959, p. 255.

this inner light, not the light of day or night, which illumines El Greco's ecstatic scene of the baptism.

El Greco's elongated figures have led some critics to seek explanations outside the realm of art and stylistic categories. Opticians have declared that he suffered from astigmatism; psychiatrists thought he suffered from mental disorders. We have only to look back at the late Michelangelo and Tintoretto, and ahead to the elliptical powerful images of Rembrandt, to realize how irrelevant this kind of criticism is. The ecstatic angel at the left who stands, or rather levitates, is a greatly elongated figure with one arm raised and palm turned heavenward. As nearly as one can guess, this heavenly representative is thirteen or more heads tall. The angel's head is tiny and ovoid, the upper torso slender and proportioned to the head and upthrust arm. But the hips and thighs and lower legs are broader, heavier, and longer, as if seen in a strange distorting mirror. The feet are depicted without the relationship to the ground that Fra Angelico's Christ has (plate 29), but with the weightless downward position of the levitating apostles of THE PENTECOST (plate 14).

Studying this angel, we see how far El Greco has departed from the naturalism of the Renaissance. Botticelli's and Van Eyck's Gabriels are both clearly delineated and their garments faithfully described. El Greco is heedless of the textures and proliferating detail that enchanted Van Eyck (plate 44) and equally without regard for the sensuous quality of sinuous line that so delighted Botticelli (plate 32). His angel's head is broadly painted; there are heavy patches of shadow eating into the contours. These outlines tend to blur or to sink into the background. Quick touches of brilliant white highlight the upturned eyes. A few spontaneous strokes delineate the ear. Note the upward thrust and twist of the narrow head as it presents to our eyes parts of the face daily observed by us, but not a part of our visual recollection of any one individual or type—the area under the chin, the base of the nose and nostril cavities, the lower eyelid. The neck seems inordinately long and thick for the proportions of the face. But the whole

unity seems to express that yearning toward the divine which lies at the heart of El Greco's expression.

The strange postures, exaggerated elongations, and deformations of the human body serve the purpose of communicating emotion to us, the observers. But if we study the individual figures we discover a curious thing. Their postures and facial expressions are less a sign of their *own* involvement in the event than they are a kind of visual stimulus to *our* involvement. The precarious posture of the Christ and the relaxed gesture of the Baptist are not expressive of their inner experience of the meaning of the event, as are the attitudes of Giotto's mourners over the dead Christ (plate 26). Giotto's John, who leans over the Christ, his arms wing-spread, and Mary, in her agonized attempt to encompass her dead son as she holds him across her knees and peers into his face, both vibrate with grief. Their postures, gestures, and facial expressions seem the inevitable expression of their suffering. We are drawn into the meaning of the event through them. We identify ourselves with them and *feel* the event through them. This is not true of any of the figures in El Greco's altarpiece. They are a part of a symphony of movement, light and shade, and color, which when taken altogether, sweeps us into the ecstatic mood of the moment in which the barriers between heaven and earth are transcended and God spoke these words, "Thou art my beloved Son; with thee I am well pleased."

It is quite evident that El Greco did not try to re-create for us the scene of the baptism as it occurred historically. We are looking upon a picturing of the event in which space is fluid and ambiguous, figures dissolve, and reality is dematerialized. But as we study the painting, the fluent, lambent, liquid flow of the forms increasingly impresses the sensibilities. The ovoid shape of the hourglass composition suggests womblike cavities, and we are reminded of the deeper meaning of baptism as rebirth. The elderly Nicodemus who went to see Jesus by night was told that " 'unless one is born anew, he cannot see the Kingdom of God.' Nicodemus said to him, 'How can a man be born when he is old? Can he enter a second time into his mother's womb and be born?'

Jesus answered, 'Truly, truly, I say to you, unless one is born of water and the Spirit, he cannot enter the kingdom of God.' " [9]

The waters of baptism are the uterine waters of a new birth. Thus the basic structure of El Greco's composition, with its double womb shape and its pervasive liquidity, refers to the deeper implications of the meaning of baptism, as a spiritual regeneration for those who would enter the kingdom of God.

Bernini's TRANSVERBERATION OF ST. THERESA

The austerity of El Greco's mysticism is apparent when we compare his works with those of a somewhat later Italian artist, Giovanni Lorenzo Bernini (1598-1680). Bernini, like El Greco, often depicted the saints in his masterpieces. But where El Greco's figures dissolve into nebulous backgrounds, Bernini's live, move, breathe, and palpitate visibly before us. Where El Greco's saints become immaterial and insubstantial, Bernini's saints are so vibrant with life that the marble of his statues seems more fleshly than flesh itself. We feel the rhythm of the saints' bodily being, sense the sharply indrawn breath, or the accelerated beating of their impassioned hearts.

Looking upon Bernini's ST. THERESA (plate 64) sinking back upon a cloud in the presence of a winged angel who gazes on her with a seraphic smile, we stand in wonder at the great skill of the sculptor who, in hard, resistant marble, can create figures of such complexity, and supple, soft, lifefulness.

But the subject matter also arrests us. We recall the thirteenth-century's St. Francis who preached to the birds, and tamed the wild wolf of Gubbio, and freed the wild doves. Francis saw all life as harmonious and knew no barriers between the natural world and man. His miracles were acts of mercy and showed a compassion for all living things. But the sixteenth-century saints are of another kind. Born at a time when the Roman Catholic Church was fighting the Protestant Reformation without, and endeavoring to work a reformation within, these saints

[9] John 3:3-5.

express a more fervid, more intense, and passionate experience of God. In describing the saints of this period, Mâle remarks that whereas the saints of the Middle Ages wrought miracles, these "saints of the Counter Reformation *were* miracles. They all possessed the gift of vision, the aureole of ecstasy which astonished their contemporaries and inspired the wonder of succeeding ages. . . . They are like explorers returning from a journey into another world. They have seen God face to face." [10]

In 1622 Theresa was canonized along with three other sixteenth-century saints, and the saint's own record of one of her ecstatic visions, her Transverberation, or the piercing of her heart by the arrow of divine love, was singled out in the official bull of canonization. The artist Bernini used Theresa's own words as the basis for his iconography:

The angel was not big, but little, and most lovely. The burning of his face showed him to be one of those spirits of a very high order who seem all flame and are probably cherubs, though they never tell me their names. I saw in his hand a long golden dart whose steel tip burned a little. This he thrust again and again through my heart and forced into my very bowels, which I felt him pull out with the dart, leaving me flaming with the love of God.[11]

The pain was so great that I screamed aloud; but simultaneously I felt such infinite sweetness that I wished the pain to last eternally. It was not bodily, but psychical pain, although it affected to a certain extent also the body. It was sweetest, caressing of the soul by God.[12]

The sixteenth-century saints suffered the consuming longing to see God face to face, to hear his voice, to touch him—to experience a physical evidence of his presence, not as proof of his existence but as a consummation of their longing for union with the divine.

To depict this vision of the saint Bernini employed not only his knowledge as a great sculptor but the skill of the experienced impresario. Bernini was an architect also, and he designed the chapel in which the TRANSVERBERATION OF ST. THERESA is placed. The statue is set in

[10] *Religious Art from the Twelfth to the Eighthteenth Century*, p. 179.

[11] Translation from A. Hyatt Mayor, "Visions and Visionaries," *Metropolitan Museum of Art Bulletin*, February, 1947, p. 163.

[12] Translation from Rudolf Wittkower, *Gian Lorenzo Bernini* (London: Phaidon Press, 1955), p. 29.

such a way that the angel and the saint appear to be part of an apparition, floating, framed by a stagelike proscenium, with a burst of light flooding down golden shafts from what seems an opening in the heavens above. The artist's intention is to create an environment in which the barriers between the beholder and the work of art may vanish, and we may experience it subjectively, knowing what Francis of Sales called the soul's liquefaction.

Studying the figure of Theresa, we see that she is dressed in the nun's habit, and the heavy material of her garments falls about her prostrate body in a multitude of rippling and resonant folds. A beautifully and classically proportioned foot hangs naked beneath her robe, reminding us that Theresa was the founder of the reformed Discalced Order of the Carmelites. This group adopted a severe Rule of Life and among the privations was the nun's going barefoot (unshod, or discalced). The body of the saint forms a deep crescent; her head falls almost lifelessly back; her mouth is open and nostrils distended; her eyes are shut, not in sleep, but in ecstatic self-surrender.

In discussing the complex position of Leonardo da Vinci's VIRGIN AND CHILD AND ST. ANNE (plate 34), we saw how Leonardo varied the movement of each part of the body along the axis.[13] But in studying Bernini's statue, we discover that the term "axis" is no longer appropriate for the analysis of these figures who bend and twist with an infinite number of permutations. With the sound knowledge of anatomy inherited from the artists of the Renaissance, Bernini treats the body always as an organic unity, but it is always seen in a moment of movement. This moment of movement is never, however, "frozen." It never resembles an instant caught and held by a camera, where all action seems suspended. Rather, all prior motion is implied in this crystallization, and the continuing movement also is suggested. We visualize, indeed experience, the forward movement of the angel's arm and hand holding the arrow. The nerveless hand of St. Theresa will move at any moment, and the foot will be drawn upward before our eyes. This immediacy of communication is achieved both by the

[13] See p. 108.

transitory positions of both protagonists and by the multiplicity of rhythmic folds in their garments. These set up eddying restless movements that are never resolved or contained but, like ascending arpeggios, delight the senses and contribute to our experience of pleasure by offering us the vivid contrast between the fainting, slumbrous flesh and the ever-moving, swirling folds of the saint's gown.

The angel's seraphic smile (plate 65) is a kind of sculptural counterpart to Van Eyck's smiling Gabriel (plate 47). But while Van Eyck's angel smiles secretly and immovably for all eternity, Bernini's cherub is visibly dimpling and its wind-tossed curls will, at any moment, form another pattern about the shapely little head.

Whereas Leonardo in his VIRGIN AND CHILD AND ST. ANNE and Michelangelo in the PIETA (plate 39) emphasized the boundaries of their groups by keeping their figures within the firm and substantial pyramidal form which contains them, Bernini denies all limits and boundaries. The contours of the figures, though in one sense clear, are entirely fluid. We have only to shift our stance and they would take on other and just as carefully conceived relationships. Though the group is located above an altar in a specific setting in which our view of them is defined, still the sculpture itself is more three-dimensional in design that Michelangelo's PIETA. Bernini has used large, vibrant, swinging curves for the bodies of the two protagonists. They open out away from, rather than bending in upon, each other, as would have been the case if a Renaissance artist had created the statue.

This fluid design, the large rhythmic lines of the composition, the cascading flow of the robes of the saint and the angel as well as the dramatic and otherworldly lighting contribute to the aura of rapture which the sculptured group communicates. The faces of the saint and the cherub have complimentary expressions. The angel's blissful smile is that of the giver, and the saint's face has the nakedness of utter submission, the ecstasis of the receiver.

Throughout the history of Christianity there have been ascetic spirits who thought they better served God by denying and chastising the flesh. Others have seen a manifestation of the divine in earthly

bodily beauty, and rather than chastising the flesh, they have yearned for its sanctification in the mystical moment of union with the divine, the moment when the body itself is so saturated with, and responsive to the Spirit that it becomes a passive instrument vibrant with the melodies of divine origin. Richard Crashaw, the seventeenth-century English metaphysical poet, saw this in the life of Theresa and wrote of her:

> O Thou undaunted daughter of desires!
> By all thy dower of lights and fires,
> By all the eagle in thee, all the dove,
> By all thy lives and deaths of love,
> By thy large draughts of intellectual day,
> And by thy thirsts of love more large than they,
> By all thy brim-filled bowls of fierce desire,
> By thy last morning's draught of liquid fire,
> By the full kingdom of that final kiss
> That seized thy parting soul, and seal'd thee His
> By all the Heavens thou hast in Him
> (Fair sister of the seraphim),[14]
> By all of Him we have in thee,
> Leave nothing of myself in me.
> Let me so read thy life, that I
> Unto all life of mine may die.[15]

Baroque Art

The art of the seventeenth century is called baroque. The term "baroque," meaning rough and irregular, was originally intended as a disparaging characterization. To the earlier critics who saw the acme of all art in the masterpieces of the High Renaissance, the open compositions and larger rhythmic schemes of the art of Bernini and Rubens

[14] The seraphim and cherubim are two of the angelic orders, the seraphim usually ranked above the cherubim, that is, closer to God. Theresa's statement refers to a cherub, whereas Crashaw's poem speaks of her as "sister of the seraphim."

[15] Richard Crashaw, "The Flaming Heart, upon the Book and Picture of the Seraphical Saint Teresa."

seemed flamboyant and extravagant. But since the time of the critic Heinrich Wölfflin, whose *Principles of Art History* opened up an understanding of the style of baroque art, there has been a reevaluation of its style and significance. The expressive power of baroque art is now recognized by all serious critics and historians of art.

We have noted Bernini's relationship to such mannerist artists as El Greco and his inheritance from the Renaissance. Wherein is Bernini's art specifically "baroque"? First, in regard to subject matter the very choice of the visionary and mystical occurrence is typical of baroque iconography. The saints have always been depicted in religious art. But prior to the baroque period they were shown with their attributes, for example, Peter with his keys in the Vézelay tympanum (plate 14); or with donors, as the Margaret and Mary Magdalene in the PORTINARI ALTARPIECE (plate 48); or enacting miracles as seen on the early Christian sarcophagi; or enduring martyrdom, as in Donatello's THE PENITENT MAGDALENE (plate 30). The baroque period most typically represents the saints as visionaries, at the moment when the barriers between reality and the supernatural are transcended.

Each period which we have studied has had its own typical kind of subject matter. The early Christians, who lived in a hostile world, most often portrayed subjects having to do with salvation and the hope of eternal life (plate 7). Later, Byzantine art mirrored eternity, focusing upon Christ as Judge and Ruler (plate 10). The Romanesque period used apocalyptic subjects and in particular the Last Judgment whereas the later medieval world centered about Notre Dâme, the Mother of the divine Child (plate 22). With Giotto and the early Renaissance the human aspects of the Gospel stories (plate 28) received the major accent in Christian art. In the latter half of the fifteenth century dramatic and psychic content became explicit in the Gospel subjects used by artists like Donatello, Piero della Francesca, and Botticelli. The High Renaissance is characterized by a great choice of biblical subjects in which there is a blending of the human and the dramatic elements. Though all the iconography derives from the Old Testament, Michelangelo's Sistine ceiling is, as De Tolnay says, the most representative

work of this period. Like the PIETA (plate 39), it embodies the harmonious "conception of earthly beauty as a manifestation of the divine idea." [16] It is interesting to note that not one member of the great triumvirate of the Italian High Renaissance—Leonardo, Raphael, Michelangelo—created a great Crucifixion. It was the northerner Grünewald who painted the atoning sacrifice of Christ (plate 52). And Grünewald, as was pointed out in the foregoing chapter, springs from a different iconographic and stylistic tradition.

Tintoretto and El Greco, the two mannerist artists whose religious works we have studied, stem from the tradition of the Italian Renaissance. Tintoretto, who worked largely for a religious confraternity, went back to the Gospel episodes of the life of Christ and to their Old Testament prefigurations for his subject matter. But he informs the traditional subject matter with a new spirit. Reality and unreality merge in his works, and his tall, eerily illumined figures prepare us for the insubstantial wraithlike figures of El Greco's visionary scenes. From Michelangelo's sculptural figures of the Sistine ceiling to the angular chrysalis-like figures of his final RONDANINI PIETA (plate 42), there is a movement away from the encumbrances of flesh and muscle to a substanceless figure which is dominated by the spirit. A similar contrast is seen between Michelangelo's Adam and Eve (plate 40) and El Greco's mannerist figures in his BAPTISM OF CHRIST (plate 62) almost a century later. It must be evident that these changes in the representation of the human body affect the way in which subject matter is represented and what it communicates.

Returning to Bernini after reviewing these points, we now see that his TRANSVERBERATION OF ST. THERESA is, in one sense, much nearer to the ideas and ideals of the High Renaissance than to the evanescent figures of his nearer contemporary El Greco. Bernini's St. Theresa is still governed by classical ideals of facial and bodily beauty. Her straight nose, rounded chin, and full jawline derive ultimately, like Michelangelo's Mary of the PIETA and Botticelli's and Leonardo's

[16] *The Sistine Ceiling*, p. 116.

Madonnas, from classical types. The shapely feet with long and carefully articulated toes and the large hands with fleshy palms and tapering fingers are also classically derived. The angel also comes to us from the classical past, from the half-robed Victories of the Hellenistic world. The sensuality of this cherub's body with its fullsome, elastic curves is reminiscent of Praxitilean Aphrodites and marble fauns.

The artists who were born in the Mediterranean area and were surrounded by the monuments of the classical past tended to see in the human body and physiognomy a reflection of the divine. And they recalled that in Genesis the Lord God made man in his own image. Thus when this mortal is touched by divine fire and lives for an instant in God's presence, the body is not negated, but it is ravished by the experience. Those who radically separate body and spirit tend to see only eroticism in the spirit-saturated sensuality of Bernini's TRANSVERBERATION OF ST. THERESA. Several decades before Bernini created his statue for the Cornaro Chapel of Santa Maria della Vittoria in Rome, the English prelate and poet John Donne wrote a sonnet which in literary form expresses an analogous God-filled moment:

> Batter my heart, three person'd God; for, you
> As yet but knocke, breathe, shine, and seeke to mend;
> That I may rise, and stand, o'erthrow mee,'and bend
> Your force, to breake, blowe, burn and make me new.
> I, like an usurpt towne, to'another due,
> Labour to'admit you, but Oh, to no end,
> Reason your viceroy in mee, mee should defend,
> But is captiv'd, and proves weake or untrue.
> Yet dearely'I love you, 'and would be loved faine,
> But am betroth'd unto your enemie:
> Divorce mee,'untie, or breake that knot againe,
> Take mee to you, imprison mee, for I
> Except you'enthrall mee, never shall be free,
> Nor ever chast, except you ravish mee.[17]

[17] "Holy Sonnet XIV."

REMBRANDT

CHRIST PREACHING

The religious art of Rembrandt is remote from the spirit pervading Bernini's TRANSVERBERATION OF ST. THERESA. Seven years after the completion of this work, Rembrandt made the etching of CHRIST PREACHING (plate 68). In this quiet scene, small in size but grand in conception, observe for a moment the face and figure of Jesus and the woman seated to his left at his feet. Here, as in the Bernini statue, divinity and humanity are juxtaposed. The angel of Bernini's statue is the agent of the Almighty; Rembrandt's Jesus is indeed the Son of the Almighty. Bernini's St. Theresa as Crashaw pictured her, is the "undaunted daughter of desires," both eagle and dove. Rembrandt's listening woman (plate 69) is one to whom the good news is just now being told, and who in pensive inwardness is pondering the meaning of the words of Jesus of Nazareth. Bernini's statue embodies a possible dimension of the divine-human relationship after the moment of revelation and commitment. Rembrandt's etching speaks of the moment when the good news is proclaimed:

Soon afterward he went on through cities and villages, preaching and bringing the good news of the kingdom of God. And the twelve were with him, and also some women who had been healed of evil spirits and infirmities. . . . And when a great crowd came together and people from town after town came to

him, he said in a parable: "A sower went out to sow his seed; and as he sowed, some fell along the path, and was trodden under foot, and the birds of the air devoured it. And some fell on the rock; and as it grew up, it withered away, because it had no moisture. And some fell among thorns; and the thorns grew with it and choked it. And some fell into good soil and grew, and yielded a hundredfold." As he said this, he called out, "He who has ears to hear, let him hear." [1]

It is a hushed and attentive group to whom Jesus here speaks, those who seem to have "ears to hear." However, the passage quoted is not given as the source for Rembrandt's iconography; rather it suggests the kind of biblical passage that Rembrandt might have had in mind when he etched this composition.

As our eyes move from face to face in the group gathered around Jesus, we see that each is self-absorbed as well as attentive to the words of the Master, as though each individual were pondering the meaning of the words for his own life and destiny. Jesus stands before them, his hands raised, the palms open in a spontaneous and gentle gesture. Though the gesture has the naturalness of a momentary movement, it has grandeur, too, and recalls the ancient attitude of prayer. Jesus' face has an inwardness of expression, as do the faces of his listeners. Nothing of the forceful or dynamic evangelical preacher is present here. Though very human and very humble, Rembrandt's Christ is a vessel for the divine will. Whereas St. Theresa's flesh and spirit were ravished by God, the Jesus of Rembrandt is wholly human yet transparent unto God. Rembrandt has etched a simple elliptical line haloing the head of Christ, but the whole figure has a soft luminosity, as if glowing from within.

The etching has grandeur in its composition as well as in its content. The verticality of the figure of Christ is emphasized by its lambency and by the light-touched pilaster behind. Subsidiary vertical emphases are found in the monumental turbaned figure at the lower left and the pilasters at the right. The landing on which Christ stands and

[1] Luke 8:1-8.

upon which his listeners sit, lean, and stand is a strong horizontal re-
iterating the horizontal boundaries of the plate at the top and bottom.
Two arch shapes draw the structure together—the darkened vaulting
at the right with its opening into the street and the curving shape
made by the succession of figures starting with the turbaned man at
the left, coming along the floor where a top with a dangling string
lies and a child sprawls, to the woman with the babe in her arms, and
to the bearded ancient who presses attentively forward. Within this
latter arching form there are many secondary curves. For instance, one
which can be carried from the string of the top up to the left along
the leg of the man seated on the landing to the arm and head of the
man wearing a large beret. All of these multifarious movements draw
the composition together into a unity.

A word should be added about the technique of etching, which, next
to drawing, was Rembrandt's favored medium. Etchings are printed
from a copperplate which has been "etched" with the design of the
artist's creation. The copperplate is prepared to receive the design by
being coated with a waxlike layer. The artist then takes an etching
needle and draws his design onto the soft wax-covered surface. Where
the needle touches the surface, the coating is pushed back and the
copperplate exposed. When the design is completed, the plate is im-
mersed in an acid bath which eats away the copperplate in the areas
where the etching needle has exposed it. The wax coating is then re-
moved and the plate inked, filling the lines which are now bitten into
the plate. The surface of the plate is wiped clean, and after heavy
pressure on a damp sheet of paper, the impression of the etching is
pulled.

Since the design is *drawn* on the plate, and not incised as was
Dürer's engraving for THE KNIGHT, DEATH, AND THE DEVIL (plate
54), the lines have the sponaneity and variety of a drawing. After
the etching process Rembrandt added to his design some drypoint
lines. These are cut directly into the soft copper by a sharp point which
causes a tiny edge of the cut-away copper, called the burr, to roll up
at the sides of the line. When the plate is inked these edges retain addi-

tional ink and cause the blurred, velvety blacks we see in Christ's beard, in the shadow beneath his left hand, along his garments at the right, and between his feet, as well as in most of the deeply shadowed areas of the composition.

The fact that the design is etched directly onto the plate allows for the printing of many "originals." This was an important factor at a time when there was neither photography nor mechanical reproductive processes. It enabled the artist to disseminate his own works, and by purchasing prints from, or trading them with, other artists, he was able to study and learn from others. But more important for us is the fact that the small scale of these works of art means that the artist intended them for individual study at close range. Since they are neither large in size nor located in semipublic places, they differ from Tintoretto's San Rocco paintings, or Giotto's frescoes in the Arena Chapel.

Rembrandt's religious etchings were not made for the church, or for the pastor's study, or necessarily even for the devout. They had no decorative or liturgical function. They were intended for the individuals who had no means to commission the artist but delighted in his works. We know that Rembrandt knew many collectors who eagerly sought his etchings. Those who were interested in the etchings were not all churchgoing Christians who wanted them for their specifically religious content. Some were collectors of art whose first interest was in connoisseurship. Thus, in the seventeenth century we witness a phenomenon also characteristic of the twentieth century— the artist who creates work of art with religious subject matter of his own choice apart from commissions from the church, and finds a buying public among art collectors rather than among the churches. Thus the organized church is bypassed at both the clerical and the congregational levels. The spirit of the artist speaks directly to the spirit of the art collector without the mediating influence of the church.

Although Rembrandt's prints in many ways can be termed a characteristic and logical development of Protestant religious art, this kind of "unchurched" religious art cannot be confined to any

creed or agglomeration of creeds. Most of the art of Georges Rouault, the famous Roman Catholic religious artist of our century, was not commissioned by the church, and with few exceptions Rouault's religious paintings are in the hands of collectors and museums, rather than in Roman Catholic churches.

Returning to Rembrandt's technique, we see that by using dry-point generously, as well as closely placed parallel lines which tend to merge into a single darkened area, Rembrandt shadows his figures. These shadows have a strongly expressive function as well as a structural role. The play of light and dark does not seem as arbitrary as it does in El Greco's BAPTISM OF CHRIST (plate 62) or even in Tintoretto's LAST SUPPER (plate 60). Yet it is not realistic in the literal sense of being explainable in terms of definite sources of light. Again it must be noted how the artists who see and therefore create in the naturalist or realist styles select and modify, exaggerate or reveal, the data received by their senses, rather than mirror reality. In the case of Rembrandt the lights and darks are manipulated to communicate spiritual content. In this small etching the velvety black shadows help to underline the separateness and self-absorption of the individuals who make up the group. We can make out twenty-seven persons about Jesus, and more are suggested. Yet the isolation of each is implied by the expressions and the postures, and by the shadows. If we look back at Bruegel's crowd on the slopes of Calvary (plate 56), we are impressed once again by the anonymous characters of Bruegel's peasants over against the individuality of each of Rembrandt's listeners. In both cases the artist used the garb and physiognomies he knew from daily existence, but Bruegel's blank, round-faced peasants have none of the individuality of the compassionately drawn listeners of Rembrandt.

These listeners are a memorable group. As our eyes move from face to face we find that each reminds us of someone we have once known —if not through personal acquaintance, then through the fleeting yet real visual images that are presented to the mind's eye by great

literature. There is the old man seated at the right with one hand stroking his chin, his eyes focused beyond this occasion as he meditates on the words he hears. There is the stolid mother seated foursquare and self-sufficient upon the floor next to him, the tonsured head and emaciated face of the man at the far left, the plump and troubled merchant whose face is in full light at Jesus' right. Rembrandt candidly depicts, with a few deft strokes, the wrinkled, aged skin, the craggy features, the pendent double chins, and scraggly beards. But never does he stop at mere description. Nor does he, like Hugo van der Goes in his portrait of the youngest shepherd (plate 48), become overly fascinated by the idiosyncrasies of the model—his irregular features or mawkish expression. And although Rembrandt possessed all of the qualities of a brilliant caricaturist—the wonderful instinct for the expressive posture and turn of the head and the incredible skill in using the few lines which capture this in minimal but quintessential contours—he is never merely a caricaturist. No matter how humble or ugly his subject, he sees and communicates the intrinsic worth and dignity of each single human being.

Christ appears before us with both arms raised in three other works of art which we have discussed. But in each of these the gesture was related to a sacramental or miraculous act. The Christ of the Byzantine mosaic (plate 9) has arms outstretched in the act of blessing the loaves and fishes, and his gesture has the majesty appropriate to the time-transcending sacramental rite. The Christ at Vézelay (plate 15) has his great hands raised, and rays of spiritual power like visible electric current pass from his fingertips to the apostles at the moment of the descent of the Holy Spirit. Fra Angelico's Christ of THE TRANSFIGURATION (plate 29) is closer to Rembrandt's in its naturalism of face and figure, but far from it in content. The emphatic, erect frontality of the transfigured Christ with arms pressed to the sides in anticipation of the cross, gives a hieratic and otherworldly aura to the posture. In contrast to these three images of Christ, Rembrandt's Christ is richly human. His face seems worn, and its expression is in-

ward, as if the words spoken were given rather than proclaimed. The gesture of the hands has the simplicity that comes when the movement is a true expression of the deeper inner being:

He was in the world, and the world was made through him, yet the world knew him not. He came to his own home, and his own people received him not. But to all who received him, who believed in his name, he gave power to become children of God; who were born, not of blood nor of the will of the flesh nor of the will of man, but of God.[2]

The type of Christ which Rembrandt portrays here has the physical characteristics of the eastern type. The long-haired, bearded Christ of mature years was seen also in catacomb paintings, in the mosaic at Cefalú (plate 10), and in the Renaissance paintings. Yet for all their variety, most of these tended toward an idealized or a hieratic type of Christ. Rembrandt, on the other hand, has endowed his image of Christ with a rich humanity and immediacy seen in none of the previous works. These characteristics derive partly from Rembrandt's many studies of the young men of the Jewish quarter of Amsterdam where he lived in his later years. He made paintings, drawings, and etchings of the young Jews who seemed to him to have the Christ-type features, studies which then formed the basis for the image we see in this etching and in his other religious masterpieces.

More important, however, than the physiognomy of this Christ-image is its spiritual content. Rembrandt represents Jesus as the bearer of compassion, mercy, and acceptance. The authority with which this Christ teaches and proclaims the good news and speaks of the forgiveness of sins is of divine origin. And yet he is wholly human. "Not a high priest who is unable to sympathize with our weaknesses, but one who in every respect has been tempted as we are, yet without sinning." [3]

[2] John 1:10-13.
[3] Heb. 4:15.

THE AGONY IN THE GARDEN

The humanity of Christ is poignantly portrayed by Rembrandt in a tiny etching which he executed about 1657, in his early fifties (plate 70). The subject is THE AGONY IN THE GARDEN:

> And they went to a place which was called Gethsemane; and he said to his disciples, "Sit here, while I pray." And he took with him Peter and James and John, and began to be greatly distressed and troubled. And he said to them, "My soul is very sorrowful, even to death; remain here, and watch." And going a little farther, he fell on the ground and prayed that, if it were possible, the hour might pass from him.
>
> "Father, if thou art willing, remove this cup from me; nevertheless not my will, but thine, be done." And there appeared to him an angel from heaven, strengthening him. And being in an agony he prayed more earnestly; and his sweat became like great drops of blood falling down upon the ground.[4]

Rembrandt has brought us in close upon the angel and Christ, who both kneel on a hillock in the foreground. At the lower left Peter, James, and John lie lost in slumber. Looming in the background we see the buildings of the city wall. Through a gate in this wall "a band of soldiers and some officers from the chief priests and the Pharisees, . . . with lanterns and torches and weapons"[5] follow their guide, Judas, who is about to betray his Master. The way to Calvary is prepared for Jesus.

Giotto and many of the earlier artists represented the traitorous kiss of Judas rather than the Agony in the Garden. But Rembrandt, rather than focusing upon the perfidiousness of man, shows the lonely and tortured agony of Christ who in his humanity cries out, "Remove this cup from me."

Later Renaissance artists represented the same event by showing an angel fluttering down from the heavens, proffering a chalice to the Christ who kneels with composure in the attitude of prayer. In that

[4] Mark 14:32-35; Luke 22:42-44.
[5] John 18:3.

setting the strengthening has already been accomplished and the chalice has a double symbolism, a reference to the grace of God and to the Eucharist. But Rembrandt goes to the very core of the moment of the spiritual suffering of Jesus. Rather than literally showing the "sweat like great drops of blood," Rembrandt represents Jesus with eyes closed in pain, cheeks hollow, his body limp and without power of movement. The succoring angel bodily sustains Jesus, his strengthening arms sturdily encircling his chest.

In looking at this tiny masterpiece (four by three and a quarter inches) as a design we find that its abstract structure is as carefully composed as a painting by Mondrian. Rectangles, cubes, and squares are locked together, giving unity and variety to the arrangement of the various shapes. The basic structure is built up architecturally. The grassy plateau on which Christ and the angel kneel forms a low oblong, their figures a cube, the city walls another oblong, and the buildings beyond a cubical shape. Diagonals made by the low black clouds, the shafts of heavenly light from the left, the angel's wing, and the edge of the hillock in the foreground, cut across or draw together the horizontal-vertical structure of the whole. Much depth is indicated by the contrast between the size of the foreground figures, the sleeping apostles, and finally by the tiny outlined band who approach through the city gate. Rembrandt suggests these spatial transitions by leaving some undefined light-filled areas and by shrouding other areas in the deepest shadows. Here there is nothing of the dramatic and sometimes arbitrary pushing back into space exhibited in the mannerist style.

Turning back to Botticelli's ANNUNCIATION (plate 32), where we find a kneeling angel in much the same position as Rembrandt's angel, we note that Botticelli's Gabriel is delineated with descriptive and musical lines. These lines form the contours for the profile, the pose, or the garments but, nonetheless, speak to us as a kind of lyrical calligraphy. Rembrandt's angel is wholly made up of lines. But the lines tend to lose their directional and descriptive function. Instead, their function is to build up form by clusters and constellations of

lines. We see the immense variety of these lines ranging from the delicate, hairbreadth drypoint lines which touch the cheeks of Christ to the heavily bitten, blunted hatchings on the angel's wings. The blurred rich blacks are the result of the drypoint lines, where the rolled-up edge of copper holds additional ink which prints them as a deep black area.

Rembrandt uses the quality of the line and the deep rich blacks and the gleaming light areas to suggest religious content. As we have seen, lights and shadows are used suggestively rather than descriptively. And their communication is to our psyche, rather than just to our emotion. El Greco and Tintoretto also used light and dark contrasts effectively, but they involved us through our emotion. Rembrandt speaks to us by inviting us, indeed compelling us, to identify ourselves with Christ in his suffering. The beholder is drawn into this work, feeling at one with the desolation and anguish of Jesus.

Of the Christ-images studied in this book this is the only one which evokes such a response from the viewer. The Byzantine Christ-images have the very opposite effect. They delineate the absolute otherness of Christ. The idealized Christ-types of the Renaissance also put a barrier between human frailty and the divine Son of God. In showing us a human Christ at his moment of greatest desolation Rembrandt has shatteringly presented to us the truth of the Incarnation.

THE DESCENT FROM THE CROSS

When it was evening, there came a rich man from Arimathea, named Joseph, who also was a disciple of Jesus. He was a member of the council, a good and righteous man, who had not consented to their purpose and deed, and he was looking for the kingdom of God. [He] took courage and went to Pilate, and asked for the body of Jesus. And Pilate wondered if he were already dead; and summoning the centurion, he asked him whether he was already dead. And when he learned from the centurion that he was dead, he granted the body to Joseph. Nicodemus also, who had at first come to him [Jesus] by night, came bringing a mixture of myrrh and aloes, about a hundred pounds' weight. They took the body of Jesus, and bound it in linen cloths with the spices, as is

the burial custom of the Jews. [Joseph] laid it in his own new tomb, which he had hewn in the rock; and he rolled a great stone to the door of the tomb, and departed.[6]

Rembrandt's painting of this event was done in the 1650's, the same decade when he executed the two etchings which have been discussed in the foregoing pages.

In this somber, tender nighttime scene (plate 67), Joseph and the elderly Nicodemus are seen holding the lifeless body of their Master as they carefully lower it from the cross. Two ladders are set against the crossbeam, and those who have disengaged the torn hands stand upon the rungs of these ladders. Much of the body and face of Joseph are hidden from us, as he has his back to us and with one arm clasps the torso of Jesus. Nicodemus supports the lower part of Jesus' body as one would a child. His sorrowing face is partially covered by a fold of the linen shroud. We recall that the visit of Nicodemus to Jesus was by night, when Jesus said to him, "And as Moses lifted up the serpent in the wilderness, so must the Son of man be lifted up, that whoever believes in him may have eternal life." [7] Here it is Nicodemus who is lifting up the Son of man. Jesus had said to him,

God so loved the world that he gave his only Son, that whoever believes in him should not perish but have eternal life. For God sent the Son into the world, not to condemn the world, but that the world might be saved through him. He who believes in him is not condemned; he who does not believe is condemned already, because he has not believed in the name of the only Son of God. And this is the judgment, that the light has come into the world, and men loved darkness rather than light, because their deeds were evil. . . . He who does what is true comes to the light, that it may be clearly seen that his deeds have been wrought in God.[8]

Nicodemus has "come to the light," yet he holds in his arms the lifeless body of his Master. The myrrh and aloes are seen in a vessel at

[6] The biblical passages here quoted are a compilation of the relevant verses in the Gospel narratives: Matt. 27:57, Luke 23:50-51, Mark 15:43-45, John 19:39-40, Matt. 27:60.

[7] John 3:14-15.

[8] John 3:16-21.

the foot of the ladder at the left. At the right Mary the Mother of Jesus collapses into the arms of one of the group of women who had watched the Crucifixion, "looking on from afar . . . among whom were Mary Magdalene, and Mary the mother of James and Joseph, and the mother of the sons of Zebedee." [9]

The Mother of Jesus here represented is far from the maidenly beauty of Michelangelo's Mary of the early PIETA (plate 39). Rembrandt's Mary is middle-aged, worn, and haggard, and emptied of all will or purpose for existence. Her arms are supported by anxious friends, and her pendent lifeless hands have the quality of truth which is peculiar to Rembrandt's art. Like the gesture of Jesus in his etching CHRIST PREACHING, the position of Mary's hands has the utter simplicity of a natural unconstrained movement expressing the inner movement of the spirit. In life and in art gesture is so seldom a direct, and therefore inevitable, expression of a spiritual state that when we do witness it, it comes as a kind of shock and has the impact of a revelation.

The composition is focused upon the lifeless body of Christ which seems visibly to sink into the arms of Nicodemus. The three ladders make a wedge-shaped frame for this movement, and within this high triangle we see two interlocking tear-shaped areas. Both have their narrow apex in the upright left arm of Christ. The first and smaller ellipse moves downward along the arm and head, and curves under the buttocks, across the knees, along the shoulders of Nicodemus and up along the linen shroud. The second tear-shaped form moves downward along Christ's forearm and the darkened fold of the linen winding cloth, and then goes behind the legs of Christ and continues downward along the light-touched folds of the shroud, curves to our right and upward along the shoulder and profile of the turbaned man in the lower center, and upward along the edge of the ladder to terminate, as it began, with the hand of Christ. No form could be more appropriate for the expression of grief than the tear-drop shape with

[9] Matt. 27:55-56.

its full, lower curve and attenuated and fragile upper contours. Rembrandt has set the jagged diagonals of the lifeless body into the elliptical shapes, and these diagonals create a dissonance which, in formal terms, adds complexity to the composition but in terms of communication accents the pathos of the event.

The weightful downward movement of the body and winding-sheet are balanced and buttressed by the solid rectangle formed by the group of figures at the foot of the cross. Within this area the vivid accent is upon the face of Mary the Mother. We note that the angle of her head repeats that of the old Nicodemus, and that her pallor is accenuated by the light which bathes her features, just as the face of Nicodemus is also accentuated by the light.

The illumination for Nicodemus' face and Christ's torso comes from a candle held by the disciple standing on the ladder at the right. He holds the candle in one hand and with the other he shields the flame (plate 66), covering from our eyes the heart of the flame, and setting off the light-touched outline of his expressive hand. The motive of the lighted candle or torch which is shielded by the hand of one of the persons in the picture area was used frequently in the seventeenth century, particularly by that strange and lately resurrected artist, Georges de La Tour. But when used by Rembrandt, the motif becomes the means of highlighting psychic content and spiritual depth. We have noted the important role of the light and dark emphases in the etchings of Rembrandt. Again it must be noted that Rembrandt's light has not the eerie and unreal quality of El Greco's light, nor the dramatic touches of highlighting which Tintoretto used. Instead, it is used to focus our eyes and our spirits upon the core and center of his composition.

If we look again at Michelangelo's Christ of the St. Peter's PIETA the harmonious curves which flow one into another provide a vivid contrast with the jagged contours of Rembrandt's Christ. The arm of Rembrandt's Christ which is steadied by the disciple who leans over the crossbeam is ugly. The forward and sideways slump of Christ's head has an awkwardness that almost makes it seem disjunc-

tive with the shoulders. Christ's right arm hangs down limply, creating an awkward angle. But these contours and movements, which in formal terms can only be described as oblique and jagged and dissonant, in terms of content express the terrible suffering that has racked Jesus' body and has left it at last a broken and pitiable thing— "This is my body which is broken for you." [10]

Having looked at three of Rembrandt's works of art with religious subject matter, we turn now to examine the place which this kind of art holds in his total production. Rosenberg has shown that the number of Rembrandt's religious works greatly exceeds every other category, that he etched, drew, or painted about 850 religious works whereas the next largest category is that of portraits, numbering about 500. Of the religious works there are more than 600 drawings. Most of these, Rosenberg points out, were not made as preparatory drawings for painting, but "clearly manifest the artist's inner urge to deal constantly and intensely with religious subjects of the most varied sort." [11] Of the approximately 160 paintings with religious subject matter, we do not know how many were commissioned, since records of commissions are few. But those which were commissioned were not done for the churches. In Rembrandt's day Holland was Calvinist in its religious orientation, and the austerity of its churches and their lack of paintings reflect the strictures of the Reformed tradition against religious art.

Calvin did not forbid art as such, and granted that "sculpture and painting are gifts of God," but he required that the practice of art should be kept "pure and legitimate. . . . Therefore, it remains that only those things are to be sculptured or painted which the eyes are capable of seeing: let not God's majesty, which is far above the perception of the eyes, be debased through unseemly representation." [12] Despite Rembrandt's enormous productivity in religious art, his works remain

[10] These are words spoken as the bread is partaken in some of the Protestant Eucharistic liturgies.

[11] Jacob Rosenberg, *Rembrandt* (Cambridge: Harvard University Press, 1948), p. 101.

[12] John Calvin, *Institutes of the Christian Religion* (Philadelphia: Westminster Press, 1960) I. xi, 112.

within the limitations implied by Calvin's directive. God's acts of crea-
tion, which were depicted by artists throughout the centuries using
grandly anthropomorphic images, were never painted by Rembrandt.
Rembrandt did not use subjects having to do with doctrine such as the
Trinity, or apocalyptic subjects such as the Last Judgment, or historical
biblical subjects in which a mass scene is involved (such as Bruegel used
for his painting CHRIST CARRYING THE CROSS). He was interested in re-
ligious subject matter which showed the divine-human encounter, the
moment of recognition and communication. The divine-human en-
counter as expressed by Rembrandt is not, however, the ecstasy of self-
surrender as experienced by Bernini's saints, but rather resides in the
profound inner psychic moment of recognition. Throughout Rem-
brandt's life he was fascinated by the Emmaus encounter, and he fre-
quently depicted this moment of revelation for the two disciples, who
in the breaking of the bread recognized the risen Christ. It is significant
that Rembrandt frequently represented the supper at Emmaus, rather
than the Last Supper.[13] The Last Supper with its dramatic focus and
eucharistic and liturgical implications did not interest the artist Rem-
brandt as much as did the intimate moment of confrontation and
recognition.

We also must note that as Rembrandt grew older, the number of sub-
jects having to do with the Passion of Christ increased. The large etch-
ings of the THREE CROSSES and the ECCE HOMO have the complexity
and grandeur of large-scale paintings, and other subjects such as Christ
at Gethsemane are repeated in varying interpretations. The increasingly
absorbing interest in Passion subjects did not, however, cause Rembrandt
to lose interest in the Old Testament stories that he depicted throughout
his lifetime. Subjects such as Abraham's sacrifice of Isaac, a group of sub-
jects relating to Joseph, and subjects having to do with David and Saul
occur frequently. Rembrandt gives to these Old Testament stories all
the depth of understanding and immediacy of an intensely personal in-
terpretation that he gives to his New Testament subjects. In studying

[13] Rembrandt did, however, make some studies after Leonardo da Vinci's LAST SUPPER, which
he must have known through engravings of the original.

these Old Testament drawings and paintings we are again aware of the ambiguities and difficulties in the term "Christian art." We can only conclude that Christian art cannot be limited to art which has specifically New Testament subject matter.

ABRAHAM'S SACRIFICE OF ISAAC

We have seen that the early Christian artists, the medieval sculptors, and even some mannerist painters, such as Tintoretto, depicted Old Testament subject matter. In most of these cases, however, the Old Testament event was seen as prefiguring events of the New Testament, as in the Scuola di San Rocco, where the Gathering of the Manna, Elisha Multiplying the Loaves, and the Paschal Feast are painted in panels adjacent to the LAST SUPPER (plate 60), as being prototypes of the Eucharist. In Rembrandt's work, however, the events of the Old Testament have a new autonomy and self-completeness. To verify this let us consider Rembrandt's etching of ABRAHAM'S SACRIFICE OF ISAAC (plate 71) done in 1655, in contrast to the same subject as it was depicted by the unknown thirteenth-century sculptor of the north portal of Chartres Cathedral (plates 17, 18).

As we have seen, the medieval sculptor shows the standing figure of the patriarch, who looks upward toward the angel and has in one hand a knife, holding the other hand against the cheek of the obedient Isaac. The medieval artist uses a kind of visual sign language which helps the initiated to identify the subject matter. The elderly, bearded patriarch-type, the upward glance and knife in hand, the figure of the boy Isaac with his feet bound, and the ram upon whose body they both stand— all these identify the persons and the event. But the real meaning of the ABRAHAM AND ISAAC at Chartres cannot be read separately from the adjacent sculptures. As was noted in the discussion of Gothic art, they are a part of a group of ten statues of "patriarchs and prophets arranged in chronological order, all symbolizing or foretelling Jesus Christ and at the same time summing up the history of the world." [14] Isaac's obedience

[14] Mâle, *Religious Art from the Twelfth to the Eighteenth Century*, pp. 76-77.

to the will of his father was a prefiguration of Christ's sacrificial offering of himself in obedience to the will of the Heavenly Father.

In Rembrandt's etching the historical, allegorical, and prefigurational ramifications of the subject are of less importance than the psychic and spiritual elements. We are not primarily interested in identifying the subject matter. Rather, we are drawn into identifying ourselves with the terrible suffering of old Abraham, who is obedient to God's command, "Take your son, your only son Isaac, whom you love, and go to the land of Moriah, and offer him there as a burnt offering upon one of the mountains of which I shall tell you." [15] The three long days' journey with Isaac, when the elderly father had too much time to meditate on the meaning of God's command, is all written in the face of Abraham in Rembrandt's etching, and we are reminded of Kierkegaard's Prelude to *Fear and Trembling*. After relating how Abraham was released from the necessity of slaying Isaac and saw the ram and offered it instead, Kierkegaard writes, "From that time on Abraham became old, he could not forget that God had required this of him. Isaac throve as before, but Abraham's eyes were darkened, and he knew joy no more." [16] Rembrandt's Abraham is indeed one whose eyes are darkened and who will know joy no more.

In the attitude and expression of the angel Rembrandt has taken an interesting liberty with the biblical story. The angel of the Lord, rather than calling to Abraham from heaven, here has descended to earth and with one great encompassing movement clasps Abraham's arms, staying the hand which holds the knife and freeing the hand which protectively covers the eyes of the obedient Isaac. The angel leans over the old patriarch, seeming to offer compassion as well as physical support. We are drawn back to the little etching of THE AGONY IN THE GARDEN discussed previously, where analagous subject matter is treated. The cup was removed for Abraham, whereas for Jesus, who in the antiphonal medieval renderings is symbolized by Isaac, the strength to receive the

[15] Gen. 22:2.
[16] Sören Kierkegaard, *Fear and Trembling* and *The Sickness unto Death* (New York: Doubleday Anchor Books, 1954), p. 28.

cup was given. It is clear, however, from Rembrandt's interpretation of the Abraham episode that he was not seeing it as a prefiguration of a New Testament event. Rather, he pondered the event much as did Kierkegaard, who repeatedly confronted the sparse biblical tale, and apparently with reference to himself wrote that "what his mind was intent upon was not the ingenious web of imagination but the shudder of thought." [17]

"The shudder of thought" which comes at the moment of self-identification is far removed from our response to the Byzantine mosaic of the CEFALU CHRIST (plate 10), or the Romanesque Christ of THE PENTECOST (plate 14), or even LE BEAU DIEU of Reims (plate 20). As we look back at these works and the Renaissance, mannerist, and baroque paintings and sculptures in the plates, it is evident that almost all of them were created for churches. As such, their size and position were related to, if not dictated by, architectural considerations. Many of them—such as the frescoes of Giotto and Michelangelo, the ISENHEIM ALTARPIECE of Grünewald, and the San Rocco paintings of Tintoretto —were conceived originally as a group or cycle of paintings, and thus related to other paintings both in terms of size and technique and in terms of subject matter and content. They were part of an environment of worship. But Rembrandt's religious art has no such external controlling factors. Even his large religious paintings were not created for a place of worship, and thus the size and proportion and technique were not predetermined, nor was the subject matter dictated. Rembrandt created religious art, not for the church, nor for the clergy, nor for the congregation, but out of his own inner necessity. Without the controlling factors of an established church he had a freedom in the choice of subject matter and its interpretation that artists of the earlier centuries did not know.

In many ways Rembrandt's great religious works are the antithesis of the religious works we have seen previously. The majority of his works are small in size, whereas others are large; his are intended for private contemplation, and others are part of an environment of worship; his

[17] *Ibid.*, p. 26.

are private and subjective in communication, whereas the others are relatively objective; his speak to the psyche, theirs to the emotions, the senses, and the beliefs of the worshipers; Rembrandt's works absolutely deny any liturgical function, whereas most of the earlier works of religious art in some way have been controlled by architectural or liturgical considerations.

Many of these nonliturgical characteristics of the art of Rembrandt are typical of much of the art with religious subject matter in our own century. Something of a hiatus exists between Rembrandt's time and the 40's of our own century in the creation of significant cycles of Christian art and individual masterpieces with religious subject matter. The final chapter is devoted to discussions of twentieth-century works of art, some of which were commissioned by churches and some of which were created, as Rembrandt's religious art was, out of personal choice and the impulse "to express deep spirituality," as the German expressionist Emil Nolde said.[18]

[18] See Chap. X, p. 202.

TWENTIETH-CENTURY ART

From the death of Rembrandt in 1669 until the twentieth century a hiatus occurs in the creation of religious art. Some few artists created paintings with religious subject matter, and some works of art were commissioned by the church. But the volume and the quality of these individual works and commissions ebbed. Traditional iconography, which is rooted in history and carried forward in ever-changing forms by each generation of artists, became an obscure language. When the dominant significant style of art ceases to have religious subjects as one of its major themes, it apparently develops in ways which are inappropriate if not inimical to the ancient sacred themes.

Eighteenth-century art is a case in point. English artists excelled as portraitists and landscape painters, but they did not create significant religious art. On the Continent the exquisite, exuberant, pastel art of the rococo includes magnificent art for the church. But the great scenes of the Ascension of Christ and the Assumption of Mary, with their pink and blue and gold heaven peopled by saints who are joyously afloat as if freed from the claims of gravity, are of a different character from the works of art selected for this book. The rococo church ceilings are like the cadenza in a concerto. They are interesting and beautiful in their setting as a part of a whole complex. But each of the other works of religious art which we have discussed—even the tiny Gethsemane etching of Rembrandt—is a total statement of the artist's vision of reality.

In the nineteenth century religious subject matter was used by a few artists. At the beginning of the century William Blake drew magnificent

illustrations for the Bible and Dante's *Divine Comedy*. Delacroix painted frescoes for the Church of Saint Sulpice in Paris in 1861. The symbolists and post-impressionists used religious subject matter in the last decades of the nineteenth century. But the symbolist Redon made lithographs for the Apocalypse which have closer affinities with the poetry of the period and the dream world of private experience and personal self-discovery than with the religious experience of the Christian believer. Gauguin's South Sea Nativities and Annunciations utilize Christian subject matter in a less gripping way than the same artist's depictions of native religious rites and the South Sea Island gods.

The first decades of our century were years of tremendous creative activity and ferment. The styles of cubism and the various forms of nonobjective art were explored by the foremost artists of the period. After World War I the style of surrealism was initiated. Each of these stylistic developments, by the very definition of the style, was inimical to religious subject matter.

But concurrent with these developments of twentieth century art was another movement characterized by the vivid use of subject matter, and on occasion the subjects chosen were religious themes. This movement, known as German expressionism, began about 1905. The reasons for the emergence of expressionism are complex and not yet fully understood. But those who study the abrupt, angular lines and respond to the intensity of emotion expressed in Emil Nolde's ENTOMBMENT (plate 72) will see the link between this painting and other northern works of art. Something of the brittle energy of the Vézelay PENTECOST (plate 14), the compressed dynamism of the Berthold Missal LAST SUPPER (plate 16), and the naked extremes of emotional participation of the Grünewald Crucifixion (plate 52) are present in this strange, crowded composition by Nolde.

Emil Nolde's ENTOMBMENT

The ENTOMBMENT was painted in 1915 and, like most of Rembrandt's religious work, was painted out of the artist's own inner necessity rather

than as a commission for a church or a patron. Between 1909 and 1912 Nolde had painted a number of subjects from the life of Christ. In his book, *Years of Struggle,* Nolde wrote of these early religious paintings,

I obeyed an irresistible impulse to express deep spirituality and ardent religious feeling, but I did so without much deliberation, knowledge or reflection. I stood almost terrified before my drawing, without any model in nature. I painted on and on scarcely aware whether it was day or night, whether I was painting or praying. Had I felt bound to keep to the letter of the Bible or that of the dogma, I do not think I could have painted these deeply experienced pictures so powerfully.[1]

These passages refer to his creation of a LAST SUPPER and a PENTECOST. But they vividly evoke the high-keyed mood of the artist as he confronted his self-appointed task. He was driven by an irresistible and ardent impulse, and painted "without much deliberation, knowledge or reflection." The artist's own description further suggests that these religious works were created within relatively short periods of time, periods in which his spontaneous fervor could be sustained. In 1915, the year in which he created the ENTOMBMENT, Nolde painted eighty-six canvases, seven of which were religious works. These too must have been created in a day or days rather than in the longer periods of sustained, patient labor necessary for the completion of a painting by Leonardo or Van Eyck or Grünewald.

While the painting is called the ENTOMBMENT, its iconography is in fact more related to the Pietá than to the traditional Entombment theme where the body of Christ is being lowered into the sepulcher. The subject is analogous to Giotto's LAMENTATION OVER THE DEAD CHRIST (plate 26), in which the mourning Mary embraces her son in a final closeness of flesh to flesh. But where Giotto's Mary sits solidly, monumentally, stably, Nolde's Mary teeters in an awkward squatting position. Whereas Giotto's Mary encircles the shoulders of Jesus in an easy, tender embrace, Nolde's Mary convulsively grips the thin, angular body of

[1] Werner Haftmann, ed., *Emil Nolde* (New York: Harry Abrams, 1959), opposite plate 2.

Jesus, which seems to be slipping from her grasp. Whereas Giotto's entire painting comes to a focus where the head of the Mother and Son meet and their halos intersect, in Nolde's ENTOMBMENT the face of Mary is hidden by the head of Jesus and the other two large faces are brought adjacent to that of the Christ. The masklike face in the background may be that of St. John, who is so often present in the Crucifixion and Pietá scenes. The elderly, bearded man may be Joseph of Arimathea, who in earlier works of art is often shown supporting the knees of Christ. But I am inclined to think of him as Nicodemus, who asked, "How can a man be born when he is old? Can he enter a second time into his mother's womb and be born?" [2] His wide-eyed intensity of gaze is directed at the convulsive movement of Mary, who seems to draw the emaciated figure of Jesus into her own womb once more.

Nolde's Jesus has the dark long locks of one of the ancient Mediterranean types. Jesus' feet, which are supported by Nicodemus' arm and thigh, are turned flatly toward us and display two large, deep stigmata rimmed with crimson blood. One of his long-fingered hands, gripped clutchingly by John, also shows a large red nail hole. A diagonal fissure is visible in the torso, and Nolde here departs from the traditional iconography in placing it in Jesus' left side. During the medieval period, when religious iconography had crystallized into a kind of code, all orientations in religious art centered in Christ. Persons and details were placed to his right and to his left, according to a prescribed arrangement. His right, where the wound in his side was traditionally placed, is, of course, the spectator's left. When the medieval orientation no longer was prescribed, and the tradition had been broken, the old forms were often modified. Whereas the medieval artist operated within a Christ-centered space, where left and right were Christ's left and right, the twentieth-century artist reverses this order and utilizes the spectator's left and right for his orientation.[3]

Our speculations about details like the stigmata or the identity of the

[2] John 3:4.

[3] Before Nolde's time Manet had chosen a similar orientation in his Christ in the Metropolitan Museum, New York.

two attendant figures are answered at one level by the artist himself in the previously quoted paragraph, where he stated that he did not try "to keep to the letter of the Bible or that of the dogma." He was not concerned with the symbolic code of medieval religious art but rather with a powerful expression of his "ardent religious feeling" through his "deeply experienced pictures."

Studying the painting from the viewpoint of its composition, we will see that the major large areas of the bodies of Nicodemus and Mary tend to merge into one cradling U-shaped pattern. Nicodemus' body is a massive, immobile, simple segment of a circle which fills most of the left half of the painting. Mary's knees and back abut onto his large body with sharp angularity, and her crooked arm further emphasizes the contrast between the slow-moving curves of the old man's body and the abrupt angles of her own. The whole composition accelerates where the three large faces are placed at the very top of the painting, each in a different plane and at a dissonant angle.

It is not possible to discuss Nolde's composition without reference to his use of color. Many readers undoubtedly saw the painting in the 1963 Nolde exhibition[4] and can recall their own experience of the hues, value, and intensity of Nolde's color. The cradling areas of the bodies of Nicodemus and Mary are blue, his body being touched with patches of green while Mary's is more intensely blue and touched with white. John's face is a reddish brown and his hair darker shades of the same. The old parchment-like face of Nicodemus ranges from yellow to brown, but the face of Jesus presents the most vivid contrasts. His hair is an inky black and his forehead a sulphurous yellow. Mary's feet have touches of crimson red, as do the shadows beneath her buttocks; the broken figure she struggles to encompass has bathed her feet in blood.

We do not need Nolde's own statement that he worked "without any model in nature." The ENTOMBMENT is a nonnaturalistic painting, with radical simplifications in posture, physiognomy, and proportion. Space is compressed uncomfortably, both for the three figures who crouch

[4] This exhibition was held at the New York Museum of Modern Art, the San Francisco Museum of Art, and the Pasadena Art Museum.

about the broken angular body of Jesus and for the viewer who is drawn forcibly into the scene. The picture plane, which in Renaissance art is the window frame through which we see the event depicted by the artist, here becomes ambiguous. Piero della Francesca in his RESURRECTION (plate 2) placed soldiers on a narrow shelf of ground between us and the figure of Christ, and the space within the composition receded naturally from this well-defined beginning point. But in Nolde's painting the various planes made by a head, a shoulder, a thigh, read with a different kind of coherence. These planes are interrelated, but their angle in depth is determined by where the eye begins its travels. The thighs of Mary seem to move forward diagonally toward us from one viewpoint, whereas from another they seem parallel to the picture plane. These alternative spatial relationships heighten the restless, unresolved, dissonant character of the composition.

The violent distortions, the oppressive spatial compression, and the restless focus upon the sulphurous body and face, give an intensity of expression to Nolde's painting reminiscent of Grünewald's Crucifixion (plate 52). Nolde admired the work of Grünewald and Dürer and considered their era to have been the first great period of German art. It was his hope to create a second great period through his own contribution.

Many of the characteristics of the ENTOMBMENT have been seen in earlier works of art. The distortion of proportions and positions, and the heightened intensity and dynamism, were present in the Vézelay PENTECOST. The dramatically macabre and grotesquely ugly—these terms are used descriptively, not pejoratively—were present in the works of Grünewald and Dürer. The nonnaturalistic colors and spatial design were seen in the Berthold Missal. But the combination of these expressive elements in a single religious painting gives an intensity of impact to Nolde's painting that is typical of twentieth-century expressionism. These characteristics combine to break open the picture plane, breaking the barriers between our world and the event depicted, and thrusting these struggling, agonized figures almost into our laps.

What Nolde calls his "deeply experienced picture" powerfully grips

the spectator. But what is the religious feeling that is expressed? The Mary by Giotto (plate 27) peered in anguish into Jesus' face as her arms encompassed his dead body. But Nolde's Mary, with a frantic, awkward gesture, grips his broken body, pressing it against hers as if to force it into the womb again. The expression of fascination and horror in the face of the old Nicodemus combines the contrary elements of attraction and repulsion so often experienced when we witness extremes of pain or suffering. The empty, masklike face of St. John between Nicodemus and Christ is a kind of foil to the violent extremes of emotion expressed at either side of him. The agony of loss, and a frantic rebellion against it, are nakedly evident in Mary. The attraction-repulsion dichotomy is starkly present in the old Nicodemus. The experience of suffering, instead of being assimilated and resolved and finally elevated, here is utterly stripped of all meaning. Life and death are presented in their simplest, rawest, and most elemental form. In his early PIETA (plate 39) Michelangelo achieved a kind of paradigm of noble, accepting suffering, and in his late RONDANINI PIETA (plate 42) a spiritualized expression of rending loss. But in his ENTOMBMENT Nolde achieved another pole of expression by plunging beneath all idealizing or conceptualizing to the most primitive springs of being.

Georges Rouault

Georges Rouault was born in 1871, four years after Nolde's birth. He was also an expressionist painter, but being of French extraction and training, he was a "fauve" [5] artist. Rouault is the one artist of the first half of the twentieth century who could be called a religious artist in the full sense of this term. He was an avowed and lifelong Roman Catholic believer whose extensive lifework consists largely of works with religious subject matter. Unlike Rembrandt he did not depict many Old Testa-

[5] The word derives from a comment of a critic who attended the Paris Salon d'Automne of 1905 and saw the work of Matisse, Rouault, and a number of other artists hung in one room. Their works, full of distortions and flat patterns and painted in violent colors, created a furore, and a critic dubbed them collectively *"les fauves"* (the wild beasts).

ment subjects. Rather, he centered his interest almost wholly on the image of Christ and a few New Testament episodes. But like Rembrandt, Rouault was attracted to the Passion subjects, the Christ whose suffering is on our behalf, who "was wounded for our transgressions . . . and with [whose] stripes we are healed." [6]

Although he created many works of religious art, it was not until he was almost seventy that one of them was placed in a Roman Catholic Church, the church at Assy, France. One of his designs for a stained-glass window was chosen in 1939 by the pastor of Notre-Dame-de-Toute-Grâce. The subject was the CHRIST OF THE PASSION (plate 74).

In this design Jesus is seated, his head bowed, in a prison-like cell. Through a window at the right the cross is visible. His face, with its heavy dark lines which constitute both the contours and the shadows, looks weary unto death, and the body is thin and worn. There is more of human emotion and intimacy in this Jesus than in any of the twentieth-century works discussed in this book. We can feel, think, and breathe with this figure. The lines themselves communicate this to us. Indeed, if we look at some of the plates for the *Miserere* series which Rouault did at an earlier period, we begin to understand the distinctive quality of this intimacy.

Rouault created the series of prints which were later to be published under the title, *Miserere*, over a period of years from 1916-18 and 1920-21 for Vollard, a famous French art publisher. The original plan was for one hundred plates to accompany a text by Andre Suares, a friend of both Rouault and Vollard. The text was never completed but fifty-eight etchings were officially issued in the original large size which was about twenty-four by seventeen inches. But the large and expensive prints inevitably became the property of museums and collectors. A few years later Rouault himself assisted in the preparation of the book entitled *Miserere*, containing all the original designs in reduced size. It was published by the Museum of Modern Art in New York, and sold for a modest sum. It was Rouault's wish "not only to spread the enjoyment

[6] Isa. 53:5.

of his art, but to convey to a new and large public the religious message which means so much to him." [7]

Turning the pages of this book, we may ponder the religious expression of a dedicated Christian artist of the twentieth century. The rich dark tones of the prints, the heavy contours of the figures and faces, and the varied and brief captions below do not easily yield their meanings. The first plate shows the bowed head of a man whose posture and features are close to those of the Christ of the window at Assy. This man, too, is enclosed in an imprisoning arched area; above him is a crossed olive branch and the secretive, round face of a cherub. The caption, in Rouault's own writing, is from the fifty-first psalm, "Have mercy upon me, O God, according to Thy loving kindness."

In the second plate the same bowed shoulders and head are seen and the same emaciated features and flesh. But this time the crown of thorns encircles the dark head and the caption reads, "Jesus reviled . . ." The third plate shows again the same features and posture, but now the full torso and thighs as well, and the body is set against a murky background, empty of humanity or nature. The caption, "Eternally scourged," seems a continuation of the second one, as does the design. The fourth plate shows a sad-faced man who bears a great burden on his back reaching forth to a child, who turns away from his touch and look. He addresses the child, "Take refuge in your heart, miserable vagabond."

Plate 5 is of particular interest because it again shows a posture similar to that of the Christ at Assy, but in reverse. The nude figure in this plate, however, is set against a barren, lonely expanse of nature, and the caption reads, "Lonely sojourner in this life of pitfalls and malice." Plate 6 shows us a male nude, but this time the head, rather than being bowed, is thrown upward strainingly and tense hands cover the genitals. In the background we see an aggressive nude woman and a woman who turns sidelong to the central figure. Behind all of them is a phallic tower. The caption reads, "Are we not all convicts?" Implicit is the suggestion that we are all prisoners of our own flesh.

[7] *Miserere,* Introduction by Monroe Wheeler (New York: Museum of Modern Art, 1952).

A succession of plates holds up the mirror to human vanity and vio-
lence: "We think ourselves kings"; "The society lady fancies she has a
reserved seat in Heaven"; "Man is a wolf to man." Others point to the
sad limitations of human existence, as the dark, unpeopled "Street of
the Lonely." One of the most beautiful plates shows a kneeling, sorrow-
ing figure, and has the caption "In all things, tears."

But always we are brought back to the image of Christ. Christ on the
cross is entitled "Love one another," and another Crucifixion has the
caption, "Jesus will be in anguish until the end of the world" (plate
73). The crucified Christ in the next to last plate has a triumphant
nimbus of light encircling his head, which is thrown back, and the
caption reads: "Obedient unto death, even the death of the cross." [8]
The final plate is of the image of Christ on the Veronica Veil, and it is
interesting that it is the fifth time in the series that Rouault uses this
iconographic image. Veronica, legend tells, was a woman healed by
Jesus. Witnessing Jesus carrying the cross and falling beneath its weight,
she gave him her veil with which to wipe his face. When it was re-
turned to her, it had his image miraculously impressed upon it. Veronica
and her veil, or sudarium, are often represented in Christian art as a sepa-
rate subject, or as part of the Way of the Cross cycle. These works of art,
like those dealing with the instruments of the Passion,[9] point to the rever-
ence and pious curiosity which has clung to all of the objects which
were supposed to have had physical contact with the body of Jesus as
he made his last burdened journey to Calvary.

The caption for this final plate of the *Miserere* leads us from the suf-
fering Christ back to the imagery of the prototype, the Suffering Ser-
vant of the Old Testament, for it reads, "And with his stripes we are
healed." Thus the series begins with man who, with the psalmist, cried
to God for mercy, and ends with the assurance:

[8] Phil. 2:8.

[9] The instruments of the Passion are the accessory objects named in the Gospel accounts of
the Passion of Christ: the crown of thorns, the robe, the scourge, the spear, the sponge, the
nails, etc.

He was wounded for our transgressions,
 he was bruised for our iniquities;
upon him was the chastisement that made us whole,
 and with his stripes we are healed.[10]

Mention has been made of a number of the *Miserere* plates which re-
semble the window at Assy in the type of Christ represented and in
the posture of his body. But closest to the Assy Christ is another Christ
of the *Miserere* (plate 75), where the heavy contours delineate the same
long nose, cavernous eyes, and narrow cheeks. Here, too, the head is
lowered, perhaps more submissively and gently, but at the same angle.
The movement of the arms has a tremulousness that is not present in the
stained-glass window. And in the etching medium more gradations of
tone are possible, allowing for more suggestions of anatomical detail
than in the stained-glass design. Yet the similarities are greater than the
differences—the narrow, emaciated body, the thin, hollow-eyed face,
the bowed head which is seen in profile. These are characteristics of
Rouault's oft-repeated image of Christ. It is the Christ seen in many
individual studies and in the frequently reproduced CHRIST MOCKED,
owned by the Museum of Modern Art. Only when Christ's image ap-
pears on the Veronica Veil is the face seen frontally. But here too the
eyes always seem closed. Powerful as some of these sudarium subjects
are, they still remain a shadow of a shadow. They do not have the in-
sistent vitality of the earlier fifteenth- and sixteenth-century Veronica
Veils, where the features of Christ seem to spring lifefully from the
fragile kerchief held by the saint.

The Christ which Rouault has imaged is not a historical figure, or a
leader, or a teacher, or the judge above all time. Instead, he is present
with men in their sufferings, having known all of human indifference,
perversity, and cruelty. He does not reproach or judge, but remains
with mankind "in agony until the end of the world."

The peculiar intimacy of these Christ images is underlined when we
compare them with the earlier works of art studied in this book. Even

[10] Isa. 53:5.

the Grünewald Crucified Christ takes on epic grandeur when contrasted with Rouault's painting of the same subject. Grünewald's Crucifixion was part of the high altar; both its dimensions and its emotional impact were dictated by its placement as the crown and focus of a place of worship. Rouault's *Miserere* series, by the artist's wish, as has been noted, was published in a small, intimate format that allows the individual to "read" the plates and ponder their captions. Unlike an illustrated missal or prayer book which sets forth the structure of corporate worship, this book is addressed to the individual and probes into the intimacy of the human psyche with a message which is indeed "religious," but many-sided in its thrust, and thus necessarily evokes individual responses of great variety.

One of Rouault's most startling Christ images is the TÊTE DE CHRIST, or Christ in Agony, in the Collection of Walter P. Chrysler, Jr. (plate 76). This painting, which cannot be included with those previously discussed, was done in Rouault's early years. In a kind of fury against the ugliness and violence of life, he painted some of his most powerful works —sorrowing clowns, ugly prostitutes, and this pained, ever-suffering Christ. The painting is surprisingly large and brilliant in color. Yet the spontaneous lashings of pigment and terse, wiry lines delineate an unforgettable image. The capacity of the great eyes to endure unendurable suffering takes us back to the Suffering Servant passages in Isaiah:

> Surely he has borne our griefs
>> and carried our sorrows. . . .
> He was oppressed, and he was afflicted,
>> yet he opened not his mouth;
> Like a lamb that is led to the slaughter,
>> and like a sheep that before its shearers is dumb,
>> so he opened not his mouth.[11]

The mouth is compressed in Rouault's painting, and the great dark eyes look forth full of suffering, yet capable of absorbing all the pain and anguish that can be heaped on them. In many of Rouault's other

[11] Isa. 53:4, 7.

works Christ turns away in passive acceptance of suffering. But this Christ both absorbs the anguish and confronts humanity. In this it has affinities with another Christ distant in time and space and artistic style, but similar in its expression—Piero's resurrected Christ (plate 1).

Nolde and Rouault both created their religious art out of an inner compulsion, and with the exception of Rouault's work for the church at Assy neither artist was commissioned by a church. Neither the subject matter, nor the technique, nor the style was in any way determined by the appropriateness to a specific setting or liturgical function. Like Rembrandt's religious art, Nolde's and Rouault's works of art are in the hands of collectors and are hung in museums rather than placed in churches and cathedrals.

The exceptional commissioning of Rouault in 1939 by the church of Notre-Dame-de-Toute-Grâce high in the French Alps was one of a number of dramatically imaginative and courageous commissionings, considering the deplorable level of much of the art in churches at that time. With the guidance of the Dominican monk and former artist, Father Couturier, this church commissioned all of the greatest French artists of the time—Matisse, Bonnard, Braque, Rouault, Leger, Lurçat, Richier. All of them created works of art for this church, making it a veritable museum of modern religious art. Two Jewish artists, Chagall and Lipchitz, were appropriately commissioned to design the baptismal font and the baptistry murals. The genesis and description of this church has been the subject of a valuable recent book by William S. Rubin [12] which should be read by all who are interested in the relationship between the artist and the church in our day.

Also in the 1940's a second significant commissioning occurred, this time not in France but in England. In this case also the initiative, energy, and wisdom of one individual, Canon Hussey, lie behind the commissioning. The English sculptor Henry Moore was asked to create a MADONNA AND CHILD (plate 23) for the transept of St. Matthew's Church, a modest Anglican neo-Gothic church in the industrial town

[12] *Modern Sacred Art and the Church of Assy* (New York: Columbia University Press, 1961).

of Northampton, north of London. The completion and installation of this statue was followed in 1946 by the commissioning of Graham Sutherland [13] to depict the Crucifixion, a painting to be hung in the adjacent transept of the same church.

Richier's CRUCIFIX

In the subsequent year one of the most debated works of religious art of our day was commissioned. The French sculptor Germaine Richier was asked to create a crucifix for the same church in the French Alps at Assy for which Rouault had worked. Though less well known in this country, Madame Richier had exhibited widely in Europe. She was born near Arles, a southern French town rich in art and history. Arles has classical ruins, the noble Romanesque of the church of St. Trophîme and recollections of scenes painted by Van Gogh and Gauguin. Germaine Richier left Arles, went to Paris in 1925, and became a student of the sculptor Bourdelle, who himself had been a student of the sculptor Rodin, who in turn had been the late-nineteenth-century heir to the tradition of Michelangelo and the Renaissance sculptors.

In her sculpture Germaine Richier affirmed the human image as the basis of her art, but most of her figures are strangely desiccated and lacerated. Many are hybrids in the commonly accepted, literal sense of exotic combinations. In the sculptor's own words her figures and faces are "an entity, a whole of expressions and gestures brought into accord with the form." [14]

Madame Richier, who had never previously used religious themes for her sculpture, was hesitant about accepting the commission, but visited the church at Assy and made several studies. As the artist's model for the CRUCIFIX progressed it is reported that she sensed more and more that "unconscious things of a unique kind were being trans-

[13] It was Sutherland who in the 1950's designed the great tapestry reredos of Christ in Glory for the new Coventry Cathedral, England.

[14] Peter Selz, New Images of Man (New York: The Museum of Modern Art, 1959), p. 129.

lated." [15] She is quoted as having said, "I am more attracted by the trunk of a dead tree than by an apple tree in full bloom." [16] Her Christ of the Assy CRUCIFIX is akin to a withered tree, but one which lives on and on in dry, lonely suffering.

In her CRUCIFIX (plate 77) a strange, weathered, shrunken shell of a figure floats before us. The figure itself makes the cross, for though the vertical post behind it is an integral part of the composition, it seems irrelevant, both symbolically and as a physical support. The artist explained that "the cross has been taken with the suffering into the flesh." [17] The figure leans forward, but the posture is not related to any movement of the Christ toward us. Rather, the posture seems to be the result of the terrible solitude of almost intolerable suffering— the suffering of the flesh, bones, and muscles at the command of the spirit.

As one studies the contours and surfaces of this CRUCIFIX, one slowly preceives two holes which suggest the eyes, a line which is read as the nose, and another where the mouth would be. The artist remarked, "There is no face because God is the spirit and faceless." [18] There is some articulation of the rib cage and suggestions of a loincloth. The fingers of the hands are clearly distinguishable, and there is a suggestion of knees and the bony structure of the feet. These anatomical allusions are subordinated, however, to the essential stiff, dry form which leans forward toward us but is so isolated from us.

The wall plaque at the church tells us that Christ is at the extreme limit of human suffering, that his arms are stretched out in an extreme endeavor toward mankind, that his physical form is so emaciated and brutalized as to show complete anguish, that he is "the Lamb of God that taketh away the sins of the world." Two works of art from the past evoke responses which are both similar to, and dissimilar from, our experience in studying the CRUCIFIX of Assy. Looking back at Grünewald's Crucifixion (plate 52), we are struck by the violence of

[15] Rubin, *Modern Sacred Art and the Church of Assy*, p. 161.
[16] *Time*, November 26, 1956, p. 86.
[17] *Time*, April 23, 1951, p. 68.
[18] *Ibid.*

the purely physical suffering. Grünewald's Jesus is dead; he is pitted and scarred but not vanquished by death. Michelangelo's Christ of the RONDANINI PIETA (plate 42) is dead too, and the slender slumping form held by Mary seems chrysalis-like—a shell for the spirit which still momentarily holds it captive. Germaine Richier's Christ seems strangely alive, and yet beyond our ken.

Germaine Richier's CRUCIFIX has had a divided reception. Created for the altar, it was first placed in the sanctuary and then removed when criticized by the more conservative clergy.[19] Reportedly the change of location was also the result of the criticism of tourists who come to the little town of Assy primarily for the several sanatoriums which flourish in its crisp, cold, thin air, and for the nearby ski runs. Notre-Dame-de-Toute-Grâce is a short walk from the pensions and hotels, and its simple hooded roof and rectangular steeple are visible from most places in the town. The bold, colorful facade mosaic by Leger must attract many visitors who enter the church not as worshipers, but motivated by curiosity. Reportedly it was these visitors whose objections caused the withdrawal of Richier's CRUCIFIX from the sanctuary to a small mortuary chapel at the rear of the nave. In a parallel situation the voice of protest against modern art forms came, not from the worshipers, but from visitors to the church. Canon Hussey of St. Matthew's Church, Northampton, England, also reported that it was the nonchurchgoing populace which was the most vocal in its criticism of Henry Moore's MADONNA AND CHILD (plate 23) and Graham Sutherland's CRUCIFIXION.

Manessier's CROWN OF THORNS

In the same years that Germaine Richier was working on the CRUCIFIX for the church at Assy, another French artist, Alfred Manessier, was designing stained-glass windows for several French churches and a tapestry for a French Dominican convent. Manessier not only has

[19] For a discussion of the debate over Richier's CRUCIFIX, see Rubin, *Modern Sacred Art and the Church at Assy*, pp. 163-64. In recent years the crucifix has been returned to its place behind the altar.

been commissioned by several churches but, since his reconversion to Roman Catholicism in the early 1940's, his uncommissioned paintings frequently have had religious subject matter. He has said, "My subjects in general are a religious and cosmic impression of man in front of the world. In every way my paintings want to be the testimonial of a thing lived from the heart and not the imitation of a thing seen through the eyes." [20]

Manessier's large, brilliantly colored painting (plate 78) which won the 1955 Carnegie International might seem at first glance to be a nonobjective painting. The title, however, provides a clue to the artist's intention. This five-foot-wide painting is called CROWN OF THORNS. With this title in mind the splintered, mobile tracery begins to take on suggestions of recognizable forms for us. The large, wheeling, jagged, deep blue shape in the left section is surely the crown of thorns of the title. Two oval red blobs set akimbo within this circle suggest the empty eyes of a skull, and gradually the rest of this skull becomes visible beneath the crown of thorns. The ancient iconography of this skull, which Manessier may have had in mind, refers to Adam, who is thought to have been buried at the very place where the cross of Christ was erected at Golgotha. At the lower right edge of the painting are three cubes, probably a reference to the dice used by the soldiers in casting lots for Jesus' "tunic [which] was without seam, woven from top to bottom." [21] Also visible is the scourge, with its thick handle moving diagonally upward, and its flexible lash bent in an uneven ellipse in the lower right part of the painting.

The diagonal upward and downward pattern of the scourge interlaces in turn with the wheeling circle of the crown of thorns. Both of these mobile motifs are in a rich dark blue, and seem set in one plane against a vibrant crimson background. Yet to locate any of these in space, as in Renaissance paintings, is difficult. The deep blue areas seem in front of the red, and yet the red areas have a mobility of their own, and an explosive force and vitality which presses them forward. The

[20] From *La Peinture Actuelle* by René Huyghe (Paris: Editions Pierre Tisné, 1945).
[21] John 19:23.

whole vast composition seems to wheel exultantly, and to palpitate visibly, as the various planes of the complex spatial pattern seem first at one depth, then at another.

Many of the characteristics of Manessier's style link him with the so-called "action painters" and the abstract expressionists of the 1940's and 50's. The large size, the spontaneous and vigorous movement of the forms, the vivid, nonnaturalistic color, and the ambiguous, nonnaturalistic space are characteristics to be found in varying combinations in the paintings of Jackson Pollock, Franz Kline, Robert Motherwell, Willem de Kooning. These artists too have not been interested in the imitation "of a thing seen through the eyes." But Manessier's preoccupation with "the testimonial of a thing lived from the heart" and "man's interior prayer" has led him again and again to paint essentially religious works. In particular he has painted repeatedly the subjects of the Crown of Thorns, and though the paintings vary greatly in color, in design, and in mood, they are expressions of a personal experience and of an inner vision.

The subject of Christ Crowned with Thorns was frequently depicted in sixteenth- and seventeenth-century art. The oft-repeated format for the subject consisted of an almost life-sized, detailed portrait of the suffering Christ, his brow encircled by spiny thorns which bristled about the head and thrust beneath the flesh of the brow. In these paintings blood and tears rolled down Christ's face as he confronted the spectator with an expression of pain and of patient, and sometimes reproachful, endurance. These paintings are essentially devotional works, and what they communicate is quite different from that of the Manessier painting. They speak directly to personal piety and are literal in their reminder that Christ suffered that all men might be freed from sin and death. Manessier has moved beyond this accusing identification to an exultant affirmation. This affirmation is not made in spite of the dark night of suffering symbolized in the thorns and scourge. Instead, these symbols are an integral part of the radiant, exploding, "Alleluia" of the whole.

Henri Matisse: The Chapel of the Rosary at Vence

In the 1940's Manessier received his first commissions from churches. In the same decade artists were commissioned by the church at Assy and by St. Matthew's at Northampton. In the same decade the artist Matisse became involved in the designs for the church at Vence, France. Matisse, a contemporary of Picasso and Rouault, had been recognized internationally as one of the grand old masters of modern art. Known and loved for his sensual, singing line, he had created a whole world of luxurious ease and sensual experience in his large oeuvre of paintings of fruit and flowers, Mediterranean vistas, and languorous Odalisques. While recovering from an operation in a hospital in southern France he had as his nurse a handsome young woman interested in art, who intended to enter a local convent but delayed doing so until Matisse had recuperated. Somewhat later she became a Dominican novice at a conventual rest home at Vence which was just across the road from Matisse's home, Villa le Rêve. She often walked over to see the artist, and it was she who awakened his interest by showing him a stained-glass window design for the proposed new convent oratory. At the same time a Dominican novice at Vence who had architectural training and an interest in contemporary painting called on Matisse and talked to him about the proposed chapel. The result was that Matisse offered to design the chapel himself, and the Dominican order, realizing the great importance of Matisse's proposed gift of his genius, enlisted all the help that was needed to assist the aged artist to carry through his plans.[22]

Matisse was helped by the architectural and liturgical knowledge of Brother Rayssiguier, but the design of the chapel is wholly the result of Matisse's vision. Not only the chapel's form and decoration were of his creation but all of the fittings—the carved sacristy door, the nuns' pews, the altar, the crucifix, the candle holders, the sanctuary lights,

[22] The details of Matisse's initial involvement with the designing of the chapel are taken from Alfred Barr's definitive volume on the artist, *Matisse, His Art and His Public* (New York: The Museum of Modern Art, 1951). pp. 279-88.

and even the gay and sumptuous colored vestments for the priest. Thus the total environment of worship in every detail is the work of one man and his extraordinary creative vision. It is reported that Matisse himself quoted with delight the remark of one of the Dominicans—"At last we have a gay chapel!"

The tiny Chapel of the Rosary (plate 82) is alternately bathed in brilliant sunshine and shaded by green-black palms and cypresses. Behind it rise the rocky foothills that join the French Alps, and in front of it the land slopes away toward the Mediterranean. In this grand setting the little chapel nestles serenely on the shoulder of its rocky hill—its flanks gleaming white, its roof as blue as the Mediterranean, and its bell tower rising, as gay as laughter, from the horizontal lines and rectangular shapes of the roof and nave wall (plate 80).

The visitor enters directly from the street, then passes through a door to a narrow staircase which leads down to a lower level. At the foot of the stairs another door leads out onto a terrace with a view of the valley and the ancient neighboring town of St. Paul-de-Vence, like the view in a Cézanne painting. But the eye is soon caught by a small white ceramic wall-font with a wing-shaped flash of blue across its projecting lip. One notes the doorway at the left, and is then drawn irresistibly into a vibrantly lovely room, the chapel, luminous with light and color. It has a white floor, ceiling, and walls, but a white that reflects the intense and singing color of the high narrow windows of stained glass. The tree of life provides the motif for the windows. They have a pattern of leaves, simple in form and in range of color, but with no two shapes alike. Subtle variations of line and level differentiate one from the other, and within the large areas of blue, green, and yellow glass there is a lively range of hue and intensity. These variations give vibrancy and lifefulness to the design. Behind the altar the stained-glass windows have a similar range of color but are in darker values and have a hand-shaped leaf as the unit of design. The altar is set diagonally, so that it faces both the nave and the bank of pews in an alcove at the left of the altar.

The tile panel on the rear wall of the chapel depicts the fourteen

events of the WAY OF THE CROSS (plate 81). Rather than using four-teen separate panels, Matisse has gathered all of the events into one large composition. Though he has retained the succession of events, even numbering them, they are elided and compressed in such a way as to present an almost cryptic and undecipherable series of scenes. They run from right to left and bottom to top rather than following our accustomed habits of seeing, conditioned by our reading habits. These features complicate the liturgical usefulness of the WAY OF THE CROSS. Indeed, the Dominican nuns who worship daily in the chapel use liturgically the Stations of the Cross in their own convent rather than the composition by Matisse.

While liturgical appropriateness is relevant, we are more concerned with the quality and meaning of this strange, sparse, angular, broken composition. The answers to these questions have ranged from one extreme to the other. Some critics believe the jagged forms to be the sad remnants of skill of a very great draftsman who was old and ill at the time he created the WAY OF THE CROSS; others believe that Matisse's illness or some other factors brought about a profound spiritual experience which affected his style. For them his first depiction of the Passion shows one of the new directions of twentieth-century art defining itself and struggling into being.

Before moving toward any assessment of Matisse's WAY OF THE CROSS, the iconography and composition must be understood. The iconography of the *Via Crucis* is familiar to all Roman Catholic worshipers but less so to Protestants. The custom of placing within the church or adjacent to the church sculptured or painted representations of various incidents related to the Passion of Christ arose at a relatively late period, the seventeenth century and thereafter. The worshiper who prays before the fourteen different Stations of the Cross is reliving the acts of devotion made by the pilgrim who visits the Holy Land and prays at each of the actual places where Jesus is believed to have suffered on the way to Calvary. Though the number of places and incidents varied in the early Stations of the Cross, fourteen stations have

been customary for some time. Matisse has assisted our identification
of the episodes by his numberings. The subjects are as follows:

1. Jesus is condemned.
2. Jesus takes the cross.
3. Jesus falls for the first time.
4. Jesus meets Mary, his mother.
5. Simon the Cyrenian helps bear the cross.
6. Jesus meets Veronica.
7. Jesus falls for the second time.
8. Jesus meets the daughters of Jerusalem.
9. Jesus falls for the third time.
10. Jesus is stripped of his garments.
11. Jesus is nailed on the cross.
12. Jesus dies on the cross.
13. Jesus is taken from the cross.
14. The entombment.

It is interesting that the earlier forms of the *Via Crucis* were some-
times referred to as the Seven Falls, and were concerned primarily with
numbers 2 through 9 above. For number 6, Jesus' meeting with Ve-
ronica, Matisse made a preparatory drawing showing a faceless Ve-
ronica standing holding the veil before the kneeling figure of Jesus
(plate 79). In the final composition, however, he eliminated the two
figures and we see only the sudarium floating unsupported before us.
On this veil the simplest outline of brow, eyes, nose, and mouth indi-
cates the features of Jesus' face. Nowhere else in the chapel is there
any image of Christ except for the very beautiful, simple Crucifix on
the altar. But neither the Christ of the Crucifix nor the Christ of the
other scenes of the WAY OF THE CROSS have any features. Only on the
Veronica Veil do we see the impress of the face of Christ. Again, it is
a shadow of a shadow, but one so sparse and so minimal that it is a
hieroglyph rather than an image.

Matisse made preparatory drawings for the individual episodes, many
of them after a model. One is a study after the hands of the Mary of
the Annunciation in the ISENHEIM ALTARPIECE by Grünewald. But

in the final composition the studies from the model and from earlier art were transformed and transcended. Strange, brittle, abrupt forms emerged, creating a black and white diagram of rejection, pain, and suffering.

Many years earlier Matisse had made a statement about how subject matter relates to the composition of the work of art. This is particularly interesting to us for he refers to the art of Giotto:

A work of art must carry in itself its complete significance and impose it upon the beholder even before he can identify the subject matter. When I see the Giotto frescoes at Padua I do not trouble to recognize which scene of the life of Christ I have before me but I perceive instantly the sentiment which radiates from it and which is instinct in the composition in every line and color. The title will only serve to confirm my impression.[23]

The "complete significance" is communicated to the beholder, Matisse believes, even before he can identify the subject matter; the beholder should perceive instantly the feeling (sentiment) "which is instinct in the composition in every line." He spoke these words about Giotto's frescoes at Padua—the LAMENTATION OVER THE DEAD CHRIST (plate 26) and the NOLI ME TANGERE (plate 28). But his words are most meaningful when applied to his own WAY OF THE CROSS at Vence, for they provide the answer to the questions raised by the splintered composition and ugly, scrawling line of the Passion episodes.

In studying the various episodes and the way in which they merge with each other, one is reminded of how pain and suffering do indeed distort space and size, and obliterate time. Matisse, recovering from a nearly fatal illness, internalized the suffering and represented it through its effects. Those who question the skill and artistic judgment of the artist as they study the broken contours of the black enamel—at times washy and transparent and at other times gluey and thick on the tiles —should look from this panel to the Ave panel on the adjacent nave wall. In this mural the Madonna holds the Child in her arms, and both are surrounded by great blossoms. Here the lines flow freely in billow-

[23] Barr, *Matisse, His Art and His Public*, p. 122.

ing, sensuous shapes that seem to expand under our gaze. The contours have the exuberance and grace of Matisse's earlier art. The subject matter here, as in the St. Dominic panel on the wall next to the altar, is of those who inhabit eternity. The joyous atmosphere of the light and color-filled place of worship is focused in these compositions and in the rich hues of the Tree of Life windows of the apse. But the *Via Crucis* on the back wall shows the anguish of life and death, the ugly, discontinuous lines communicate the tragic significance of this one death.

At a time when Matisse was already deeply involved in the designs for the chapel he wrote of another series of his drawings:

Each of these drawings, as I see it, has its own individual invention which comes from the artist's penetration of his subject, going so far that he identifies himself with it, so that its essential truth makes the drawing. It is not changed by the different conditions under which the drawing is made; on the contrary, the expression of this truth by the elasticity of its line and by its freedom, lends itself to the demands of the composition; it takes on light and shade and even life; by the turn of spirit of the artist whose expression it is. L'exactitude n'est pas la verité.[24]

This statement, like all his remarks about his own work and viewpoint, has a characteristic directness and precision. We note that the artist's presentation of his subject matter is what gives essential truth to the drawing. The words and the thought bring to mind Rembrandt's draftsmanship. Rembrandt also used abrupt and ugly lines and forms when the "essential truth" demanded it.

Despite the barren, sparse, and abstract character of the final composition of the WAY OF THE CROSS, Matisse had made many preparatory sketches and drawings of models. Many of these, though faceless, are essentially naturalistic. The curving contours of the Veronica sketch disclose the volume of the two figures effectively. Matisse's original sketch for the first episode, Christ before Pilate, shows the canopied throne of the ruler rendered with considerable detail, even the im-

[24] *Henri Matisse: Retrospective Exhibition*, Philadelphia Museum of Art, 1948, p. 34.

perial wreath upon the side and front of the podium and a perspectival view of the Hall of Judgment. Matisse, like the great artists of the naturalistic tradition, never decried or denied nature. Instead, he transformed it to better express its inherent qualities. Speaking of several self-portraits, he said, "It is evident that the anatomical, organic, inexactitude in these drawings, has not harmed the expression of the intimate character and inherent truth of the personality, but on the contrary has helped to clarify it." [25] After following with our eyes the difficult, abrupt, pained lines of the WAY OF THE CROSS, we begin to see that the "inexactitude" in these drawings has clarified the expression of the inherent truth within the interpretation of the subject matter. "With more of the abstract and the absolute," Matisse said, "I have arrived at a distillation of form." [26] And for the beholder the distillation of form he speaks of has distilled the content as well.

Conclusion

The first fifty years of our century are now history, but the interpretation of the events of those decades is still a hazardous enterprise. The kaleidoscopic multiplicity of events is too recent for clarity of vision or soundness of judgment. But the twentieth-century works studied in this chapter do exhibit some characteristics in common, and we can derive some conclusions in regard to this particular selection. It may be objected that this selection represents a highly personal choice, and I can only admit that this is necessarily true. The nearer the work of art is to our own time, the more exposed is the art historian or critic who stands before it. How these works of art will stand the rigorous test of time, which will join the company of the giants of the past, are questions for prophets and forecasters. Here we are interested in their distinguishing qualities as works of religious art of this century.

One of the qualities the recent religious art discussed here shares—and this was involved in the selection of the group—is an absolute fidelity to the sources of their own inspiration. Lionello Venturi wrote,

[25] *Ibid.*
[26] *Ibid.*

"A painter who creates his picture in order to stimulate faith in others, rather than to give free expression to his own faith, is not a sincere artist, even though he is a sincere believer." [27] The integrity of the artist as an artist is the source of his greatness, whatever his subject matter or style.

Each of these artists has testified to this integrity. Nolde has an "irresistible impulse to express deep spirituality and ardent religious feeling." Richier was hesitant to accept the commission, but as the sculptural form grew, she felt that "unconscious things of a unique kind were being translated." Manessier wants his paintings to be a "testimonial of a thing lived from the heart." Matisse, after completing his long labor as architect, designer, and decorator for the Chapel of the Rosary at Vence, wrote, "This chapel is for me the crown of a life of work and the flower of an enormous effort, sincere and difficult." Rouault, looking at the religious art of the past, said, "The art of the cathedrals is at once collective and personal, but the way of life, the modes of feeling, understanding, and loving that were at the root of this art cannot be artificially revived. *We can do other things,* but we cannot re-create what the spontaneous collective effort of generations built with the faith that was theirs." [28] This group of artists had an awareness of the necessity for fidelity to their own creative impulse and of the necessity of forging a style which was adequate as a vehicle for their expression of this creative impulse.

These artists have also contributed to a new iconography, a new symbolic language for religious themes. When Nolde's ENTOMBMENT was contrasted with Giotto's LAMENTATION, it was to underline the radical departures from the traditional patterns that Nolde's iconography represents. Matisse's WAY OF THE CROSS, which in its first inception echoed the long-established motifs, in its final form was compressed and radically transformed. Matisse's featureless faces and Richier's fleshless bodies speak to us of a new kind of spirituality. All that is personal, arbitrary, or transitory has been winnowed away.

[27] Pierre Courthion, *Georges Rouault* (New York: Harry Abrams, 1962), p. 351.
[28] *Ibid.,* p. 396. Italics added.

Though the artistic styles of each of these twentieth-century artists differ greatly, all are nonnaturalistic. The Renaissance intoxication with this world—and the artist's exultant mirroring of it—was a strong force deep into the nineteenth century. The elderly Matisse said that all his life he had reacted against the teachings of the masters at the Beaux-Arts who told their pupils to copy nature. Nolde said he painted "without any model in nature, without deliberation, knowledge or reflection." Manessier paints religious and cosmic impressions —"not the imitation of a thing seen through the eyes." And Rouault said, "I have painted with my eyes open to the visible world night and day; but I have also closed them from time to time the better to achieve greater depth of vision." [29]

Another characteristic seen in some of these twentieth-century religious works is the expression of joy. Rouault called himself a painter of joy, and remarked that the critics had not noticed this because his subjects were tragic. He asked, "But is joy to be found only in the subject one paints?" [30] Manessier chose symbols of pain, suffering, and death for his CROWN OF THORNS; yet the painting is an exultant cry of joy. Matisse's chapel, as an architectural and decorative unity, also radiates joy. The old artist was delighted by the remark about the "gay chapel." And indeed, the intense blues, greens, and yellows of its stained-glass windows bathe the white interior in ever-changing brilliant pools of color that surprise by joy and draw from the spectator, unbidden, the impulse for praise and thanksgiving.

Thus all the works of religious art considered in this chapter were characterized by the artists' absolute fidelity to the inner wellsprings of the creative impulse. All contributed to a new iconography. All were nonnaturalistic in style. Many depicted anguish and intolerable suffering, but some of them expressed an exultant sense of joy.

Two kinds of twentieth-century religious art have been discussed concurrently in this chapter—works of art which have been commis-

[29] *Ibid.*, p. 358.
[30] *Ibid.*

sioned by Christian churches and works of art which are created by the artist out of an inner necessity. Richier's CRUCIFIX, Rouault's windows for Assy,[31] and Matisse's WAY OF THE CROSS at Vence were commissioned by churches and were the result of the vision of Father Marie-Alain Couturier, the Dominican priest who had once been an artist himself. Father Couturier was directly or partially responsible for so many of the distinguished commissionings of our day that one is reminded of Émile Mâle's remark, "When iconography is transformed, when art adopts new themes, it is because a thinker has collaborated with the artists." [32] His remark was about the medieval world; the notion that the medieval cathedrals were a collective product, built by the people by instinct, he declared to be a romantic fancy, saying that if we knew history better we would find a single intelligence as the source of every important innovation. Certainly this Dominican priest with his discriminating taste, courage, and persistence was responsible for commissioning an astonishing number of distinguished works of art in our time—the work of Matisse, Bonnard, Lurçat, Braque, Lipchitz, Leger and Chagall for Assy; the Leger stained-glass windows for Audincourt; the church at Ronchamp by Le Corbusier; and, of course, Matisse's creation of the Chapel of the Rosary at Vence. Father Couturier posed for Matisse's mural of St. Dominic for the altar wall of the church at Vence.

It was Father Couturier who first inaugurated a new position for the church in regard to employing non-Catholic artists, some of whom were professed atheists. He admitted that it would be best to have geniuses who happened also to be saints, "but under actual conditions, since men of this kind do not exist . . . it would be safer to turn to geniuses without faith than to believers without talent." He and Father Regamey, editors of *L'Art Sacré*, insisted on the essentially spiritual character of all great art, that "since the genius of great artists lies so deep within them that it touches the 'inner wellsprings

[31] The first commissioning actually followed the conception of the work of art. See the discussion, p. 207.

[32] *Religious Art from the Twelfth to the Eighteenth Century*, p. 29.

of faith,' they might be Christians without realizing it." [33] This position of Father Couturier's reflects a viewpoint in harmony with the premise of the first chapter of this book, that only great art can be great religious art.

As for the religious paintings not commissioned by any church or individual, Emil Nolde's ENTOMBMENT and Rouault's paintings and prints of Christ's Passion have some of the characteristics which were seen earlier in the art of Rembrandt. Nolde's series of paintings on the life of Christ were not commissioned, and they were never permanently installed in a church. Rouault, though a devout Roman Catholic, was not commissioned by a church until he was in his late sixties. Thus, most of his paintings with Christian subject matter are owned, as Rembrandt's are, by collectors and museums. Like Rembrandt, Rouault had an overwhelming interest in subjects that had to do with the Passion of Christ, and these he depicted again and again throughout his life. Like Rembrandt, he used light and dark to express the spiritual and emotional dimensions of his themes, and the ugly or disharmonious line or mass when it served his purpose.

Thus, the deeply moving unchurched art of the twentieth-century Roman Catholic Rouault has affinities with the art of the seventeenth-century Protestant Rembrandt. Again, all of the questions about religious art are raised—What is religious art? What is Christian art? What is Catholic or Protestant art? What subject matter is Christian or religious? What style, or styles, are Christian or religious?

In one way the method used in this book is an evasion of these questions, and in another way it is an answer. The questions have meaning only when asked in regard to one particular work of art. And even then the answer is not in our hands until we have explored all the facets of the work of art to the utmost of our ability. When this is done, we discover how complex and multiple are the meanings borne by all the great masterpieces; how they point in many directions— sometimes even in opposite directions—how they are capable of new and renewed meanings, and teach us of ourselves, as well as of faith.

[33] William S. Rubin, *Modern Sacred Art and the Church at Assy*, p. 69.

ON BUYING ART BOOKS

Author's Note to the Second Edition

For those interested in the literature in the field, John Cook's "Sources for the Study of Christianity and the Arts," in the useful collection of writings edited by Diane Apostolos-Cappadona, *Art, Creativity, and the Sacred* (Crossroad, 1985), brings this addendum "On Buying Art Books" up to about 1979.

Among the books on art and religion published recently from the theological world are *The Bible and American Arts and Letters*, edited by Giles Gunn (Fortress Press and Scholars Press, 1983), with chapters on "The Bible in American Painting" by John W. Dixon and "The Bible in American Folk Arts" by Daniel W. Patterson; and *Image as Insight: Visual Understanding in Western Christianity and Secular Culture* by Margaret M. Miles (Beacon Press, 1985).

Notable among recent publications by art historians concerned with problems in art and religion are *Nature and Culture: American Landscape Painting* by Barbara Novak (Oxford University Press, 1980); *Modern Painting and the Northern Romantic Tradition: Friedrich to Rothko* by Robert Rosenblum (Harper & Row, 1975); *The Altar and the Altarpiece: Sacramental Themes in Early Netherlandish Painting* by Barbara G. Lane (Harper & Row, 1984); and *The Sexuality of Christ in Renaissance Art and in Modern Oblivion* by Leo Steinberg (Pantheon Books, 1984).

There are three basic types of books available to those who are interested in building a small collection of books on art. First, there are picture books—those consisting mostly of plates with relatively little text. These range from the handsome, expensive, large volumes (often too heavy to be held comfortably, like the recent book on Rouault weighing five and one-half pounds) to small paperbound books. The smaller books range in quality of color reproduction from poor, or indifferent, to what in some cases is surprisingly good. These books are for viewing, a kind of gallery in a book.

The second category consists of historical and critical books. These books are to be read; in them the text dominates, and the plates are supplementary. In this area there is a rich assortment of paperbound volumes, some of them originals, others attractive reprints of earlier hardback editions.

The last category is reference books, to be used for looking up specific facts and information. Although the basic references are too expensive and too detailed for the needs of the layman in art and religion, many recent handbooks and concise reference volumes have been published for the growing art-conscious reading public. Some of these are paperbound and contain a wealth of information at a modest price.

Picture Books

Picture books are usually either monographs (books on one artist) or anthologies (books which include the works of many artists and many styles). Those who are interested in building an art library should purchase monographs rather than anthologies. Anthologies inevitably represent a personal bias (sometimes a delightful one) or an impersonal screening. Inevitably, their plates and information overlap. An exception to this rule of thumb is the picture book on a collection or an exhibit which one has seen and enjoyed as an entity. Thus the picture book on the Museum of Modern Art in New York, called *Masters of Modern Art* by Alfred Barr, or the catalog of the Johnson Collection of the Philadelphia Museum of Art, has an interest for those who have seen the particular collections. Such catalogs or picture books will re-create for the visitor the splendors of the original experience.

Phaidon Press was a pioneer in the field of art monographs. In 1940 this press published a handsome, large-format volume, *The Sculptures of Michelangelo*, with fine black-and-white photographs of all of the master's sculptured work, as well as many stunning details of these sculptures. Phaidon Press has since published monographs on many of the artists discussed in this book; Fra Angelico, Botticelli, Donatello, Piero della Francesca, Leonardo da Vinci, Michelangelo, Peter Bruegel, Tintoretto, El Greco, Rembrandt, and Bernini.

The monographs with many fine color plates published by Harry Abrams are expensive but choice. Two volumes on artists discussed in this book, *Rouault* by Pierre Courthion and *Emil Nolde* by Werner Haftmann, are notable examples. Both have many fine color plates and a substantial, documented text. A series of smaller, modest monographs, also published by Abrams, is exceptional in that the introductory essays were written by established scholars. Included in the series are monographs on most of the artists discussed in this book.

The Skira "Taste of Our Time" monographs are somewhat larger, considerably thicker, and are hardbound. They have a substantial text and are generously illustrated with color plates of superior quality. Volumes now available include Fra Angelico, El Greco, Piero della Francesa, Rembrandt, Botticelli.

Historical and Critical Books: General Histories

The Story of Art by E. H. Gombrich (Phaidon Press) combines readability and sound scholarship in a handsome but compact volume. This general history has more material on the church and religious art than is contained in the other currently available surveys. The author uses a minimum of technical terms and writes with an almost colloquial ease, yet he never simplifies the complex interplay of the numerous factors which shape the work of art. A smaller, briefer, paperbound volume, also helpful for those who want an engaging and sound introduction to the field, is Herbert Read's *The Meaning of Art* (paperback, Penguin Books).

The Social History of Art by Arnold Hauser (originally Knopf, now available

in paperback, Vintage Books) utilizes some Marxist categories of criticism, but contains many provocative suggestions and insights about major artistic styles. It is an interesting antidote to the overly philosophical psychological, or theological interpretations of art history in our day, though it does not ignore the contributions of any of these disciplines. Another general work, but one in which the history of art is seen through one subject, is Sir Kenneth Clark's *The Nude: A Study in Ideal Form* (originally a Bollingen Foundation publication, but now available in paperback, Doubleday Anchorbook). Sir Kenneth examines the male and female nude in its manifold forms in the art of all periods. Inasmuch as Adam and Eve and the crucified Christ are subjects which are repeatedly represented from the second century to our own day, a large part of the book deals with religious art.

Two paperbound books on criticism and evaluation, each notable in its own way, are Erwin Panofsky's *Meaning in the Visual Arts* (Doubleday Anchorbook) and Roger Fry's *Vision and Design* (Meridian Books). Professor Panofsky's book contains an important essay, "Iconography and Iconology," which delves deeply into the matters dealt with in this book in Chapter II. Also to be noted by readers of this book are his study of "Human Proportions as a Reflection of the History of Style," and his chapter on Abbot Suger, who in the twelfth century made St. Denis in Paris a center from which a rejuvenated art illumined France and Europe. In *Vision and Design* Roger Fry's lucid prose makes his perceptive analyses delightful reading. His "Essay in Aesthetics" goes as deeply into the problems of analysis and terminology as the layman is likely to want to go. The chapters on Giotto will be of interest to readers of the present book. It may be noted in passing that Roger Fry was an English critic, who was himself a painter, and the subject of a biography by Virginia Woolf.

Reference Books

Two paperbound reference works are noted here. *A Dictionary of Art and Artists* by Peter and Linda Murray (Penguin Books) was designed as a companion for gallery visitors. It contains much useful information in a pocket-sized paperbound book. It has entries under the names of most of the artists discussed in this book, and definitions and discussions of technical terms, styles, and commonly used foreign terms. The other valuable paperbound reference is E. G. Holt's *Documentary History of Art* (Doubleday Anchorbook, 2 vols.). More vivid than any generalizations or conclusions of the art historian are the words of the artists or witnesses whose documents are reprinted in these two volumes. Michelangelo's contract for the PIETA and his sonnets, Leonardo's and Dürer's writings, selections from Abbot Suger's treatise on the rebuilding of St. Denis, Rembrandt's few extant letters, help bring the person and the period before us with immediacy.

Historical Works by Period

Art in the Early Church by Walter Lowrie (Pantheon Books, 1947, originally,

now in paperback, Harper Torchbooks) deals with Christian art from the catacombs through the early Byzantine period. This book, gracefully written by an Anglican clergyman, draws together materials and provides an introduction to the relationship between the church, the artists, and the theologians in the early centuries. The late Professor Lowrie (who was also a translator of Kierkegaard) discusses the developing iconography and architecture of the early church. His book has many plates, much bibliographic information, and a helpful index.

D. T. Rice has written a succession both of useful small volumes and of handsome large ones on Byzantine art. A recent paperback simply entitled *Byzantine Art* (Penguin Books) is a good beginning reference.

Emile Mâle's *Religious Art from the 12th to the 18th Century* (paperback, Noonday Press) exhibits the core of this scholar's conclusions and is excerpted from his fine series of scholarly volumes on French art and architecture. The late author was one of the great medieval scholars, and his prose is illumined both by his own faith and by his vivid aesthetic response to the work of art. Mâle's *The Gothic Image* (paperback, Harper Torchbooks) is a translation of his book on thirteenth-century French art and architecture. It is a detailed study of the thought of this period which saw the fruition of Gothic art, the period in which the great cathedrals were built—Chartres, Paris, Amiens, Reims.

Erwin Panofsky's *Gothic Architecture and Scholasticism* (paperback, Meridian Books) is a compact small volume with the thesis that Gothic architectural style and structure provided visible and tangible equivalents to the scholastic definitions of the order and form of thought. Professor Panofsky is one of the foremost living art historians; his appointment to the Institute for Advanced Study at Princeton was one of the two original lifetime appointments (the other was Albert Einstein). He has written and spoken extensively, and as lecturer at New York University he has stimulated and influenced several generations of young scholars.

Form in Gothic by Wilhelm Worringer (paperback, Schocken Books) is one of the most fascinating works of criticism of our century. Worringer sees the distinctions between classical and northern man as basic to the differences in their artistic styles. The differences between what in this book has been called naturalism (classical art is naturalistic) as opposed to what has been here called realism (the style of northern artists) are elaborated with a wealth of observation and comment.

The Dutch historian Johan Huizinga brings the late medieval world vividly before us in his *Waning of the Middle Ages* (paperback, Doubleday Anchorbook). Though not primarily about art, the whole fabric of this book illumines the late medieval world.

Bernard Berenson's *Italian Painters of the Renaissance* (paperback, Meridian Books) is a classic reference on the fifteenth- and early sixteenth-century artists of Italy. It is really a series of monographs on the individual artists, grouped to-

gether geographically. But these studies are interspersed with paragraphs on The Grotesque in Art, Analysis of Enjoyment, Humanity and the Renaissance, and many other pithy passages. Berenson, a famous connoisseur, known affectionately to his friends as BiBi, lived his life in art. He gave his Florentine villa with its magnificent library and art collection to Harvard University for a center of Renaissance studies.

Classic Art by Heinrich Wölfflin (Phaidon Press, 1952) is an important study of Italian Renaissance art which includes the study of sculpture. In this book Wölfflin writes of fifteenth-century art—the early works of Leonardo, Michelangelo, Raphael—and then of the work of these masters during what is called the High Renaissance. Wölfflin introduced a new method of art criticism which found its fullest expression in his *Principles of Art History* (paperback, Dover Publications). His method is contained in a less systematic but more readable form in *Classic Art*. The *Principles* contrasts Renaissance and baroque art and is one of the most important studies of the baroque style.

For information on the mannerist and baroque artists readers of this book will find the Phaidon and other monographs on the individual artists helpful. Jakob Rosenberg's book *Rembrandt* (published by Harvard University Press in 1948 in two volumes, and recently reissued as one volume by Phaidon Press) has a splendid chapter on Rembrandt's portrayal of biblical subjects. *Rembrandt and the Gospel* by W. A. V. 't Hooft is an interesting book (London: S. C. M. Press, 1957) which has both the strengths and the weaknesses of a partisan viewpoint. The author's ease with Dutch culture and his knowledge of Dutch history make him an alert and informed interpreter of his compatriot's art. But intermittently his Protestantism is a barrier to his understanding of baroque art, the work of Bernini and other artists of the Counter Reformation.

Twentieth-century art has been written about and reproduced in color in numerous books and catalogs and periodicals. Here also, it is wise to restrict one's purchases to monographs. The catalogs of one-man shows at the Museum of Modern Art are excellent monographs, all having many illustrations and essays by distinguished critics and historians. Of other books available on recent art three works are especially noteworthy, each quite unique in its way. Georges Rouault's *Miserere* (see Chapter X in this book) was first published by the Museum of Modern Art in 1952, and has recently been reissued with an introductory essay by Monroe Wheeler. The fifty-eight lithographs which make up the book were originally available as individual large prints. They were arranged for publication in book form and captioned by Rouault himself, who wanted a wider public to know the *Miserere* and to be able to peruse it as a book.

Modern Sacred Art and the Church at Assy by William S. Rubin (Columbia University Press) presents the history of the commissioning and the creation of the many works of art for the church at Assy. Matisse and Rouault and Richier were among the masters who created religious art for this church (see

Chapter X). The wider significance of the book is that it presents a case study of one of the most courageous, imaginative, and fruitful relationships between an established church and the great masters of our own day.

Finally, a slender paperbound book by Alfred H. Barr, *What Is Modern Painting* (Museum of Modern Art) was first published in 1943; the tremendous sale of this readable essay, written by the Director of the Collections of the Museum of Modern Art in New York, gives evidence that Mr. Barr achieved his objective of "undermining prejudice, disturbing indifference, and awakening interest in and love for the more adventurous painting of our day." Mr. Barr has long been one of the ablest, keenest, and gentlest writers on modern art. Though the essay does not deal specifically with religious art, readers of this book will find much that relates to Chapter X in this book. The final paragraphs on truth, freedom, and perfection in modern art are both an apologia for, and a salute to, the distinguished art of our own era.

illustration credits

The author and the publisher wish to thank the custodians of the works of art for supplying photographs and granting permission to use them. Alinari/Art Resource, New York: 1, 2, 6-13, 24-34, 40-43, 48-51, 53, 59-61, 64, 65; Ampliaciones y Reproductiones, Barcelona: 62, 63; Bildarchiv Foto Marburg/Art Resource, New York: 4; The Chrysler Museum, Norfolk, Virginia: 76 (Gift of Walter P. Chrysler): Church of Notre-Dame-de-Toute-Grâce, Vence: 74, 77; John Dillenberger: 3, 38; Foyer Lacordaire, Vence: 79-81; Giraudon/Art Resource, New York: 17-21; Kunsthistorisches Museum, Vienna: 56-58; Lois Lord: 80, 82; The Metropolitan Museum of Art, New York: 5 (Gift of Edward S. Harkness, 1914), 54, 55 (The Harris Brisbane Dick Fund, 1943), 68, 69 (Bequest of Mrs. H.O. Havermeyer, 1929. The H.O. Havermeyer Collection), 70 (The Harris Brisbane Dick Fund, 1923), 71 (Bequest of Ida Kammerer in memory of her husband, Frederic Kammerer, M.D., 1933); Musée Historique de l'Orleanais, and Cliche Serge Martin, Orleans: 22; Musée d'Unterlinden, Colmar: 52; The Museum of Modern Art: 73, 75 (Abby Aldrich Rockefeller Purchase Fund); The Museum of Art, Carnegie Institute: 78 (Patrons Fund); The National Gallery, London, by permission of the Trustees: 35-37; The National Gallery of Art, Washington, D.C.: 44-47 (The Andrew W. Mellon Collection), 66-67 (The Widener Collection); The Pierpont Morgan Library: 16; Stiftung Ada und Emil Nolde: 72; Vicar of St. Matthew's Church, Northampton: 23.

index